Gods and Heroes in Art

Lucia Impelluso

Gods and Heroes in Art

Edited by Stefano Zuffi
Translated by Thomas Michael Hartmann

The J. Paul Getty Museum
Los Angeles

Original graphic design: Dario Tagliabue
Original editorial coordinator: Simona Oreglia
Original production coordinator: Anna Piccarreta
Original layout: Sara De Michele
Original editing: Carla Ferrucci
Image research: Lucia Impelluso and Anna Sconzá

First published in the United States of America in 2003 by

Getty Publications
1200 Getty Center Drive, Suite 500
Los Angeles, California 90049–1682
www.getty.edu

Christopher Hudson, *Publisher*
Mark Greenberg, *Editor in Chief*
Ann Lucke, *Managing Editor*

Thomas Michael Hartmann, *Translator and Editor*
Hespenheide Design, *Designer and Typesetter*

Library of Congress Cataloging-in-Publication Data

Impelluso, Lucia.
 [Eroi e dei dell'antichità. English]
 Gods and heroes in art / Lucia Impelluso ; edited by
Stefano Zuffi; translated by Thomas Michael Hartmann.
 p. cm.
 Includes bibliographical references and index.
 ISBN 0-89236-702-4 (pbk.)
 1. Mythology, Classical, in art—Dictionaries—Italian.
 2. Mythology, Classical—Dictionaries—Italian. I. Zuffi, Stefano,
 1961– II. Title.
 N7760 .I47 2003
 700′.415—dc21 2002013422

Printed and bound in Italy

Contents

6 Introduction

9 Myths, Gods, and Heroes

257 The Homeric Poems

258 The Trojan Cycle

281 *The Odyssey*

299 Characters and History
from Ancient Greece

323 Characters and History
from Ancient Rome

376 Appendixes

377 Index of Names

378 Sources

381 Symbols and Attributes

382 Index of Artists

384 Photographic References

Introduction

Myths originated at the dawn of civilization. They are the beginning of religious traditions and history and a specific conception of the world. These legendary narratives were derived from the first intuitive forms of knowledge; they describe phenomena of nature and life by animating and personifying them through imagination. Handed down through oral tradition, myths through the centuries have been modified and expanded with changes and extensions, becoming a valuable intellectual inheritance for a variety of societies.

A case in point is how Western culture inherited a combination of myths from the Greeks, whose fertile imagination had interpreted natural and spiritual events in an animistic and anthropomorphic way. Plato described mythos as a tale revolving around gods, divine beings, heroes, and those returned from the afterlife. This was opposed to logos, the typical rational argumentation of philosophical speculation. A myth is, therefore, a story or a series of tales that has often reached us in a fragmentary way.

Such an inheritance found its harmonious complement in poetry, literature, and art. Greek and Roman artists were inspired by mythological tradition in their vase painting, frescoes, and sculptures for public and private monuments. During the Middle Ages, barbarian invasions and Christian aversion were not enough to erase pagan antiquity, which survived in forms and meanings that continued to resonate with that period. In the Renaissance, classical civilization kept its role as a model of the highest human values. Myths were revived in paintings and in the great Renaissance and Baroque frescoes that enliven the walls and ceilings of aristocratic residences. During this time, essays on mythology began to surface. These were quite useful for painters executing cycles of frescoes or single canvases that often had ethical, moral, educational, or festive purposes. Already embedded in culture, myths in the

nineteenth and twentieth centuries remained sources of inspiration for artists. The many legends that feature heroes, humans, gods, and demigods are deeply rooted in modern collective memory and continue to fascinate us.

It is not hard to find compositions with mythological subjects in ancient palaces and museums, although it can often be difficult to identify the main characters in a given episode. Sometimes it is not particularly easy to even obtain thorough information on a work, since museum catalogues and art books often assume the viewer is already familiar with the theme portrayed.

This volume aims at making such a complex subject as myths more accessible. Each entry includes a descriptive format that explains how a mythological character is depicted by artists, their distinctive stories, and special attributes. Examples from art follow, where the reader can examine images and explanations of details.

The volume is divided into four sections. The first concerns gods, heroes, and divine beings from the Greek and Roman pantheon. The second regards characters from legends of the Trojan War and Homer's Odyssey. Finally, the third and fourth sections describe historical figures from classical antiquity—kings, emperors, philosophers, heroes, artists, and famous soldiers—who have by now become legendary, although they are still difficult to identify without consulting classical texts. The dictionary concludes with an appendix that includes a list of symbols that identify each mythological figure as well as other indexes. In addition, a bibliographical section reports on the main sources, allowing a more profound look at the subjects treated here.

Myths, Gods, and Heroes

Actaeon

Actaeon is typically portrayed discovering Diana bathing at a fountain or spring, changing into a stag, or being torn apart by his dogs.

Greek Name
Actaeon

**Relatives and
Mythic Origins**
Son of Aristaeus and
Autonoe

**Characteristics
and Activity**
A skilled hunter, he
was educated and
trained in hunting by
the Centaur Cheiron

On the preceding pages:
Giovanni Bellini, *The Feast
of the Gods*, 1504. Wash-
ington, National Gallery.

▲ Titian, *Diana and
Actaeon* (detail), circa
1559. London, National
Gallery.

Actaeon is an expert hunter and learned his craft from Cheiron—the wisest Centaur and educator of the most famous heroes, including Achilles and Peleus. One day, during a deer hunt with his dogs, Actaeon comes upon Diana near a spring, where the goddess is refreshing herself in the company of her nymphs. As soon as she realizes he is there, the goddess of the hunt resents it, splashes water in his face, and changes him into a stag as punishment. Fleeing, the hunter is surprised at how fast he is able to run, until he sees his reflection in a spring and realizes what he has become. Stupefied, hysterical, and uncertain of what to do, he is discovered by his dogs, which hurl themselves in chase and kill him after running him down. The myth of Actaeon is one of the most commonly portrayed by artists. The young man is often depicted at the moment he notices Diana and is being transformed. Other times his discovery of the goddess and the dogs' aggression are shown separately.

A stag's skull appears
as an ominous
foreshadowing of
Actaeon's fate.

Diana stands out
because of the
crescent moon,
a characteristic
symbol of the
goddess.

The dog next to the young man dressed as a
hunter suggests that this character is Actaeon.
The presence of Diana and nymphs near a
fountain confirms this.

◄ Bernardino Cesari, *Diana and
Actaeon*, 1600–1601. Rome,
Galleria Borghese.

▲ Titian, *Diana and Actaeon*,
1558. Edinburgh, National
Gallery of Scotland.

Stag horns are sprouting on Actaeon's head.

The dogs are about to hurl themselves at the hunter.

▲ Rembrandt, *Diana with Actaeon and Callisto*, 1634. Anhalt, Museum Wasserburg.

The crescent moon identifies Diana, goddess of the hunt and night.

The nymphs
discover that
Callisto, a
nymph in
Diana's
company whom
Jupiter loved,
is pregnant.
Juno later
transforms
her into a bear.

Adonis is usually depicted as an extraordinarily beautiful young man—often with Venus—dressed as a hunter or being killed by a wild boar.

Adonis

Greek Name
Adonis

**Relatives and
Mythic Origins**
According to Ovid,
he was born from the
incestuous relationship
between Cinyras, king
of Cyprus, and his
daughter Myrrha

**Characteristics
and Activity**
His myth is linked to
the portrayal of the
seasons: the death of
nature in winter and its
rebirth in springtime

Special Devotions
The worship of Adonis
originated in Asia and
spread to Greece dur-
ing the Hellenistic
period; the Adonia
festival lasted for eight
days and celebrated
the union of Adonis
and Venus and their
separation

Related Myths
Loved by Venus and
Proserpina

▲ Sebastiano Ricci, *Venus
and Adonis* (detail), 1705–6.
Orléans, Musée des beaux-arts.

Adonis is born of a relationship between Cinyras, king of Cyprus, and his daughter Myrrha, with whom the unknowing king stays for twelve nights. When he discovers that his lover is actually his own daughter, he tries to kill her. Myrrha flees, and after wandering to the point of exhaustion, she begs the gods to transform her into a being that neither belongs to the kingdom of the living nor that of the dead. The young woman is then transformed into a myrrh tree. The fruit of this incestuous union is born when the bark of the tree splits open with some help from Lucina, the goddess of childbirth, and is named Adonis. Venus, struck by the infant's beauty, takes the newborn under her protection and entrusts him to Proserpina's care.

Proserpina also falls in love with the baby, however, and refuses to give him back. Jupiter intervenes to resolve the dispute and rules that Adonis live part of the year with Venus and the other with Proserpina. Ovid tells how Venus falls in love with Adonis after accidentally being shot with one of Cupid's arrows. Adonis is killed by a wild boar during a hunt, and the myth recalls how anemones sprout from his spilled blood.

◀ Giuseppe Mazzola, *The Death
of Adonis*, 1709. Saint Petersburg,
Hermitage.

Myrrha's body is transformed into a tree trunk; her arms and hair stretch into leafy branches.

The figure holding Adonis in her arms is Lucina, the Roman goddess of childbirth. Nevertheless, the crescent moon on her head is a symbol of Diana, the goddess who originally had the same function as Lucina for the ancient Italic peoples. Only later was she assimilated with the Greek goddess Artemis.

Two nymphs watch Myrrha's metamorphosis.

Cherubs often appear in Renaissance and Baroque painting, recalling symbols of Greek eroticism that were also present in Pompeian painting. They are often in the company of Cupid or Venus.

▲ Marc Antonio Franceschini and workshop, *The Birth of Adonis*, 1648–1729. Bologna, Palazzo Durazzo Pallavicini.

Adonis

Cupid, the faithful companion of Venus, sounds a hunting horn with another cherub.

Venus, holding an arrow, is shown here as a huntress. Since she is in love with Adonis, the goddess ignores her divine duties in order to follow the young man hunting.

Adonis has killed a stag. Venus, knowing her lover's fate, encourages him to hunt animals who flee, not those who defend themselves.

▲ Marc Antonio Franceschini,
The Hunt of Adonis, 1691–1710.
Vienna, Liechtenstein Collection.

Venus is usually depicted nude. According to Renaissance mythographers, those who abandoned themselves to sensual pleasure remained devoid of any good.

Doves often identify the goddess Venus.

A quiver of arrows is one of Cupid's symbols. He was born from the union of Venus and either Jupiter, Mars, or Mercury, depending on the version of the myth.

Adonis is often shown with one or more dogs, his faithful hunting companions.

▲ Bartholomeus Spranger,
Venus and Adonis, circa 1597.
Vienna, Kunsthistorisches Museum.

Venus attempts to keep Adonis from hunting, since she knows that a ferocious animal will kill him. This episode is not mentioned in the ancient sources but was freely interpreted and depicted by Titian and Rubens, becoming a reference point for later generations of painters.

Armed with a spear and holding the dogs on a leash, Adonis attempts to free himself from his lover. He is unaware of his destiny.

Cupid, Venus's son, tries to help his mother by holding one of Adonis's dogs.

▲ Veronese, *Venus Tries to Hold Back Adonis Without Success*, 1560–65.
Augusta, Staatlische Kunstsammlungen.

Swans, symbols of Venus, pull the goddess's chariot.

The frantic Venus runs to Adonis's side. He is dying.

The boar flees into the forest. According to some interpretations, the boar is none other than Mars himself, who kills Adonis out of jealousy.

Anemones sprout from Adonis's blood. They are flowers that last for a very short time before the wind disperses their petals. Their name itself comes from the Greek word ánemos, meaning "wind."

Adonis's dog rests a short way from his fallen master's lifeless body.

▲ Domenichino, *The Death of Adonis*, circa 1629–31. Genoa, Palazzo Durazzo Pallavicini.

Antiope

An extremely beautiful nymph or mortal, Antiope is often depicted lying down sleeping in a deep forest.

Greek Name
Antiope

**Relatives and
Mythic Origins**
According to Homer,
she is the daughter of
the river Asopus;
according to others,
she is the daughter of
Nycteus, the king of
Thebes

**Characteristics
and Activity**
As daughter of Asopus,
she is a nymph;
according to others,
she is a mortal being

Related Myths
Amphion and Zethus,
the twin sons of
Antiope, conquer
Thebes and fortify the
city with its famous
walls

The classical texts give only brief hints about Antiope. In the *Odyssey,* Homer describes her as a nymph, the daughter of the river Asopus, who boasts of having slept in Jupiter's arms and given birth to the twins Amphion and Zethus. Homer does not tell how Jupiter transforms into a satyr to join Antiope, an account of which appears in Ovid's *Metamorphoses.*

The twins born from Antiope and Jupiter's union are abandoned and raised by shepherds. They learn their true identities when they are full grown and march on Thebes, where Antiope is being held prisoner by King Lycus. There they avenge their mother.

Although it does not have a prominent position in the ancient sources, the myth of Jupiter and Antiope had modest success among artists of various eras, who were probably inspired by this subject as they depicted a female nude resting. In fact, Antiope is most often portrayed as a sleeping woman lying in the forest as Jupiter, in the form of a satyr, draws near and gently lifts her clothing. Cupid often appears next to her with his bow and arrow.

The satyr near Antiope is Jupiter, as the eagle at his side suggests. Satyrs are mythical creatures who live in the forest and are part human and part animal; they especially prefer sensual pleasures and wine.

The eagle and the lightning bolts that it holds in its beak are symbols of Jupiter.

Antiope lies sleeping as Jupiter removes her clothing.

◄ Jean-Auguste-Dominique Ingres, *Jupiter and Antiope* (detail), 1851. Paris, Musée d'Orsay.

▲ Anthony van Dyck, *Jupiter with Antiope,* circa 1630. Cologne, Wallraf-Richartz-Museum.

21

Apollo

Apollo is often shown as a youth of rare beauty with his head surrounded by light, driving the sun chariot, which crosses the sky each day pulled by four horses. The bow, arrow, quiver, lyre, and laurel are his symbols.

Greek Name
Apollo

Relatives and Mythic Origins
Son of Jupiter and Latona; twin brother of Diana

Characteristics and Activity
God of the sun, beauty, moral order, oracles, prophesies, music, and poetry

Special Devotions
Worship of Apollo was widespread throughout the Hellenized world; the most important temples were in Crete, Corinth, and Delphi, where the famous oracle was located and the Pythian Games were held; the most famous temple in the Roman world was erected on Palatine Hill; the Ludi Apollinares were celebrated from July 6 to July 13

Related Myths
Phaethon; Apollo visits Vulcan's forge; Marsyas; the judgment of King Midas; the Sibyl of Cumae; the death of Niobe's children; Hyacinthus

Apollo is one of the twelve gods of Olympus. When he is still a child he kills Python, a serpent who was terrorizing the Delphi area. That place eventually becomes the worship sanctuary of Apollo, where the god communicates to gods and humans through oracles.

Apollo can be warlike and deadly, provoking pestilence and unforeseen death. During the Trojan War, he spread sickness throughout the Greek camp.

However, he is never as dangerous to humans as much as he helps them, and, as father to Aesculapius, the god of medicine, he helps keep evils at bay. Finally, Apollo is also the inventor of music, and he cheers the gods with his lyre when they gather for a banquet. As patron of the Muses, he is called Musagetes.

Apollo is often portrayed nude with a crown of laurel on his head. As a musician, he usually wears a long tunic when he plays the lyre or, in certain Renaissance paintings, the violin or cello. A curious monster with three heads (lion, wolf, and dog)

and a serpent's body accompanies Apollo only rarely; this was a mythical beast connected with the Egyptian god Osiris (god of the Underworld). During the Renaissance, mythographers still associated the monster with the sun god.

▲ Diego Velázquez, *The Forge of Vulcan* (detail), 1630. Madrid, Prado.

◄ Pietro Benvenuti, *Apollo*, circa 1813. From a private collection.

Mercury holds a caduceus, one of his emblems. This messenger of the gods also wears his characteristic winged shoes.

A winged cap is a symbol of Mercury.

Apollo drives the sun chariot. He and Sol, the sun god, were once two distinct gods; they were later assimilated into the single figure of Apollo.

According to medieval tradition, horses of the sun chariot had different colors. In the Renaissance, however, they were portrayed as all white, similar to those used to pull the Roman triumphal four-horse chariots (quadrigae).

▲ Giovanni Battista Tiepolo, *The Court of the Sun*, 1740. Milan, Palazzo Clerici.

The hammer is one of the symbols of Vulcan, the god of fire, who is often shown in his forge working metal on an anvil.

Apollo's head is surrounded by a luminous halo that emphasizes his being the sun god. One of his qualities is knowing everything, and here Apollo is telling Vulcan how he has been betrayed by Venus and Mars.

Laurel is an attribute of Apollo. It has been his symbol since the nymph Daphne was transformed into the plant while fleeing from him.

▶ Diego Velázquez, *The Forge of Vulcan*, 1630. Madrid, Prado.

Vulcan's helpers should be the Cyclopes, which are described in myths as giants with a single eye. Velázquez, however, interprets them realistically as foundry workers.

Arachne

A famous weaver, Arachne is often portrayed seated at her loom while the goddess Minerva, dressed in full armor, watches her work. Other times the young girl, standing with her arm extended, proudly displays her work or holds a web between her hands.

Arachne, a young girl from Lydia, is quite skilled in the art of weaving, so much so that even the nymphs gather to watch her work. Becoming proud, Arachne boasts of being better than even Minerva and challenges the goddess, who is protector of all arts and crafts, including weaving.

Disguised as an old lady, Minerva initially tries to encourage Arachne to take back her impudent words, but the young girl continues to boast and becomes stubborn and shameless. Minerva then reveals herself and accepts the challenge. Not fearful at all, Arachne begins weaving her cloth, which portrays the lovers of the gods. The goddess, however, does not appreciate the subject matter and furiously reduces the cloth to shreds and strikes Arachne with the shuttle.

At this point the girl, who by now is quite overwhelmed by the goddess's wrath, tries to hang herself, but Minerva transforms her into a spider. The Greeks, in fact, believed that a spider—*aráchne* in Greek—made its web by weaving.

Greek Name
Arachne

Relatives and Mythic Origins
A girl from Lydia; daughter of Idmon, a famous purple dyer

Characteristics and Activity
Famous for her skill at weaving

▲ Diego Velázquez, *The Spinners (Las hilanderas)* (detail), circa 1653. Madrid, Prado.

▶ Veronese, *Arachne* or *Dialectics*, 1575–77. Venice, Palazzo Ducale.

*Minerva wears
a helmet on
her head, as she
traditionally
does.*

*A spider fore-
shadows the
young girl's
imminent
transformation.*

*The loom
is usually
associated
with the myth
of Arachne.*

*Nymphs
watch the
contest.*

▲ Tintoretto, *Athena and Arachne*, circa
1543–44. Florence, Palazzo Pitti.

Argus

Greek Name
Argus

**Relatives and
Mythic Origins**
Tradition does not
agree on who fathered
Argus; he is considered
a son of Agenor or
Inachus

**Characteristics
and Activity**
He is called Argus
Panoptes, the "all-
seer," or Argus "of
the many eyes"

Related Myths
Juno charges him with
guarding Io, whom
Jupiter had turned into
a white heifer

Argus, a shepherd with many eyes, is frequently shown sleeping, leaning against a rock, or lying down at the foot of a tree.

Argus is mainly remembered as a character in the myth of Io, the daughter of the river god Inachus. Jupiter falls in love with her, and in order to evade the wrath of his wife, Juno, he changes Io into a cow. Realizing Jupiter's deceit, the queen of the gods asks her husband to give her the heifer as a gift and charges Argus with guarding it. Since he has numerous eyes, she counts on his being able to sleep and keep watch at the same time by giving each of his eyes a turn to rest. Worried for his lover, Jupiter asks Mercury for help. By playing his flute, Mercury manages to put Argus completely to sleep; he then kills him. According to other versions of the myth, Mercury puts Argus to sleep by using his divine wand or defeats him by hurling a stone. To honor her fallen servant, Juno attaches his eyes to the peacock's tail, a sacred bird for the goddess.

Argus is often portrayed being observed by Mercury as he guards Io or falling asleep at the sound of the flute. Painters also depict him lying lifeless as Juno places his eyes on a peacock's tail with the help of cherubs.

The colored marks on the peacocks' tails are Argus's eyes. Juno places them on these animals sacred to her in memory of Argus, the hundred-eyed guard whom she charged with guarding Io. Mercury killed him.

The rainbow, a path between heaven and earth, is a symbol of Iris, messenger of the gods, who is in the service of Juno. Here she is detaching Argus's eyes from his head.

The peacock is a symbol of Juno, who is seen here taking Argus's eyes and placing them on the birds' tails.

Argus lies lifeless on the ground.

◄ Diego Velázquez, *Mercury and Argus*, 1659. Madrid, Prado.

▲ Peter Paul Rubens, *Juno and Argus*, 1610–11. Cologne, Wallraf-Richartz-Museum.

Ariadne is shown either giving thread to Theseus or deserted on the island of Naxos. She can also appear together with Bacchus or in a chariot at his side with his followers.

Ariadne

Greek Name
Ariadne

Relatives and Mythic Origins
Daughter of Minos, king of Crete, and Pasiphae

Characteristics and Activity
Ariadne helps Theseus defeat the Minotaur

Special Devotions
Ariadne was especially worshipped on Crete and Argos, but also on Delos, Cyprus, and Locris, where she was called "Ariadne Aphrodite"

Ariadne is the daughter of King Minos of Crete and Pasiphae. When Theseus reaches Crete to battle the Minotaur that is imprisoned deep within the famous Labyrinth, Ariadne falls in love with him and helps him. The young woman gives the hero a ball of thread, advising him to attach one end at the Labyrinth's entrance and never let go of the other. The Athenian hero, after slaying the horrible creature, easily finds his way out. Theseus then departs for Athens with his lover, but upon landing on the island of Naxos, he deserts her as she lies in a deep sleep. Later Bacchus meets Ariadne on the island and falls in love with her. The god hurls her crown into the sky and transforms it into a constellation. Consoled by the god, she marries him.

Ancient images often show Bacchus as he watches Ariadne sleeping. In his *Metamorphoses,* Ovid tells how Ariadne, realizing that Theseus has abandoned her, despairs until Bacchus comes to her aid. Artists from the Renaissance and later periods portray her awake and weeping, either by herself or with Bacchus.

A ball of thread is one of the symbols of Ariadne; here she gives it to Theseus to help him find his way out of the Labyrinth.

Theseus takes the ball of thread.

▶ Giovanni Battista Pittoni, *Bacchus and Ariadne* (detail), 1730–32. Stuttgart, Staatsgalerie.

◀ Cima da Conegliano, *The Triumph of Bacchus and Ariadne*, circa 1505–10. Milan, Poldi Pezzoli.

▲ Filippo Pelagio Palagi, *Ariadne Gives Theseus the Thread to Exit the Labyrinth*, circa 1814. Bologna, Galleria d'Arte Moderna.

Reflecting a passage in Ovid's Metamorphoses, *artists often portray the deserted Ariadne afflicted with pain.*

Theseus's ship has left the island.

▲ Angelica Kauffmann, *Ariadne Abandoned by Theseus*. From a private collection.

A cherub weeps with Ariadne. The cherub, a winged child, often appears in Renaissance and Baroque painting. Its image dates to the ancient images of Greek eroticism that also appeared in Pompeian painting.

A crown of vine branches is a symbol of Bacchus, the god of wine.

The sails of Theseus's ships are quite far away by now.

▲ Guido Reni, *Bacchus and Ariadne*, 1619–21. Los Angeles, County Museum of Art.

The deserted Ariadne is disheartened.

Ariadne

Bacchus throws
Ariadne's crown
into the sky,
where it turns
into a constella-
tion of stars.

Vine branches
symbolize
Bacchus, here
shown in his
chariot with
his followers
close by.

Theseus's ship
is seen in the
distance.

Leopards pull
Bacchus's
chariot. The
presence of
these animals
illustrates that
worship of Bac-
chus had spread
to Asia.

▶ Titian, *Bacchus and Ariadne*,
1522–23. London, National Gallery.

Percussion instruments are characteristic of bacchic music. Stringed instruments, instead, refer to Apollo.

The bacchants, also called maenads, are followers of Bacchus.

The donkey is inseparable from Silenus, Bacchus's teacher, who is usually depicted as a flabby man who is always drunk.

Partly savage creatures, satyrs are part of Bacchus's court. They became snakes during rites in honor of the god, so they are often shown with snakes twisting around their bodies.

Arion

Greek Name
Arion

**Relatives and
Mythic Origins**
Native of Lesbos

**Characteristics
and Activity**
Famous Greek poet,
skilled at playing
the lyre

*Arion is usually portrayed on the back of a dolphin holding a
lyre, and he often wears a crown of laurel.*

A famous Greek musician originally from Lesbos, Arion is
renowned for his ability to play the lyre and spends his days at
the court of King Periander in Corinth. One day he decides to
travel to Sicily for a lyric poetry competition. After having won
the contest, he sets out on a ship returning to Corinth. The
sailors, however, plot to kill him and steal his prize. After
pleading in vain with the robbers for his life, Arion manages to
get their permission to play his lyre for the last time. Dolphins,
sacred to the god of music, Apollo, hear the music and gather
around the ship. The musician then jumps into the sea and is
carried to safety by a dolphin. Returning to Corinth, he
describes his adventure to King Periander, who captures the vil-
lains as soon as they dock and orders their execution. Apollo
eventually transforms the lyre and dolphin into constellations
in Arion's honor.

▲ Andrea Mantegna, *Arion
Being Saved by a Dolphin*
(detail), 1474. Mantua,
Palazzo Ducale, Camera
degli Sposi.

▶ Albrecht Dürer, *Arion*,
1514. Vienna, Kunst-
historisches Museum.

PISCE SVPER CVRVO VECTVS CANTABAT ARION

An unbeatable runner and expert hunter, Atalanta is often depicted stooping to pick up the golden apples that Hippomenes drops.

Atalanta

Among the many versions of this myth, the most commonly portrayed in art is Boeotian in origin and inspired Ovid. It is an example of vanity and feminine curiosity. Since an oracle prophesied that she would no longer be herself if she did so, Atalanta, a beautiful huntress, does not intend to marry. To rid herself of suitors, the young woman challenges them all to a race, promising them her hand if they win, but their death if she does. For a long time Atalanta remains unbeaten, until Hippomenes (Melanion in other versions) throws three apples along the racecourse that Venus had given him. Atalanta, who finds the fruit irresistible, stops three times to pick them up and loses the race as a result. The two young people make love in a temple dedicated to Cybele and offend Venus, who changes them into lions. Artists usually depict Atalanta gathering the apples as Hippomenes runs past. Other times they have chosen to show Hippomenes receiving the apples from Venus.

Greek Name
Atalanta

Relatives and Mythic Origins
Daughter of Clymene

Characteristics and Activity
Huntress and unbeatable runner

Related Myths
Atalanta attacks the Calydonian boar with Meleager

Edward John Poynter, ▲
The Race of Atalanta (detail),
1876. From a private
collection.

Guido Reni, ◄
Atalanta and Hippomenes,
1622–25. Naples,
Capodimonte.

Atlas

Greek Name
Atlas

Relatives and Mythic Origins
Titan son of Iapetos and Clymene; brother of Prometheus and Epimetheus

Characteristics and Activity
Carries the vault of heaven

Related Myths
Hercules carries the vault of heaven in Atlas's place while the Titan steals the Golden Apples from the Garden of the Hesperides

Atlas is shown as a bearded man who holds up the vault of heaven. Hercules can also appear in the scene; he takes the Titan's place and carries the heavy burden himself.

The son of Iapetos and Clymene, Atlas takes part in the Titan revolt against Jupiter. After they are defeated, Atlas is condemned to hold up the vault of heaven. Atlas's story is interwoven with tales of Hercules. During his eleventh labor, Hercules sets out to retrieve the Golden Apples of the Hesperides, and he convinces Atlas to get them for him in exchange for holding up the sky himself. Returning with the apples, Atlas refuses to take back the enormous weight on his shoulders, and only by a clever trick is Hercules able to give the burden back to him.

Later versions describe Atlas as an astronomer who teaches humans the mysteries of the heavens. He is deified because of this.

Supporting considerable weight has always been associated with the name Atlas. In architecture, for example, male figures that take the place of pillars or columns to support other architectural elements, such as architraves, corbels, or cornices, are called atlantes.

▲ *The Spheres; Hercules* (detail), a tapestry from the first half of the sixteenth century. Madrid, Patrimonio Nacional.

▶ Il Guercino, *Atlas*, 1645–46. Florence, Museo Bardini.

▶ Michel de Bos, *Hercules and Atlas*, 1656–66. Munich, Bayerische Verwatlung der Staatlichen Schlösser.

The lion skin
is a typical
emblem of
Hercules,
together with
the club.

Atlas gives Hercules the
vault of heaven, where
the stars can be seen.

Aurora

Greek Name
Eos

**Relatives and
Mythic Origins**
Daughter of Hyperion
and Theia

**Characteristics
and Activity**
Goddess of the dawn,
she rises each day to
dissolve the shadows
and announce the
light of day

Related Myths
She is the wife of
Tithonus and falls in
love with Cephalus

*She is presented as a winged goddess with a halo of light and
can appear in a chariot pulled by two horses.*

Aurora, Sol's sister, is also called "rose fingers." She is the first
light of day. Rising from her bed each day and putting on a
golden cape, she boards her carriage to bring light to the
gods and humans, spreading rose petals along her way. She
announces the sun chariot and accompanies it through the sky.

Aurora is married to Tithonus, Priam's brother. The goddess
asks Jupiter for Tithonus's immortality but forgets to ask for
his eternal youth as well. He is therefore destined to grow old
forever and appears as an elderly, bearded man.

When she falls in love with Cephalus, Aurora deserts all
her tasks and causes disorder in the universe. Cupid comes to
her aid and makes sure that Cephalus returns her feelings by
shooting one of his arrows at him. The goddess then carries
Cephalus off in the sun chariot. However, Aurora lives to see
Cephalus return to Procris, his true love.

The character of Aurora enjoyed quite an amount of success,
especially during the seventeenth century. She often appears on
the ceilings of Baroque residences riding her chariot.

▲ Il Guercino, *Aurora* (detail),
1621. Rome, Casino Ludovisi.

▶ Jean-Baptiste de Champaigne,
Aurora, 1668. Paris, Musée du
Louvre.

The presence of a cherub alludes to the love between Cephalus and Aurora.

Enveloped in light, Aurora sprinkles rose petals.

The sleeping youth whom Aurora brought high amid the clouds in her carriage is Cephalus, whom she loves. With some nudging from Cupid, he loves her, too.

▲ Pierre-Narcisse Baron Guérin,
Cephalus and Aurora, 1810. Paris,
Musée du Louvre.

The lighted
torch is a
symbol of
Phosphorus,
the morning
star. His name
literally means
"light carrier."

Apollo appears in
the sky, driving
the sun chariot.

The figures
holding hands
around the
sun chariot
are the Horae,
or Seasons.

Aurora precedes
the sun chariot
with handfuls
of flowers,
dissolving
any shadows.

▲ Guido Reni, *Aurora*, 1612–14. Rome,
Palazzo Parravicini Rospigliosi.

▶ Francesco Solimena, *Tithonus Dazzled
by the Crowning of Aurora*, 1704.
Los Angeles, The J. Paul Getty Museum.

The bearded man is Tithonus, Aurora's husband. The goddess secured immortality for him from Jupiter but forgot to ask for eternal youth.

A cherub offers Aurora a torch. The goddess is often portrayed dissolving shadows with a torch in hand.

A cherub gives Aurora roses, whose petals the goddess will sprinkle along her way.

Aurora gets ready to bring the new light of day to gods and humans alike.

Bacchus appears as a nude youth—often intoxicated—his head crowned with grape vines or ivy. He holds a thyrsus (a decorated staff), raises a cup of wine, or carries a bunch of grapes. He can be riding a chariot pulled by tigers, leopards, or goats.

Bacchus

Bacchus was originally the god of fertility, but he is more famous as the god of wine.

The child of Jupiter and Semele, Bacchus is born from his father's side, where Jupiter sewed him after involuntarily killing his mother. The child is entrusted to the care of the nymphs and then raised by satyrs and the wise Silenus. Bacchus's cult in Greece spread to exactly those areas where grapes were cultivated. The bacchants, also called maenads, participated at festivals in the god's honor.

Many images show Bacchus with his drunken followers engaged in unbridled dancing and playing tambourines or cymbals. This type of image is called the "triumph of Bacchus." In addition to the maenads, satyrs often appear in Bacchus's court playing their pipes. Silenus usually appears on the back of a donkey. Ariadne can also be found among this noisy company; Bacchus consoles her after Theseus deserts her, and she later becomes his wife. The two are often portrayed together with their followers, riding in a carriage pulled by tigers, leopards, or goats. While tigers probably refer to the spreading of Bacchian worship in Asia Minor, the goats recall the god's origins, when he was venerated in the shape of a goat or bull.

Greek Name
Dionysos

Relatives and Mythic Origins
Son of Jupiter and Semele, he was born from Jupiter's side

Characteristics and Activity
Commonly held to be the god of wine, originally the god of fertility

Special Devotions
This myth was widespread in Greece and Rome; among the many festivals dedicated to the god were the Dionysia, which were celebrated in Athens in the springtime

Related Myths
Semele, Bacchus's mother, was killed by Jupiter himself after she asked him to show himself in his full splendor; Ariadne, who was abandoned by Theseus, marries Bacchus

▲ Diego Velázquez, *The Drunkards (Los Borrachos)* (detail), 1628–29. Madrid, Prado.

◄ Caravaggio, *Bacchus*, 1596–97. Florence, Uffizi.

The diadem
identifies the
goddess Juno.

Lightning bolts
are a symbol of
Jupiter.

Jupiter reduces
Semele to ashes
after she asks
him—as the
treacherous
Juno advised
her—to show
himself in all
his glory.

Bacchus is
given to
nymphs.

▲ Giulio Romano and workshop, *The Birth of Bacchus*, circa 1530. Los Angeles, The J. Paul Getty Museum.

A crown of ivy is a symbol of Bacchus.

Sometimes Bacchus holds a pitcher of wine.

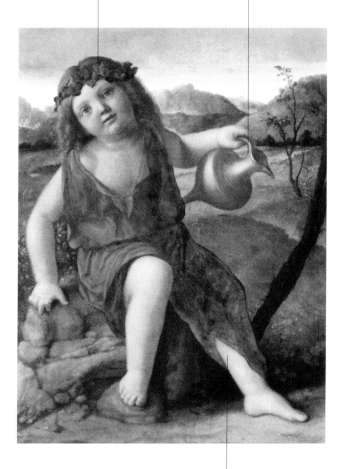

According to some legends, Bacchus is an infant god.

▲ Giovanni Bellini, *The Infant Bacchus*, 1505–10. Washington D.C., National Gallery.

A cherub gives a diadem to Ariadne as it becomes a crown of stars. Bacchus threw it into the sky and transformed it into a constellation.

A crown of grape vines or ivy is an emblem of Bacchus.

Bacchus sometimes appears dressed in leopard skins; the animal is one of his symbols.

▲ Sebastiano Ricci, *Bacchus and Ariadne*, circa 1712–14. London, Chiswick House.

A cherub places a crown of stars on Ariadne's head, evoking Bacchus's generous act of transforming her diadem into a constellation.

The thyrsus, or decorated staff, is an emblem of Bacchus. Here the god is shown with many of his other symbols: leopard skins, bunches of grapes, and a crown of ivy.

Tigers pull Bacchus's carriage. Together with the leopard, these animals probably allude to widespread worship of the god in Asia Minor.

▲ Annibale Carracci, *The Triumph of Bacchus*, 1597–1602. Rome, Palazzo Farnese.

The tambourine is one of the instruments played by bacchants, followers of Bacchus.

Silenus, Bacchus's teacher, is usually shown drunk with a crown of grape vines on his head.

The donkey is the inseparable companion of Silenus, who is always too drunk to stand on his own two feet.

Goats, animals that recall the ancient origins of Bacchus, when the god was venerated in the shape of a bull or goat, draw Ariadne's carriage.

Bellerophon is depicted as a young hero armed with a spear or bow. He is often shown killing the Chimaera on the winged horse Pegasus.

Bellerophon

A legendary Corinthian hero, Bellerophon is the son of Glaucus and grandson of Sisyphus. For some unclear reason, the young man is forced to leave his homeland and seeks refuge at Tiryns under King Proteus. There Queen Anteia (others name her as Stheneboea) falls in love with Bellerophon and tries to seduce him. When the young man does not respond to her charms, the king's wife accuses him of tempting her. King Proteus then sends Bellerophon to his father-in-law, Iobates, the king of Lycia, with a letter ordering him to kill the traitor. Iobates reads the letter and gives Bellerophon the task of fighting the terrible Chimaera, certain that he will not return. Bellerophon, however, defeats the monster with Pegasus. He tames the winged horse with the help of Minerva, who gives him a golden bridle for the animal. Returning victorious, Bellerophon is given other adventures, until Iobates, admiring the hero's courage and seeing he is obviously protected by the gods, reconciles with Bellerophon and offers him his daughter's hand in marriage. Later Bellerophon loses the gods' favor, and he dies alone, deserted by everyone.

Greek Name
Bellerophon

Relatives and Mythic Origins
According to Homer, Bellerophon was the son of Eurymede and Glaucus, king of Corinth; he was a descendant of Sisyphus

Characteristics and Activity
He is a famous hero who overcomes many tests, the most famous of which is killing the Chimaera

Related Myths
Pegasus, the famous winged horse, is born from Medusa's head after Perseus kills her

▲ Bertoldo di Giovanni, *Bellerophon Tames Pegasus* (detail), circa 1480. Vienna, Kunsthistorisches Museum.

▶ Giovanni Battista Tiepolo, *Bellerophon on Pegasus Kills the Chimaera* (detail), circa 1723. Venice, Palazzo Sandí.

Berenice, queen of Egypt, is usually shown in front of a mirror cutting a lock of her beautiful hair.

Berenice

The evocative legend of Berenice was told by the Greek poet Callimachus and was later translated into Latin by Catullus.

The queen is famous for her wonderful hair, a source of pride and admiration for all her kingdom. Soon after her marriage to King Ptolemy III Euergetes, the king is forced to leave for war against Syria. Worried for her husband, Berenice decides to cut off a lock of hair and offer it to the gods so he might return home unharmed. The queen sends a tuft of hair, which inexplicably disappears, as an offering to the temple. Conon, the court astronomer, sights her hair in the sky, where Venus has placed it. It inspires a new constellation called the Lock of Berenice.

Ptolemy IV, Berenice's son, murdered her, and her name was given to a city in Cyrenaica, Benghazi, which was once called Hesperide. Legend has it this was where the famous Garden of the Hesperides was.

Greek Name
Berenice

Relatives and Mythic Origins
Daughter of Magas, the king of Cyrene, and wife of Ptolemy III Euergetes

Characteristics and Activity
Queen of Egypt

Special Devotions
After having her killed, Berenice's son Ptolemy IV gave her divine honors and named a priestess in her honor

▲ Bernardo Strozzi, *Berenice* (detail), 1615. Milan, Civiche raccolte d'arte del Castello Sforzesco.

◄ Michel Desoubleay, *Berenice*. From a private collection.

Boreas

Greek Name
Boreas

**Relatives and
Mythic Origins**
The Titan son of
Aurora and Astraeus

**Characteristics
and Activity**
God of the north
wind, he lived in
Thrace

Special Devotions
Festivals were
celebrated in his
honor in Athens

*Boreas is frequently shown aged and gray with wings, flying
and carrying off the young girl Oreithyia in his arms.*

Boreas, the cold north wind who is also called Aquilo, lives in a
mountain cavern in Thrace. The Greeks considered this area
one of the coldest. Boreas falls in love with Oreithyia, a daugh-
ter of Erechtheus, king of Attica, and asks her father for her
hand. Not receiving any response, Boreas decides to abduct the
young girl. Swooping down from the mountains, the north
wind raises clouds of dust and, hidden in the mist, he takes
Oreithyia under his wing and carries her off. Twins named
Calais and Zetes are born from their union. Ovid narrates that
the two children were born with the human features of their
mother, and only later, when they had reached adolescence, did
they grow their father's wings. In allegories of the four seasons,
Boreas usually personifies winter. The Greek writer Pausanias
describes Boreas with a serpent's tail instead of legs, and some
artists—such as Rubens—have portrayed him this way.

▲ John William Waterhouse,
Boreas (detail), 1903. From a
private collection.

▶ Francesco Solimena, *Boreas
Raping Oreithyia*, circa 1700.
Rome, Galleria Spada.

Cadmus, one of the most celebrated heroes of antiquity, is shown either killing the dragon that guards the spring or sowing the monster's teeth after slaying it.

Cadmus

Cadmus is the famous founder of Thebes. Following the advice of the oracle at Delphi, he follows a heifer to a chosen place where a city is to be founded. Reaching the site, the hero prepares to sacrifice the cow to Jupiter, sending his companions to a nearby spring to draw water for libations. Unfortunately, the spring is guarded by a dragon, which kills them all. A short time later, the unsuspecting Cadmus comes to the spring and, seeing the carnage, confronts the dragon and slays it. After this, following a suggestion from Minerva, Cadmus plants the teeth of the monster. A row of armed men sprout from the earth and kill one another. Only five remain, and these help Cadmus found the new city.

The mythical hero is usually depicted as he faces the dragon near a cave. The monster can resemble a winged dragon similar to that of medieval tradition or a horrid, multiheaded animal. Other paintings show the hero planting the dragon's teeth as Minerva watches from a cloud on high.

Greek Name
Cadmus

Relatives and Mythic Origins
Son of Agenor, king of Phoenicia, and Telephassa; he is the brother of Europa, whom Jupiter steals away to Crete

Characteristics and Activity
Legendary Greek hero who founded Thebes

Special Devotions
Especially worshipped in Thebes

Related Myths
Cadmus searches in vain for his sister Europa after Jupiter, disguised as a bull, carries her off

Giovanni Antonio Pellegrini, ▲
Cadmus (detail), circa 1708.
Mira (Venice), Villa Alessandri-Furegon Fontana.

Hendrick Goltzius, ◄
The Followers of Cadmus Devoured by the Dragon.
Kolding, Museet på Koldinghus.

Callisto

Callisto is often portrayed together with Jupiter, who has disguised himself as Diana. She can also be shown at the moment the nymphs and the goddess of the hunt discover she is pregnant or as she is subsequently transformed into a bear.

Greek Name
Callisto

**Relatives and
Mythic Origins**
Daughter of Nycteus
or Lycaon

**Characteristics
and Activity**
This nymph of Diana's
company was loved by
Jupiter; according to
Ovid, Juno trans-
formed her into a bear

Some consider Callisto, whose name literally means "the most beautiful," to be a nymph from Arcadia, while others say she is the daughter of Lycaon or Nycteus. Her myth has different versions, but usually images of the myth are taken from Ovid's *Metamorphoses*. Callisto takes a vow of chastity and becomes part of Diana's company, but Jupiter comes upon her resting in a forest and falls in love with her. The father of the gods quickly takes the shape of the goddess of the hunt (since Callisto hides herself from men) and seduces her. Some time later, after an exhausting hunt, Diana stops to bathe near a spring with her followers. Callisto hesitates to undress, and the company lift her clothes to discover the terrible truth: she is pregnant. Diana expels her, and Juno is so outraged that she changes Callisto into a bear. The child that Callisto gives birth to, Arcas, eventually attempts to kill his mother in a hunt. Jupiter intervenes just in time and changes both mother and child into a constellation (Ursa Major and Ursa Minor).

Callisto is usually represented as Jupiter nears her disguised as Diana or when the nymphs discover she is pregnant. More rarely, Callisto appears as a bear near Juno.

▲ Giuseppe Bossi, *Jupiter Disguised as Diana Seduces Callisto* (detail), after 1810. Milan, Pinacoteca di Brera.

▶ Gillis Congnet, *Diana Discovers Callisto's Guilt*, before 1586. Budapest, Szépmüvészeti Múzeum.

The Centaurs are beings that are half man and half horse. They are often portrayed during the famous fight that broke out during the marriage banquet of Hippodameia and Peirithous.

Centaurs

A story is told that Centaurs, rough and brutal creatures, were born from Ixion, the king of the Lapiths, and a cloud that Jupiter changed to resemble Juno. Centaurs can be found in various episodes of mythology. One of the most famous tells the story of their battle against the Lapiths, a population of Thessaly. Peirithous, another king of the Lapiths, invites Centaurs to the banquet at his wedding with Hippodameia. They proceed to get drunk and act in a cruel and disrespectful manner, to the point that one of them, Eurytion (or Eurytus), even attacks the bride. This sets off a violent struggle, and in the end the Centaurs are thrown out. Ever since antiquity this episode has been interpreted as the victory of reason over instinct, civilization over barbarism. The banquet was highly regarded by Baroque painters, who portrayed Hippodameia rejecting Eurytion's assault with the struggle raging all around. Minerva, goddess of wisdom, appears in a number of Renaissance paintings with a Centaur, a symbol of the basest level of human nature.

Greek Name
Centaurs

Relatives and Mythic Origins
Centaurs were born from the union of Ixion, a king of the Lapiths, and a cloud

Characteristics and Activity
They are described as savage and coarse creatures that live in the forests and mountains and feed upon raw meat

Related Myths
While hunting the Erymanthian boar, Hercules kills a number of Centaurs; the Centaur Nessus attempts to carry off Deianeira; Cheiron educates the most famous heroes, such as Achilles and Peleus

▲ Filippino Lippi, *The Wounded Centaur* (detail). Oxford, Christ Church.

▶ Sandro Botticelli, *Minerva and the Centaur* (detail), circa 1485. Florence, Uffizi.

55

Centaurs

A Lapith prepares to hurl a rock.
Michelangelo interprets the myth freely
here, since this relief does not match the
ancient sources regarding the types of
weapons the Centaurs used.

These Centaurs
are armed with
clubs, not their
traditional bows
and arrows.

The woman
being pulled by
her hair is
Hippodameia.

A Centaur lies wounded
on the ground.

▲ Michelangelo Buonarroti, *Battle of
the Centaurs*, 1504–5. Florence, Casa
Buonarroti.

Cephalus is primarily shown at Procris's death, distressed beside his adored wife and accompanied by dogs.

Cephalus

Aurora is in love with Cephalus, but he eventually leaves her to return to his wife Procris. At this point the goddess, upon letting him go, instills suspicion and jealousy in him. To test his beloved wife, Cephalus disguises himself and attempts to seduce her. After much insistence, he is at the point of compromising her when he reveals who he is. Overcome with shame and anger, Procris flees to the mountains, where she is welcomed into Diana's company. After a short while, the two lovers forgive each other and Procris offers Cephalus two gifts that she received from the goddess, a dog and a javelin. Then Procris herself becomes jealous and follows her husband hunting. He accidentally kills her with the very weapons she gave him as a gift.

In illustrating this myth, Renaissance artists frequently began with a drama written by Niccolò da Correggio (1450–1508) entitled *Cephalus*. The play was inspired by the ancient story yet enriched by new characters and a happy ending. In the play, in fact, Diana brings Procris back to life.

Greek Name
Cephalus

Relatives and Mythic Origins
According to Ovid, he was the son of Deion and grandson of Aeolus

Characteristics and Activity
This young hunter was the husband of Procris and Aurora's lover

Related Myths
Aurora falls in love with him

▲ Piero di Cosimo, *The Death of Procris* (detail), circa 1495. London, National Gallery.

◄ Luca Giordano, *Cephalus and Procris*, 1698–1700. Madrid, Patrimonio Nacional.

This satyr, who was not present in the
ancient sources, reflects one of the
characters that Niccolò da Correggio
inserted in the play Cephalus.

Procris lies lifeless, killed by the
javelin that she herself had given
her husband. In the drama by
Correggio, Diana brings Procris
back to life.

▲ Piero di Cosimo, *The Death of
Procris*, circa 1495. London, National
Gallery.

The dog, together with the javelin, is a gift Diana gave to Procris, who in turn gave them both to Cephalus. Cephalus does not appear in this painting, yet this close-up of the animal seems to evoke his presence.

Ceres

Greek Name
Demeter

**Relatives and
Mythic Origins**
Daughter of Saturn
and Cybele; sister
of Jupiter

**Characteristics
and Activity**
Earth goddess, she is
protector of agriculture
and plant life

Special Devotions
The famous Eleusinian
Mysteries were
celebrated each year
in honor of Demeter

*Searching for her daughter, Ceres is depicted in a chariot pulled
by dragons, lighting her way with a torch. In sculpture from
the Archaic period, the dragons are portrayed as serpents in the
hands of the goddess.*

Goddess of earth and agriculture, Ceres is one of the most
important divinities of the Greek and Roman pantheon.
She is particularly remembered for the episode when her
daughter Proserpina, whom she had by Jupiter, is abducted
by Pluto, the god of the Underworld. Proserpina eventually
becomes Pluto's wife. Searching for her in vain, Ceres learns
the truth about her daughter from Sol. Her consequent wrath
causes the earth to dry up and harvests to fail, forcing Jupiter
to intervene. He rules that Proserpina spend two-thirds of the
year on earth and the other third in the kingdom of the dead.

 During the long search for her daughter, Ceres stops near a
house to rest and an elderly woman offers her something to
drink. She drinks avidly, since her search has left her parched.
Because of this, the woman's son Stelion derides the goddess,
accusing her of being a glutton. She immediately turns him into
a lizard. In connection with this episode, the goddess can be
shown at the entrance to a house with a cup in hand, while a
young boy points at her laughing.

▲ Jean-Antoine Watteau, *Ceres
(Summer)*, 1715–16. Washington,
D.C., National Gallery.

▶ Flemish School of the seven-
teenth century, *Allegory of the
Earth*. From a private collection.

The winged child is Cupid, who is inseparable from his mother, Venus.

The crown of grape vines, the bunches of grapes on his lap, and the pitcher all suggest that this god is Bacchus, the god of wine.

The torch recalls Ceres' frantic search for her daughter Proserpina.

The crown of grain is a symbol of Ceres. This painting illustrates the saying "Love cools if food and wine are missing" (Sine Cerere et Baco friget Venus). This proverb was taken from a work by the Roman playwright Terence (circa 190–159? B.C.) and had particular success during the seventeenth century, when it was illustrated by Flemish painters.

Doves are symbols of Venus.

The cornucopia of fruit and vegetables is one of Ceres' symbols.

▲ Abraham Janssens, *Ceres, Bacchus, and Venus*, after 1601. Sibiu, Museo Nazionale Brukenthal.

Ceres

The torch evokes Ceres' frantic search for her daughter Proserpina.

This figure drinking fervently is Ceres. She is tired and asks hospitality of an old woman, who offers her water.

The young child who points at Ceres and laughs is Stelion. His impudence will not go unpunished; in fact, the goddess will soon turn him into a lizard.

▲ Adam Elsheimer, *Ceres and Stelion.*
Madrid, Prado.

The wisest of all Centaurs, Cheiron is generally depicted in his role as teacher of heroes, intent on instructing his pupils to shoot a bow or play music.

Cheiron

Cheiron is born from the union of Philyra, a daughter of Oceanus, and Saturn, who had transformed himself into a horse to seduce her. As a result, Cheiron is half human and half horse. The Centaur lives on Mount Pelion, in Thessaly, and is a famous hunter skilled in music, gymnastics, medicine, and the art of prophecy. A large number of heroes, such as Peleus, Achilles, and Diomedes, were his students. Cheiron also taught Aesculapius, the god of medicine. His friend Hercules strikes him by accident with a poisoned arrow during a battle with Centaurs, and even if Cheiron is immortal, he still carries a deep wound that cannot be healed, since the hero's arrows are quite lethal. Torn by the pain, the Centaur decides to renounce immortality and descends into the Under-world in place of Prometheus, who was born mortal and is being punished for his wrongdoings.

Cheiron is frequently shown teaching a child—most often Achilles—to play music or shoot a bow. He is also featured during the death of Coronis, Aesculapius's mother, when he holds the young god of medicine in his arms.

Greek Name
Cheiron

Relatives and Mythic Origins
Born from the union of Saturn and Philyra, one of Oceanus's daughters

Characteristics and Activity
He is the wisest of all Centaurs and educates a number of heroes, including Achilles

◄ Pompeo Batoni, *Achilles and the Centaur Chiron*, 1746. Florence, Uffizi.

▲ Giuseppe Maria Crespi, *The Centaur Cheiron Teaching Young Achilles* (detail), circa 1695. Vienna, Kunsthistorisches Museum.

Clytie

Greek Name
Clytie

**Relatives and
Mythic Origins**
One of the Oceanids,
the daughters of
Oceanus

**Characteristics
and Activity**
In love with Apollo,
she was punished after
she reported the god's
love for Leucothoe to
Leuothoe's father

*Scorned by Apollo, whom she loved, Clytie is portrayed either
as a girl mourning or being transformed into a sunflower.*

Clytie is one of the young lovers of Apollo, god of the sun. The
god, however, falls in love with Leucothoe, King Orchamus's
daughter, and seduces her by disguising himself as her mother
to enter her bedroom. Jealous and hurt, Clytie reports what ha
happened to Leucothoe's father. Overcome with anger,
Orchamus orders his daughter to be buried alive in a deep hole
Learning what has happened, the despairing Apollo disperses
scented nectar where Leucothoe is buried, and an incense plant
rises from the moist earth. Rejected by Apollo, Clytie spends
her days gazing at the sun chariot, until she is consumed by her
pain and transforms into a sunflower, which always faces the
sun.

Clytie is frequently depicted during her metamorphosis or
with a sunflower next to her or on her head. The departing sun
chariot usually appears in the distance.

(The sunflower also appears in Van Dyck's self-portraits, but
in this case to represent the artist's deep devotion to Charles I
of England, with whom he stayed for a brief period.)

► Charles de La Fosse, *Clytie
Changed into a Sunflower,*
1688. Versailles, Musée
National du Château et de
Trianon.

Coronis is often shown being killed by Apollo as Cheiron takes the tiny Aesculapius in his arms; at times the figure of a crow appears.

Coronis

Coronis, whose name means "crow," is the daughter of Plegyas, king of the Lapiths. She is loved by Apollo but betrays the god to be with Ischys, son of Elatus. A crow discovers her treachery and tells Apollo everything that has happened. Full of wrath, the god shoots the girl with an arrow but instantly regrets it and attempts to revive her, in vain. Before placing her body on the funeral pyre, Apollo takes a child—the god of medicine, Aesculapius—from her womb and entrusts him to Cheiron. The crow, which up to that time had always been white, is punished by Apollo for bringing bad news and turns black.

Artists often illustrate the episode of Coronis falling to the ground lifeless, when Apollo gives Aesculapius to the Centaur. Adam Elsheimer's painting (*below*) shows what happened in an unusual way: Coronis rests while Apollo searches for medicinal herbs, and satyrs prepare the funeral pyre.

Greek Name
Coronis

Relatives and Mythic Origins
Daughter of Plegyas, king of the Lapiths

Characteristics and Activity
A lover of Apollo, she has a child by him named Aesculapius, the god of medicine

Related Myths
Cheiron teaches Aesculapius the art of medicine

Domenico Antonio Vaccaro, ▲ *The Birth of Aesculapius* (detail), circa 1735. From a private collection.

Adam Elsheimer, ◄ *Landscape with Apollo and Coronis*, 1607–8. Liverpool, Walker Art Gallery.

Cupid

Cupid is portrayed as a winged cherub armed with a bow and arrow. He shoots gods and people to instill passion and often appears with his mother, Venus.

Greek Name
Eros

Relatives and Mythic Origins
According to the oldest legends he was born of Chaos; he is commonly known as the son of Venus and Mars

Characteristics and Activity
God of love

Related Myths
Adonis; Psyche; Venus

Cupid, also known as Amor and Love, is described by the most ancient sources as a divinity born from Chaos, the original void. Later he becomes a clever, somewhat impudent winged child. His arrows usually make gods and humans fall in love—more precisely, a golden arrow makes someone fall in love; a lead one makes someone feel aversion toward whoever loves him or her. Every once in a while, however, Cupid is punished for his misdeeds.

Although he is a minor divinity, the god is often portrayed in art from the Hellenistic period, the Renaissance, and later eras. His presence is often symbolic and indicates that the subject of an image is amorous. In shooting an arrow, the god hovers lightly over the two lovers. Sometimes he is seen playing with Mars's weapons or making his bow from Hercules' club, which represents love's ability to win over even the strong. He is often shown blindfolded, but not only because love is blind, as they say. Blindfolded Cupids began appearing in art during the Middle Ages, symbolizing the darkness of sin.

▲ Sandro Botticelli, *La Primavera* (detail), circa 1482–83. Florence, Uffizi.

► Caravaggio, *Sleeping Cupid,* 1608–9. Florence, Palazzo Pitti, Galleria Palatina.

The winged cap, or petasus, is one of the attributes of Mercury.

In line with traditional imagery, Venus is portrayed nude. She holds Cupid's bow and encourages him to read the papers that his teacher Mercury has brought.

Mercury wears winged sandals, another of his trademarks.

Cupid is concentrating on reading. The theme of Cupid's education, and of gods and heroes in general, does not refer to any specific myth but became widespread during the Renaissance to indicate a rebirth of interest in classical culture.

▲ Correggio, *The Education of Cupid* (*The School of Love*), circa 1525. London, National Gallery.

The Graces, goddesses of beauty, personify perfect love. This love offers itself without demanding anything in return and detaches from the earthly world to turn toward the spiritual.

A personification of reason and good counsel, Mercury watches over love's transformation, preventing any clouds of passion from gaining the upper hand.

The caduceus is one of the symbols of Mercury. It is a sign of unity and peace, and is so named because its appearance causes any conflict to immediately "fall" (cade) away.

The winged shoes allow Mercury, the messenger of the gods, to move swiftly.

▲ Sandro Botticelli, *La Primavera*, circa 1482–83. Florence, Uffizi.

Cupid is pivotal in this composition as he shoots flaming arrows. An arrow sets off the passion of love, which is elevated by Venus from the earthly world to the spiritual.

Zephyrus, the sweet wind of spring, follows the nymph Chloris. Zephyrus, Chloris, and Flora symbolize sexual and irrational love, which is also an origin of life.

At the center of the composition is Venus, who transforms the passionate love of Zephyrus into spiritual love.

Chloris transforms into Flora, sower of flowers. This alludes to the regenerating abilities of humans, who overcome earthly passions (Zephyrus) and tend toward the immortality of their souls by dedicating themselves to spiritual love (Venus).

The cherub
happily looking
toward the
observer is
Anteros, the
god of mutual,
reciprocal, or
requited love.

Cupid, the
winged child
of Venus, is
making
his bow.

The cherub who
seems cross is
Liseros, the
personification
of the force that
makes love
subside.

The books that Cupid is standing
on perhaps refer to passion's
disdain for intellect.

▲ Parmigianino, *Cupid Makes a Bow*,
circa 1533–34. Vienna, Kunsthistorisches
Museum.

Here the god is shown as divine love, which has won over the emptiness of earthly passion. The theme is inspired by a verse from Virgil's Bucolics, *"Love conquers all" (Omnia vincit amor).*

Musical instruments represent earthly passions.

The armor and laurel allude to aspirations of fame through combat, a measure of the vanity of earthly ambition as opposed to divine love (Cupid), which rises above everything.

▲ Caravaggio, *Victorious Love,* 1602–3.
Berlin, Gemäldegalerie.

Cupid

The deception of passion is also revealed in Cupid's actions as he reaches for Venus's diadem to remove it.

Venus, together with Cupid in a sensual embrace, takes away the god's arrows, a gesture that recalls passion's deceit.

The hourglass allows us to identify the bearded man who holds it on his shoulder as Time. He covers the scen with a dark curtain to indicate that time cancels out all passion.

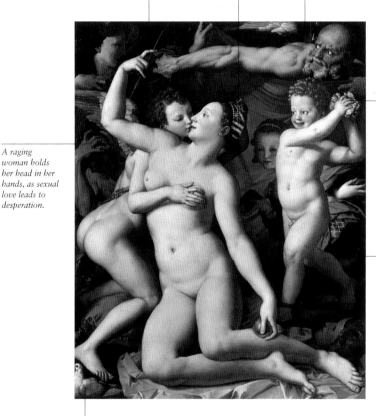

The cherub who sprinkles rose petals represents the folly that accompanies sexual love.

A raging woman holds her head in her hands, as sexual love leads to desperation.

Sensual love is preferred by deceit, which is personified here as a being that is half woman and half reptile with lion paws.

Doves are one of Venus's symbols.

▲ Bronzino, *Venus, Cupid, Folly, and Time*, circa 1545. London, National Gallery.

► Lucas Cranach the Elder, *Cupid Complaining to Venus*, circa 1529. London, National Gallery.

Cupid, who has been stung by bees after stealing a honeycomb, complains to his mother, Venus.

Venus reproaches Cupid, whose arrows inflict wounds like bees. By portraying this anecdote, which has been taken from Theocritus's Idylls, *the painter hopes to warn against the risks of lust. During the sixteenth century, in fact, "venereal" diseases were being spread by troops of soldiers.*

Anteros, the winged youth who rips Cupid's wings as punishment, becomes the symbol of sacred love, which invites one to direct the soul toward divine contemplation.

The blindfolded Cupid represents sensual love, as opposed to the divine kind. In the Renaissance humanists distinguished between sacred love—aimed at contemplation—and profane, or earthly, love.

The extinguished torch indicates how transitory earthly goods and profane love are.

Venus mourns the punishment of her child.

▲ Sebastiano Ricci, *The Punishment of Cupid*, 1706–7. Florence, Palazzo Marucelli-Fenzi.

*Venus gathers
Cupid's arrows
while she tries
to hold back
Mars.*

*Mars punishes Cupid. After
Cupid brought out feelings of
love in him toward Venus, the
other gods derided him.*

*The dove is a
sign of Venus.*

*The blindfolded
Cupid is a
symbol of the
passionate love
between Mars
and Venus.*

*This piece of
armor identifies
Mars, the god
of war.*

Bartolommeo Manfredi, *The Chastisement
of Love,* 1605–10. Chicago, The Art Institute.

Danae

Greek Name
Danae

**Relatives and
Mythic Origins**
Daughter of Acrisius,
king of Argos

**Characteristics
and Activity**
One of Jupiter's lovers

Related Myths
Perseus, son of Jupiter
and Danae, kills
Medusa

*Painters often depict Danae resting as Jupiter descends on her
in the form of a gentle, golden rain.*

Danae is the daughter of Acrisius, king of Argos. Upon hearing
an oracle's prediction that his grandson will kill him, the king
shuts his daughter in an underground chamber. Jupiter, how-
ever, falls in love with the girl and manages to enter the room
as mild, golden rain. Perseus is born from their union. Discov-
ering what has happened, Acrisius orders mother and child
closed in a chest and cast into the sea, yet the two are saved.
After many ups and downs in life, Acrisius and Perseus meet
again, and the prophecy comes true when the young man kills
his father by accident during a javelin-throwing contest.

The myth of Danae was quite prevalent in artistic circles of
the Renaissance. By portraying the tale, artists at that time
could concentrate on depicting the nude body. The young
woman often rests on a soft bed, lying on cushions, and looks
up to see golden rain falling from a cloud, which at times can
be represented as actual coins. A maidservant can also appear,
attempting to gather the precious rain in her apron.

▲ Orazio Gentileschi, *Danae*
(detail), circa 1621. Cleveland,
Museum of Art.

▶ Titian, *Danäe,* 1546.
Naples, Capodimonte.

The painter sets the myth of Danae in a splendid semicircle of columns, with marvelous architecture from various historical periods in the background.

A light, golden rain falls on Danae.

In the Middle Ages the character of Danae was a symbol of chastity. As an example of the union between a god and a virgin, her story was also interpreted as foreshadowing the Annunciation of the Virgin Mary.

▲ Mabuse, *Danae Receiving the Shower of Golden Rain,* 1527. Munich, Alte Pinakothek.

Daphne, a nymph loved by Apollo, is often portrayed being transformed into a laurel bush.

Daphne

Greek Name
Daphne

Relatives and Mythic Origins
Daughter of the river god Peneius

Characteristics and Activity
A nymph Apollo fell in love with

After killing the monster Python, Apollo meets Cupid, who is making his bow. Conceited and proud of his deed, Apollo derides the young god and suggests he give up shooting, which he, the infallible hunter, is far better at than a winged child. In response, Cupid shoots one of his lead arrows at Daphne, the daughter of the river god Peneius, and one of his golden arrows at Apollo. The first makes Daphne reject anyone who loves her, and the second causes Apollo to fall in love with her. He chases her incessantly until the young woman calls to her father for help. Just as Apollo is about to reach her, the nymph is transformed into a laurel bush. In desperation, Apollo decides that if she will never be his lover, at least laurel will be a sacred plant for him.

Daphne is generally shown fleeing, with her raised arms transforming into branches of laurel. Apollo, often wearing a crown of laurel leaves, pursues or embraces her. Daphne can also be shown begging her father to help her.

▶ Gian Lorenzo Bernini, *Apollo and Daphne*, 1622–25. Rome, Galleria Borghese.

78

Daphne

Apollo is shown here dressed as
a Renaissance youth. Artists
commonly set an episode from
mythology in their own eras.

Daphne is transforming into a laurel
tree. This myth enjoyed great suc-
cess among artists in many eras
since it was interpreted as a victory
of chastity over sexual love.

▲ Antonio del Pollaiuolo, *Apollo
and Daphne*, 1470–80. London,
National Gallery.

Deianeira, Hercules' wife, is usually shown with the hero or being abducted by the Centaur Nessus.

Deianeira

Greek Name
Deianeira

Relatives and Mythic Origins
Daughter of Oeneus, king of Calydon; sister of Meleager

Characteristics and Activity
Wife of Hercules

Related Myths
The horn that Hercules broke off Achelous, who had changed into a bull, was later found by Naiads and filled with flowers; it became a sacred object: the horn of plenty

Hercules and Achelous, a river god, both fall in love with Deianeira and face each other in a strenuous fight for her hand. Achelous transforms himself into a number of monstrous creatures before changing into a bull; Hercules kills him by pulling off one of his horns.

The hero and his new wife leave Calydon, and, nearing a river, Hercules entrusts Deianeira to the Centaur Nessus to carry across to the opposite bank. Nessus, however, falls in love with the young woman and tries to carry her off, but he is struck by one of Hercules' deadly arrows. Before dying, the Centaur gives Deianeira some of his blood, telling her that she can prepare an ointment from it that will ensure her husband's love forever. Later, when Hercules falls in love with Iole, Deianeira sends her husband a robe anointed with Nessus's blood. As soon as Hercules touches it, a terrible disease spreads throughout his entire body. Overcome by the dreadful pain, Hercules orders a funeral pyre built for him on Mount Oeta and dies. Hearing what happened, Deianeira takes her own life in desperation.

▶ Laurent Pécheux, *Nessus and Deianeira*, 1762. Turin, Galleria Sabauda.

*Deianeira does not have any particular
identifying traits. In this example she
can easily be recognized thanks to the
characters that surround her: Hercules
carries her in his arms, and the Centaur
at his feet is certainly Nessus.*

The bow is an
emblem of
Cupid, whose
arrows arouse
passion in gods
and humans. The
god appears here
to emphasize the
amorous theme
of the work.

A quiver of
arrows is one
of Hercules'
symbols.

The lion skin
is another
attribute of
Hercules. Some
hold that it is
the skin of the
Nemean lion,
which Hercules
slew in the first
of his famous
twelve tasks.

▲ Bartholomeus Spranger, *Hercules,
Deianeira, and the Dead Centaur
Nessus*, circa 1582. Vienna,
Kunsthistorisches Museum.

Nessus the Centaur
lies dead on the
ground.

Deianeira

Deianeira is frequently depicted being abducted by Nessus.

Hercules, identifiable by the lion skin, prepares to shoot Nessus with the arrow that will strike him down.

Nessus the Centaur is often shown carrying off Deianeira. Centaurs are half man and half horse, usually described as savage creatures.

▲ Guido Reni, *Nessus and Deianeira*, 1620–21. Paris, Musée du Louvre.

Diana is depicted as a young huntress, dressed in a tunic with her hair tied back. The crescent moon on her head is one of her emblems, as are the bow and arrow. At times she holds a spear. Dogs or a stag usually accompanies her.

Diana

Diana is Jupiter and Latona's daughter and Apollo's twin sister. As soon as she is born at Delos, she helps her mother give birth to her brother.

Diana does not have a partner; she is the virgin goddess par excellence. She is a symbol of chastity and protector of young girls until they marry. She is skilled at hunting and spends most of her time in the forest together with dogs and the nymphs of her company, who are also pure and chaste. After a hunt, the goddess usually prefers bathing in a spring.

Diana the huntress appears as a tall, thin young woman armed with a bow and arrow. She follows a group of dogs or a stag. Her hair is kept up and there is a crescent moon on her head. Her image, in fact, in later versions of the myth, was associated with Luna (Selene), the moon goddess. In other examples, the goddess is shown bathing at a spring alone or with her followers. Artists often show the group being taken by surprise by satyrs. In reality, this is not a tale from mythology, but rather an allegory that alludes to the vice of lust prevailing over chastity.

Greek Name
Artemis

Relatives and Mythic Origins
One of the twelve gods of Olympus; daughter of Jupiter and Latona; twin sister of Apollo

Characteristics and Activity
Goddess of the hunt, she was later identified with the moon goddess, Luna (Selene)

Special Devotions
She was especially worshipped in Delos (Ortygia), her traditional birthplace

Related Myths
Diana transforms Actaeon into a stag; she changes Callisto into a bear; Diana falls in love with Endymion; together with Apollo, Diana kills the children of Niobe, who dared to boast that hers were more beautiful than Latona's

▲ Domenichino, *Diana Hunting* (detail), 1616–17. Rome, Galleria Borghese.

► Parmigianino, *The Bath of Diana* (detail), 1520. Fontanellato, Rocca Sanvitale.

The crescent moon on her head
is one of Diana's symbols.

The choice of
portraying a
particular
goddess can
be linked to
emphasizing the
virtue she sym-
bolizes. In this
case Diana
can represent
chastity or
feminine beauty.
Some have
identified the
model for this
mythological
portrait as
Diana of Poitier,
lover of France's
King Henry II.

The bow and
arrows are
also emblems
of Diana

The dog that accompanies Diana
alludes to her zeal for the hunt.

▲ Fontainebleau school, *Diana the Huntress*,
1530–60. Paris, Musée du Louvre.

*The satyrs are mythological crea-
tures, beings that are part animal
and live in the forest. They particu-
larly enjoy sensual pleasures. This
painting probably alludes to lust in
contrast to Diana's chastity.*

*The crescent moon
identifies Diana.*

*The stag being torn apart by
dogs refers to Actaeon, who
was punished for having
spied on Diana while she
bathed at a spring.*

▲ François Clouet, *The Bath of Diana.*
Rouen, Musée des beaux-arts.

Nymphs are Diana's companions. Here they try to shoot a dove that is tied to a pole. Domenichino was actually freely interpreting an episode from the Aeneid. Virgil, in fact, tells of a contest that Aeneas's companions organized to shoot a dove that was tied to the mast of a ship.

The second shot cuts the ribbon that ties the bird, and only the third actually hits the bird, exactly matching Virgil's account.

The first arrow that the nymphs shoot hits the pole, just as the first by Aeneas's companions did in the tale by Virgil.

The two watching figures in hiding perhaps allude to the myth of Actaeon, who was transformed into a stag and torn apart by his own dogs for having seen the goddess bathe in a spring.

▲ Domenichino, *Diana Hunting*, 1616–17. Rome, Galleria Borghese.

Endymion, an extremely handsome youth whom Diana loved, is usually portrayed lying down sleeping, with animals often nearby.

Endymion

The myths connected with the character of Endymion vary. Some say that Jupiter punishes him because when the king of the gods brings him to Olympus, Endymion dares to fall in love with Juno. In a more common version, Endymion is a young shepherd who is extremely handsome, and Diana falls in love with him. Jupiter puts him into an infinite sleep and assures his eternal youth. One evening Luna visits him, and fifty daughters are born from their union. After this, Diana's image becomes assimilated with that of Luna.

The figure of a young man immersed in eternal sleep inspired many artists and poets, who saw him as an image of timeless beauty. A sleeping animal often accompanies Endymion, and at his side, Diana embraces him. The goddess's presence can also be illustrated symbolically as a ray of moonlight shining on the young man. Cupid, the winged child, can also appear, alone or in the company of cherubs. In other versions Endymion is shown awake, kneeling as he faces the goddess.

Greek Name
Endymion

Relatives and Mythic Origins
Commonly held to be king of Elis; son of Aethlius and Calyce

Characteristics and Activity
Generally depicted as an exceptionally handsome shepherd or hunter

Annibale Carracci, ▲ *Diana and Endymion* (detail), circa 1597–1604. Rome, Palazzo Farnese.

Cima da Conegliano, ◄ *Endymion Sleeping*, circa 1510. Parma, Galleria Nazionale.

Endymion

The winged
child with a
bow in hand is
Cupid, also
called Amor.

The full moon behind this goddess
clearly identifies her as Diana, who
was assimilated with the moon
goddess, Luna.

This resting
youth is
Endymion,
whom Diana
loved, and
whom
Jupiter put
into a perpet-
ual sleep.

There are often
sleeping animals
near Endymion.

▲ Pier Francesco Mola, *Diana and
Endymion,* circa 1660. Rome, Pinacoteca
Capitolina.

Europa, a young girl loved by Jupiter, is often seated on the back of a bull that flees upon the waves of the sea.

Europa

Jupiter, the king of the gods, falls in love with Europa and changes himself into a white bull. He arrives at the beach where the young woman is playing with her maidservants. Europa is frightened at first but then takes courage and begins to pet the animal and decorate his horns with garlands of flowers. She finally comes to sit on the bull's back and then screams as Jupiter suddenly flees upon the waves and takes her to Crete to be with him. Europa gives birth to three sons: Minos, Rhadamanthys, and Sarpedon.

Artists have portrayed this episode from mythology almost more than any other. This is perhaps due to *Ovide Moralise,* a famous medieval text that interprets the ancient myths as allegories of Christianity. In it, the character of Europa being abducted by the bull is interpreted as an image of Christ, who, incarnated as a bull, brings the human soul to heaven.

In art, the rape of Europa is often depicted with Jupiter fleeing with the girl on his back as her maidservants fret on the bank. Sometimes cherubs fly above Europa and the bull.

Greek Name
Europa

Relatives and Mythic Origins
Daughter of the Phoenician king Agenor and Telephassa; sister of Cadmus

Characteristics and Activity
Jupiter falls in love with her; disguised as a bull, he carries her off

Special Devotions
On Crete, the island where the bull landed, Europa was celebrated during the Hellotia

Related Myths
Cadmus, Europa's brother, founded the city of Thebes after anxiously searching for her

Alessandro Turchi ▲ (L'Orbetto), *The Abduction of Europa* (detail). Matano di Castenaso, The Molinari Pradelli Collection.

Titian, ◄ *The Rape of Europa,* circa 1559. Boston, Isabella Stewart Gardner Museum.

Europa

The port in the background can be interpreted as a city port of Europe or, in a moralistic interpretation, the divine world.

The bull that flees with the girl on his back is Jupiter abducting Europa. A moral interpretation has been given to this painting: here the human soul is abducted from the dimension of the earthly passions and taken to the divine.

The girls left behind on the beach are Europa's maidservants.

▲ Rembrandt, *The Abduction of Europa*, 1632. Los Angeles, The J. Paul Getty Museum.

Eurydice is portrayed being bitten by a serpent or with her husband, Orpheus, as they return from the Underworld.

Eurydice

Eurydice is a nymph who marries Orpheus, the legendary poet from Thrace who is unsurpassed in playing the lyre. Aristaeus the hunter falls in love with her and attempts to seduce her, but the horrified nymph flees. She is bitten by a serpent while running and dies. Orpheus is distressed at the loss of his love and decides to descend into the Underworld to search for her. With his extraordinary songs, he manages to move the deities of the Underworld, who let the young woman go on one condition: Orpheus must not look back at his wife before seeing the light of the sun. Eurydice follows her husband on the return path, but as they are about to reach their goal, Orpheus gives in to his desire to see her again and turns. Immediately Eurydice is swept back to the Underworld, leaving Orpheus to return to the surface by himself.

Eurydice is usually shown as a snake bites her or lying lifeless on the ground while Orpheus weeps. Other times she is portrayed fleeing from Aristaeus. She can also appear in the background of a landscape, startled by a snake wrapped around her arm or ankle, as Orpheus plays his lyre in the foreground.

Greek Name
Eurydice

Relatives and Mythic Origins
Dryad or wood nymph

Characteristics and Activity
Wife of Orpheus

Ludwig van Schoor, ▲
Eurydice Bitten By a Snake (detail), circa 1700–1725. Vienna, Kunsthistorisches Museum.

Antonio Canova, ◄
Eurydice, 1775–76. Venice, Museo Correr.

Eurydice

Eurydice is shown here with nymphs. The artist has illustrated an alternate version of this myth, where the serpent bites Eurydice while she takes a walk in the woods with her friends.

The lighted torch symbolizes the fire of love. Hymen, the god of marriage, holds it.

The serpent is about to strike Eurydice.

▲ Ludwig van Schoor, *Eurydice Bitten by a Snake,* circa 1700–1725. Vienna, Kunsthistorisches Museum.

The Fates are generally shown as elderly spinners. They are always together, usually in the world of shadows, where they prepare and measure the thread of human life.

Fates

Our ancestors held that life was controlled by destiny. The events of each human life were established at birth, including the time of death. Although they believed that everything depended on the will of the gods and Jupiter, they also held that fate was something beyond the will of the gods, something that not even the gods could escape. The destiny of Achilles, for example, is to die during the Trojan War, and although his mother, Thetis, tries to protect him in every way possible, the hero does in fact fall on the battlefield.

The Fates, or Parcae, are personifications of destiny and are commonly considered daughters of Jupiter and Themis. Alternatively, they were daughters of Nyx (Night), according to Hesiod. The Fates are often shown spinning and cutting the thread of human life according to lengths corresponding to the number of days in a person's life. There are three Fates: Clotho, the "spinner"; Lachesis, the "caster of lots," who assigns humans their fate; and Atropos, the "unbending," who cuts the thread. Clotho holds the distaff; Lachesis either holds the spindle or measures the length of life; and Atropos, the most terrifying, cuts the thread of life. They can be portrayed by themselves in the Underworld or in complex allegorical scenes where the image of Death appears.

Greek Name
Moirae

**Relatives and
Mythic Origins**
Daughters of Jupiter
and Themis; according
to Hesiod they were
the daughters of Nyx,
the goddess of night

**Characteristics
and Activity**
Goddesses of destiny

Giuseppe Maria Crespi, ▲
Banquet of the Gods
(detail), 1691–1706.
Bologna, Palazzo Pepoli.

Francesco Salviati, ◄
*Clotho, Lachesis, and
Atropos (The Three Fates),*
circa 1550. Florence,
Galleria Palatina.

The thread of life is about to be cut by Atropos, one of the Fates (Parcae).

Clotho holds the distaff.

The hooded character is Demogorgon, considered the supreme holder of occult powers or founding father of the gods.

Lachesis measures out the thread of life.

▲ Luca Giordano, *Den of the Gods,*
circa 1865. London, National Gallery.

Flora is generally depicted as a woman of pleasant appearance whose head is decorated with a garland of flowers. She carries flowers in her lap, which are sometimes shown in a tiny bunch.

Flora

Flora is the goddess of spring, flowers, and blossoming. Ovid, who reconnected the character of Flora with a Hellenic myth, held that Flora was the same as Chloris.

One spring day, as she is walking through the fields, Zephyrus, the wind of spring, sees her and falls in love. He steals her away and they marry. To prove his love for her, he allows her to reign over all the flowers in gardens and cultivated fields. Among the many gifts that the goddess brings to humans, together with an infinite variety of flowers, is honey.

Flora can be depicted wearing a garland of flowers on her head as she carries a large quantity of flowers in her lap. She is often with Zephyrus or dances in her garden, spreading flowers all around her. Prosperity and youth are linked with Flora, as well as the joys of life and sweetness. Her image is often used in female portraits.

Greek Name
Chloris, according
to Ovid

**Relatives and
Mythic Origins**
The tradition of this
mythological figure
dates back to the
Italic peoples

**Characteristics
and Activity**
Ancient Italic
goddess of spring

Special Devotions
The Floralia, the festival dedicated to Flora,
was held each year
between the end of
April and the first
of May

Rembrandt, ▲
Portrait of Saskia as Flora
(detail), 1634. Saint
Petersburg, Hermitage.

Bartolommeo Veneto, ◄
Flora, 1507–8. Frankfurt,
Städelsches Kunstinstitut.

Flora

One of the distinctive
signs of Flora is that
she wears a garland of
flowers on her head.

Zephyrus, the
sweet wind of
spring, pursues
Chloris

▲ Sandro Botticelli, *La Primavera*
(detail), circa 1482–83. Florence, Uffizi.

Chloris is shown
with flowers
sprouting from
her mouth.

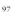

A sea divinity, Galatea is frequently portrayed on the water in a chariot pulled by dolphins, followed by tritons and Nereids.

Galatea

Galatea is the daughter of Nereus and Doris. Polyphemus, the famous giant with a single eye, falls in love with her, but the goddess does not respond to his advances because she is in love with the handsome Acis, the shepherd son of Pan and the nymph Symaethus. One day the Cyclops sits at the top of a hill to play his flute in honor of his lover. Later on, walking nearby, he comes upon Acis and Galatea in each other's arms at the seashore. Blinded by jealousy, he picks up a boulder and hurls it at the shepherd, killing him instantly. Galatea immediately transforms her lover into a river.

Artists have depicted Acis and Galatea hiding, declaring their love to each other in whispers as Polyphemus plays his flute nearby. The two lovers can also be alone in a sea landscape or fleeing together from the Cyclops. Galatea often appears in her carriage, which is made of a shell being pulled by dolphins, circled by tritons and Nereids. This was one of the most preferred mythological scenes in seventeenth-century art.

Greek Name
Galatea

Relatives and Mythic Origins
Daughter of Nereus and Doris

Characteristics and Activity
A sea divinity, she loved the shepherd Acis and refused the advances of Polyphemus

Claude Lorrain, ▲
Marine Scene with Acis and Galatea (detail), 1657.
Dresden, Gemäldegalerie.

Giacinto Gimignani, ◄
Triumph of Galatea, circa 1640. From a private collection.

97

These are winged cherubs armed with bows
and arrows. The fact that they are not
blindfolded perhaps alludes to heavenly
love, which Galatea tends toward.

The horn, in
this case a
conch shell
used as a wind
instrument, is
one of the
emblems of the
tritons. These
sea divinities
are children of
Neptune and
Amphitrite, half
men and half
fish.

According to
moral interpre-
tation of the
myth, Galatea
and her love for
Acis are image
of the human
soul's aspiration
to join God

The Nereids, together with tritons,
are part of Galatea's court. Read in
a moralistic way, these creatures,
which are half human and half fish,
represent the human condition,
halfway between an earthly and
heavenly nature.

Galatea's chariot
is a giant shell
complete with
paddle wheels.

▲ Raphael, *The Triumph of Galatea,*
1511. Rome, Villa Farnesina.

*The conch-shell
horn is an emblem
of tritons.*

*Acis appears as
a personification
of the stream.*

*Nereids and tritons, sea gods and
goddesses who make up Galatea's
court, carry the goddess in triumph.*

▲ Luca Giordano, *Triumph of Galatea*,
1675–76. Florence, Palazzo Pitti.

An exceptionally handsome young man, Ganymede is often depicted being abducted by Jupiter, who has transformed himself into an eagle.

Ganymede

Greek Name
Ganymede

Relatives and Mythic Origins
In the Homeric tradition, he is the son of the Trojan king Tros and Callirrhoe

Characteristics and Activity
Cupbearer to the gods

According to the Homeric texts, the gods abduct Ganymede to become their cupbearer and serve them during their banquets. Later versions tell how Jupiter falls in love with the young man and changes himself into an eagle to abduct Ganymede and bring him to Olympus as his personal cupbearer. This latter version is more prominent in art. The youth is shown either in the clutches of an eagle or riding upon its back as he is brought to the heavens. Ganymede often carries a small amphora, which refers to his future task as cupbearer, or he can be seen on Olympus as Hebe hands him a cup (she was cupbearer before him). The "moralizers" of Ovid saw Ganymede as an image of John the Evangelist and the eagle as a symbol of Christ. The Renaissance humanists, instead, interpreted this mythological episode as an allegory of the human soul being drawn to God.

▲ Rembrandt, *The Abduction of Ganymede* (detail), 1635. Dresden, Gemäldegalerie.

▶ Correggio, *Ganymede*, circa 1531. Vienna, Kunsthistorisches Museum.

Often featured together, Scylla is portrayed as a beautiful girl and Glaucus a sea divinity with a long white beard, half man and half fish.

Ovid narrates the tale of Glaucus and Scylla in *Meta-morphoses*.

Glaucus and Scylla

After a good catch, Glaucus the fisherman stops to spread his nets out on a lawn near a beach. Suddenly the fish that had been laid there begin to move, until they all dive back into the sea. Surprised and scared at the same time—not knowing if this is the work of a god or magic from the grass—Glaucus takes a tuft of grass and brings it to his mouth. He is immediately turned into a sea creature and dives into the water.

Later on Glaucus becomes infatuated with the nymph Scylla, but she finds his advances repulsive. He asks Circe the sorceress to prepare a magic potion to make the beautiful nymph love him. Unfortunately, Circe has feelings for Glaucus herself that he does not return, and she prepares a mixture that transforms Scylla into a horrible monster. The episode most frequently illustrated from this myth shows Scylla fleeing Glaucus by climbing a rock near the sea. The fisherman, now half man and half fish with a long white beard, pleads with her in vain.

Greek Names
Glaucus; Skylla

Relatives and Mythic Origins
According to Ovid, Glaucus is a native of Boeotia; Scylla is generally considered the daughter of the nymph Craetaeis

Characteristics and Activity
Glaucus is a fisherman, Scylla a nymph

Related Myths
Scylla becomes the monster that attacks Ulysses' ship, killing a number of his companions

Bartholomeus Spranger ◀▲, *Glaucus and Scylla* (details), circa 1582. Vienna, Kunsthistorisches Museum.

*The sea divinity with
a human body and
the tail of a fish is
Glaucus.*

▲ Laurent de La Hyre, *Glaucus and
Scylla*, 1640–44. Los Angeles, The
J. Paul Getty Museum.

The three Graces appear as nude girls leaning on one another's shoulders. They may hold a rose, a cube, an apple, or a myrtle branch.

Graces

Daughters of Jupiter and Eurynome, the Graces personify beauty and grace, instilling joy in the hearts of people and gods alike. Hesiod records their names in his *Theogony* as Euphrosyne, Thalia, and Aglaea. They are part of the company of Apollo, the god of music, or Venus, from whom they have inherited a number of attributes. They often hold a rose, myrtle branch, apple, or cube and are usually shown nude as they embrace one another. Traditionally the center character has her back turned, while the other two face the viewer. This composition originally appeared on a wall painting in Pompeii and was used as a model by many artists in later eras. In various historical periods, the Graces were seen as an allegory. According to Seneca, for example, the goddesses represent three characteristics of generosity: giving, receiving, and exchanging. Humanists in the Renaissance, instead, considered them images of chastity, beauty, and love, and the inscription *Castitas, Pulchritudo, Amor* (Chastity, beauty, and love) often appears in their portraits.

Greek Name
Charites

Relatives and Mythic Origins
Daughters of Jupiter and Eurynome

Characteristics and Activity
Goddesses of grace and beauty

Raphael, ▲
The Three Graces,
1504. Chantilly, Musée Condé.

Antonio Canova, ◄
The Three Graces,
1812–16. Saint Petersburg, Hermitage.

The book possibly refers to the seven liberal arts.

Here the artist handles the symbolic imagery of the three Graces in an original way. The objects that they are holding, or those on the ground, allude to intellectual activities that the three goddesses have beneficial influence over.

The lute can be considered a symbol of music.

Perhaps the swan refers to lyric and romantic poetry.

▲ Hans Baldung (Grien), *The Three Graces*, circa 1544. Madrid, Prado.

Hebe is often shown standing with a cup in hand and a pitcher on her shoulder or in the act of pouring nectar in a cup and offering it to the eagle of Jupiter.

Hebe

Hebe is the daughter of Jupiter and Juno. She is the goddess of eternal youth, and, as cupbearer to the gods, she serves nectar during the banquets. Within the realm of Olympus, she assumes the role of servant or "daughter of the house." She helps Juno prepare her carriage and dances to Apollo's lyre with the Horae and Muses. After the role of cupbearer is transferred to Ganymede, Hebe's role changes to being Hercules' wife.

Worship of this goddess in Greece was often connected with Juno or Hercules. In ancient Rome, however, Hebe was identified with the ancient god Juventus. Her figure took on political connotations as she represented the state's rejuvenation and flowering youth. Since Hebe is the personification of blossoming youth, female portraits often resembled her during the eighteenth century, with the obvious intention of celebrating a subject's youth and beauty.

Greek Name
Hebe

Relatives and Mythic Origins
Daughter of Jupiter and Juno

Characteristics and Activity
Goddess of eternal youth and cupbearer to the gods

Special Devotions
Her worship was widespread in Rome, where she was held to be the symbol of the state's constant rejuvenation

Baldassarre Peruzzi, ▲
The Marriage of Hebe and Hercules (detail), circa 1520.
Rome, Villa Mattei.

Antonio Canova, ◄
Hebe, 1816–17. Forlì,
Pinacoteca Civica.

Portrayed as a muscular, bearded man clothed in a lion skin and holding a club, the hero is sometimes armed with a bow and quiver of arrows that he received as a gift from Apollo.

Hercules

Greek Name
Herakles

**Relatives and
Mythic Origins**
According to Ovid, he
is the son of Jupiter
and Alcmena

**Characteristics
and Activity**
The most celebrated
hero of mythology, a per-
sonification of courage
and physical strength

Special Devotions
According to some, the
hero was the first to
institute the tradition of
the Olympic games;
various places in Greece
celebrated the Herakleia,
a festival in honor
of Hercules

**Related
Myths**
Hercules
traveled with
the Argonauts'
expedition and hunted
the Calydonian boar

▲ Paolo de' Matteis, *Triumph of Hercules*
(detail), circa 1719. Lancaster, California, the
K. R. McDonald Collection.

▶ Antonio Pollaiuolo, *Hercules and Antaeus*,
circa 1470. Florence, Museo Nazionale del
Bargello.

Hercules is born from the union of Jupiter and Alcmena. The god seduces the woman by disguising himself as her husband, Amphitryon, and because of this, Juno always resents Hercules. The hero first marries Megara, the daughter of King Creon of Thebes. They have three children, whom Hercules kills with his own hands in a fit of madness caused by Juno. In order to atone for his terrible deed, the hero is guided by the oracle at Delphi to place himself under Eurystheus, king of Tiryns, who gives him the famous twelve Labors of Hercules to accomplish. Eventually Hercules succeeds and marries Deianeira, who unwittingly causes the hero's death. Then, brought to Olympus by the gods, Hercules becomes immortal and takes Hebe as his wife.

Hercules is the hero par excellence, one of the most famous and popular characters in all Classical art and that of later periods. His main attributes are the club and lion skin, and he can appear with a bow and quiver of arrows on his back.

As an allegory, Hercules' character symbolizes physical strength and courage, and the twelve labors take on a moral significance as an allusion to the victory of good over evil.

In order to punish Alcmena, whom
Jupiter loved, Juno sends two snakes to
kill Hercules. The infant hero, who
already possesses marvelous strength,
grasps the serpents and slays them.

The twelve
Labors of
Hercules have
been sculpted
on the statue's
base.

Hercules frees the three-headed
dog Cerberus, the guardian of
the Underworld.

Hercules kills the
Nemean lion.

Guglielmo della Porta, *Hercules Killing the
Serpents,* before 1560. Naples, Capodimonte.

This armed woman is
Minerva, the goddess
of wisdom, who
shows Hercules the
steep path of virtue
that leads to the
temple of fame.

Hercules must choose between the
paths of virtue and vice, personified by
two female characters. The theme of
Hercules' choice, first developed by the
Greek Sophist Prodicus and taken up
again by Xenophon, resonated strongly
in Renaissance and Baroque art.

The mask symbolizes the deceit that
can often accompany lust.

The club is one of Hercules' emblems.
According to Theocritus, a Greek poet,
the hero made his weapon from the
trunk of a wild olive tree, which he
uprooted with his bare hands.

The rose is a symbol of Venus. The
goddess of beauty attempts to lead
Hercules on the path to pleasure.

▲ Pompeo Batoni, *Hercules between Vice and
Virtue*, circa 1753. Turin, Galleria Sabauda.

The bow and arrow are symbols of
Hercules, who is shown here afflicted
with the madness that Juno brought
on him. He is about to slay his chil-
dren.

The hysterical woman is Megara,
Hercules' wife. According to the most
widespread version of the myth, she
perishes with her children.

▲ Antonio Canova, *Hercules Shoots His
Children*, 1799. Bassano del Grappa,
Museo Civico.

The only way Hercules manages to kill the lion is by strangling it with his bare hands, since neither his club nor arrows from his bow could hurt the animal.

The lion spreads terror and death in the region of Nemea. According to tradition, the skin of the ferocious animal, a trophy from the first of the Labors of Hercules, becomes one of the hero's defining characteristics.

▲ Peter Paul Rubens, *Hercules Fighting the Nemean Lion,* after 1608. Bucharest, Muzeul National de Artă al României.

▶ Gustave Moreau, *Hercules and the Hydra of Lerna,* 1869–76 Paris, Musée Gustave Moreau

The lion skin is one of Hercules' trademarks. The hero is often depicted wearing the animal's head like a hood or helmet.

The Hydra, a multiheaded monster, threatened the area of Lerna. Hercules, in another of his tasks, defeats the monster with help from his faithful friend Iolaus. The hero then makes his arrows lethal by immersing them in the horrid creature's blood.

*The animals with bronze talons and
beaks are birds that live in the swamps
near Stymphalus. They shoot their feath-
ers like arrows and eat human flesh.
Here the artist has modeled them after
descriptions of Harpies found in Dante.*

*Hercules, here shown with a bow and
arrows, manages to make the monsters fly
and slays them with arrows he received as
a gift from Apollo. Killing the Stymphalian
birds is one of his twelve labors.*

▲ Albrecht Dürer, *Hercules*, 1500.
Nuremberg, Germanisches
Nationalmuseum.

The animal shown in this tapestry resembles the wild horses of King Diomedes that feed on human flesh. Captured by Hercules, they become tame after Hercules kills their owner and feeds him to the beasts.

The lion skin is one of Hercules' symbols. The episode shown here is one of the Labors of Hercules.

Hercules' club, one of the typical symbols of the hero, was made from an olive tree that he uprooted with his bare hands.

▲ Oudenaarde, *Hercules Tames the Horses of Diomedes*, tapestry, 1545–65. Paris, Musée du Louvre.

Here the lion skin, one of Hercules' attri-
butes, appears again. According to a lesser-
known version of the myth, this is not the
skin of the Nemean lion but that of a beast
the hero slays on Mount Cithaeron as a
young man while tending his father's animals.

The fruit that
Hercules is
picking are the
Golden Apples
from the
Garden of the
Hesperides; this
episode is linked
to the tale of the
twelve labors.

A club is one
of the signs
that identify
Hercules.

Ladon the
dragon, whom
Hercules defeats
before gathering
the precious
fruit, guards the
tree of the
Golden Apples.

The three-headed dog is Cerberus, a monster guarding the door of the Underworld. The last of the Labors of Hercules was to tame the beast and bring it back alive to King Eurystheus.

Once again, the lion skin identifies Hercules. Traditionally it is the skin of the Nemean lion, a trophy from the first of the hero's twelve labors.

The club is an emblem of Hercules, who obtained it by uprooting an olive tree with his bare hands.

◄ Peter Paul Rubens, *Hercules in the Garden of the Hesperides*, circa 1638. Turin, Galleria Sabauda.

▲ Francisco de Zurbarán, *Hercules Fighting Cerberus*, 1634. Madrid, Prado.

Admetus, the husband of Alcestis,
watches the scene horrified. Apollo
persuaded the Fates to spare Admetus
from death if his father, mother, or
wife would take his place. Only his
wife, Alcestis, accepted death in order
to save him.

▲ John William Waterhouse, *Hercules Fights
Death for Alcestis*, 1869–71. Hartford,
Connecticut, Wadsworth Atheneum.

Hercules, who here is shown with the lion skin, faces Death in hand-to-hand combat in order to save Alcestis.

The woman lying lifeless is Alcestis.

The winged character in a black cape is Death. This image is taken from a description by the Greek tragedian Euripides in the play Alcestis, *which inspired the painter.*

The giant Antaeus, son of Neptune and Terra, is invincible as long as he is touching the earth.

Having discovered the giant's secret, Hercules manages to grab hold of Antaeus and lift him off the ground to take away his power and slay him.

Hercules wears the traditional lion skin.

The pair of partridges hanging
on the wall symbolizes Cupid's
victory over Hercules.

The man spinning wool is Hercules.
The oracle at Delphi ordered Hercules
to sell himself as a slave to atone for
killing Iphitus. In this episode, Her-
cules is often shown in women's
clothes with a spindle in hand.

The woman holding the spindle is
Omphale, queen of Lydia, who takes
Hercules as a slave and soon becomes his
lover. The queen is often shown wearing
the lion skin and holding the hero's club.

◄ Antonio Pollaiuolo, *Hercules and
Antaeus*, circa 1475. Florence, Uffizi.

▲ Lucas Cranach the Elder, *Hercules and
Omphale*, 1537. Brunswick, Herzog Anton
Ulrich-Museum.

Pan, a creature that is half man and half animal, is being kicked out of Omphale's bed. According to a story by Ovid, Pan was in love with the queen.

Hercules kicks Pan out of Omphale's bed. Dressed as a woman, the hero was not recognized by the god, who tried to sneak in.

Omphale is holding the club, one of Hercules' symbols.

▲ Abraham Janssens, *Hercules and Omphale,* 1607. Copenhagen, Statens Museum for Kunst.

▶ Antonio Canova, *Hercules and Lycus,* 1795–1815. Possagno, Gipsoteca Canoviana.

Taking Lycus by the foot, Hercules is about to hurl him through the air.

Lycus, one of Hercules' companions, brought the hero the shirt that Deianeira had mistakenly immersed in the poisonous blood of Nessus. Racked by the pain, the hero is infuriated with his friend and flings him through the air.

Once again the lion skin, Hercules' attribute, is present.

Here again is Hercules' club, one of his symbols, which he made by uprooting an olive tree with his bare hands.

Lightning bolts are a symbol of Jupiter, who welcomes Hercules to Olympus.

Hercules' lion skin is shown here

The bow and quiver of arrows are weapons that Hercules gives his friend Philoctetes—he is shown here kneeling—in recognition for having lighted his funeral pyre.

The shirt worn by Hercules is one that Deianeira mistakenly immersed in the poisonous blood of the Centaur Nessus. She hoped to obtain the hero's everlasting love.

▲ Luca Giordano, *Hercules on the Pyre*, 1697–1700. Madrid, El Escorial, Casita del Principe, Patrimonio National.

Leander is depicted either swimming in the sea toward a lighted tower far away or as his lifeless body is brought to shore by Nereids as Hero throws herself from the tower.

Hero and Leander

Leander is a young man who lives in Abydos. He falls in love with Hero, a priestess of Venus at Sestos. The two cities are across from each other on the banks of the Hellespont (the present-day Dardanelles). Every night Leander swims across the strait, guided by a torch that Hero lights on the high tower where she lives. One stormy night, however, the torch goes out and Leander perishes amid the waves. In the morning, after she finds her lover's lifeless body on the shore, Hero throws herself from the tower in desperation.

This myth was particularly popular with Italian and Flemish painters during the seventeenth century. Leander is usually portrayed swimming the Hellespont guided by Hero's torch, or as his lifeless body is brought to the shore by Nereids. Hero is shown overcome by extreme emotion near her lover's body or throwing herself from the tower. Only rarely does Leander reach the other shore; Hero welcomes him together with her nurse, who holds the torch.

Greek Names
Hero; Leander

Relatives and Mythic Origins
Hero is a priestess of Venus; Leander is a young man from Abydos (present-day Çanakkale)

Characteristics and Activity
A couple in love

Giuseppe Bacigalupo, ▲
Hero and Leander, before 1790. Genoa, Palazzo Durazzo Pallavicini.

Peter Paul Rubens, ◄
Hero and Leander, 1604–5. New Haven, Connecticut, Yale University Art Gallery.

123

The conch shell pulled by sea-horses is a symbol of Neptune, god of the sea.

The stretch of water that Leander swims each night is the strait of the Dardanelles. Swimming the strait was considered impossible until Lord Byron demonstrated that it was actually doable. In 1807 the famous romantic poet crossed the strait cheered on by enthusiastic onlookers.

The extinguished torch in the hands of the crying Cupid shows the end of love.

The Nereids, sea divinities who are daughters of Nereus and Doris, bring the lifeless body of Leander to shore.

▲ Domenico Fetti, *Hero and Leander,* circa 1622–23. Vienna, Kunsthistorisches Museum.

Hero throws herself from the tower in desperation after Leander's death.

Hyacinthus is often portrayed lying on the ground lifeless with Apollo at his side, distraught at his friend's death. The flower that shares Hyacinthus's name—the hyacinth—is usually near his body.

Hyacinthus

Greek Name
Hyacinthus

Relatives and Mythic Origins
Spartan prince, son of Amyclas and Diomedes

Characteristics and Activity
Loved by Apollo, his blood was transformed into a flower after his death

Hyacinthus is generally held to be the son of Diomedes and Amyclas; he is a handsome youth who is close to Apollo. One day the god and the young man are walking among the hills and valleys when they decide to throw a discus. Apollo throws first and it unexpectedly ricochets and strikes Hyacinthus, who falls dead to the ground. Too late to save him, Apollo transforms the blood flowing from his friend's wound into a flower, the hyacinth. The god then inscribes the Greek letters for "Alas" on each petal, expressing his profound pain and sorrow.

According to another version of the myth, Zephyrus is in love with Hyacinthus, and he misguides the discus in vengeance for the young man's not returning his love.

Hyacinthus is usually shown fallen to the ground. The sun god appears at his side or holding his body, and a hyacinth is typically a short distance away.

The laurel crown is a symbol of Apollo.

The cypress trees evoke an image of mourning.

The characters are dressed according to the fashion of the painter's time; the artist has transported the story of Apollo and Hyacinthus to his own era.

The winged child is Cupid, symbolizing the profound emotion that united the two characters.

Hyacinthus's blood is transformed into the flower that takes his name.

The racket and balls suggest that the myth has been transported to the painter's era; Tiepolo has exchanged discus throwing for eighteenth-century tennis.

Hyacinthus's fingers are still curved from having futilely tried to stop the fatal ball.

Domenichino, *Apollo and Hyacinthus*, 1603–4. Rome, Palazzo Farnese.

▲ Giovanni Battista Tiepolo, *Death of Hyacinthus* (detail), 1752–53. Madrid, Museo Thyssen-Bornemisza.

Hylas

The young man Hylas is frequently portrayed drawing water from a spring; Naiads, who are in love with him, carry him away.

Greek Name
Hylas

Relatives and Mythic Origins
Son of Theiodamas, king of the Dryopes

Characteristics and Activity
A young man whom Hercules loved; he was abducted by nymphs while drawing water at a spring

During the Argonauts' quest, Hercules falls in love with Hylas, a handsome young adventurer. During the voyage, the Argonauts land at Cios, where Hercules stops to search for a tree from which to carve a new oar, since one had been broken during the trip. Hylas's task is to draw water, and he reaches a spring inhabited by Naiads, nymphs of springs and rivers. Struck by the beauty of the young man, the nymphs pull him toward them in the water to give him immortality. Realizing that his lover is missing and suspecting the people of the region, Hercules makes them help in the search.

Artists especially illustrate the episode when the nymphs attract Hylas at the spring. An overturned water jug is next to him or in his hands. The scene can also be shown by moonlight.

▲ John William Waterhouse, *Hylas and the Nymphs* (detail), 1896. Manchester, City Art Galleries.

▶ François Baron Gérard, *Hylas and the Nymph*, 1825–26. Bayeaux, Musée Baron Gérard.

Icarus is generally shown donning the wings that his father attaches to his shoulders or falling into the stretch of sea near the island of Samos that eventually took his name: the Icarian Sea.

Icarus is the son of Daedalus, the famous creator of the Labyrinth, and Naucrate, one of King Minos's slaves. The king of Crete locks Daedalus and his son in the Labyrinth because the architect had advised Ariadne on how to help Theseus escape the intricately tangled paths there. In order to escape, Daedalus builds wings for himself and his son out of wax and feathers. He teaches Icarus how to use them, warning him to never fly too high or low in the sky. After hesitating at first, Icarus becomes confident and, forgetting his father's advice, soars higher and higher until the sun's heat melts his wings. The young man falls into the sea and drowns.

In the figurative arts, the episode most frequently illustrated has been the fall of Icarus, when the young man plunges into the sea as his wings fall to pieces. At times the moment before the flight is shown, when Daedalus ties wings to his son's shoulders.

Icarus

Greek Name
Icarus

Relatives and Mythic Origins
Son of Daedalus and Naucrate

Characteristics and Activity
The young man escaped from the Labyrinth with wings of wax that his father had made

Related Myths
His father, Daedalus, built the famous Labyrinth where the Minotaur was imprisoned

◄ Pieter Brueghel the Elder, *Landscape with the Fall of Icarus* (detail), circa 1558. Brussels, Musées royaux des beaux-arts de Belgique.

► Andrea Sacchi, *Daedalus and Icarus*, 1640–48. Rome, Galleria Doria Pamphili.

The man with wings attached to his outstretched arms is Daedalus. Frantic, he is powerless to help his son.

The wax is melting, and Icarus falls into the sea. In certain moralistic versions of the myth from the Renaissance, Icarus' tragic adventure is held up as a warning of the dangers of being too ambitious.

▲ Peter Paul Rubens, *The Fall of Icarus*, 1636. Brussels, Musées royaux des beaux-arts de Belgique.

*Icarus falls into the sea. The
stretch of sea where the myth says
he fell was named the Icarian Sea,
near the Greek island of Samos.*

Pieter Brueghel the Elder, *Landscape
ith the Fall of Icarus,* circa 1558.
russels, Musées royaux des beaux-arts
e Belgique.

Io

Greek Name
Io

**Relatives and
Mythic Origins**
According to Ovid, the
daughter of Inachus,
river god of Argolis

**Characteristics
and Activity**
She was seduced by
Jupiter, who was dis-
guised as a cloud

*Io is frequently portrayed as Jupiter, in the form of a cloud,
seduces her. The young girl can also appear as a heifer, which
Jupiter transformed her into to hide her from Juno.*

Having fallen in love with Io, Jupiter changes himself into a
cloud and seduces her. Juno, who is suspicious at such unusual
cloudiness in the middle of the day, goes searching for her hus-
band, who hurriedly transforms the girl into a splendid heifer.
Discovering his deceit, Juno convinces him to give her the cow
as a gift and then gives it to Argus, a guardian with a hundred
eyes. Jupiter, regretting Io's predicament, asks Mercury to free
her. The messenger of the gods manages to make Argus fall
asleep with the sweet sound of his flute and close all his eyes,
then slays him. Furious, Juno sends a nasty gadfly to torment
Io, who flees throughout the entire world. In the end, Jupiter
convinces the goddess to
calm herself, and Io is
restored to her original
shape.

In terms of imagery, Io is
usually shown with Jupiter
seducing her in the form of
a cloud or when she has
already been changed into a
heifer. In some scenes, Juno
also appears, asking Jupiter
for the animal as a gift, or to
hand over the cow to Argus
Mercury can appear near
Argus in scenes of the
guardian's death, and Io
watches from hiding. The
figure of the cow usually
appears in the background.

▶ Correggio, *Jupiter and Io*,
circa 1531. Vienna, Kunst-
historisches Museum.

Io has been transformed into a cow.

Lightning bolts are an attribute of Jupiter.

The goddess asks Jupiter to give her the cow as a gift.

Juno charges Argus with guarding the cow.

Argus takes Io into his custody. He is a guardian with a hundred eyes.

▲ Giovanni Battista Zelotti, *Juno Asks Jupiter for Io as a Gift,* circa 1565. Fanzolo, Villa Emo.

▲ Giovanni Battista Zelotti, *Juno Gives Io to Argus,* circa 1565. Fanzolo, Villa Emo.

Agamemnon's daughter is depicted near the altar where she is to be sacrificed; a short distance away Diana observes the fainting girl and, taking pity on her, prepares to save her.

Iphigeneia

Greek Name
Iphigeneia

**Relatives and
Mythic Origins**
Daughter of
Agamemnon and
Clytemnestra

**Characteristics
and Activity**
Her father offered her
in sacrifice to appease
Diana's wrath

Related Myths
Clytemnestra plots to
kill Agamemnon in
order to avenge her
daughter's sacrifice

While out hunting, Agamemnon accidentally kills a stag that is sacred to Diana. The goddess is enraged by what happened and causes contrary winds to blow, preventing the king from sailing from the port of Aulis. Agamemnon interrogates the soothsayer Calchas, who tells him that the goddess's wrath can be placated only by sacrificing his daughter Iphigeneia. The king makes the grave decision to do so and summons Clytemnestra with their children, saying that Iphigeneia will be Achilles' wife. As the girl is about to be sacrificed, Diana is moved to pity, substitutes a deer for Iphigeneia, and leads her to the land of the Taurians, where she becomes a priestess.

In artistic representations, Iphigeneia is often portrayed as having fainted in front of an altar. A cloud hovers nearby with Diana and the deer. Next to the girl is an old priest with long robes and a white beard.

▶ Giovanni Battista Tiepolo, *The Sacrifice of Iphigeneia*, 1757. Vicenza, Villa Valmarana.

Jason is usually shown defeating the dragon with the help of Medea, who uses her magic powers to aid the man she loves.

Jason

Jason, the son of King Aeson of Iolcus, is the famous hero who headed the Argonauts' quest for the Golden Fleece. When Pelias, Aeson's brother, usurps the throne, young Jason is miraculously saved from sure death. After he becomes an adult, Jason returns to Iolcus to retake his kingdom, but Pelias promises it to him only in exchange for the Golden Fleece, which is guarded in Colchis by a ferocious dragon. Jason commissions Argus, a famous shipbuilder, to build an exquisite craft, which is called the *Argo* after its creator. He then gathers the most famous heroes of the time for help, and they call themselves Argonauts. After a series of adventures, they finally reach Colchis. Medea, the daughter of King Aeetes, lord of the region, falls in love with Jason and helps him seize the Golden Fleece by using her magical potions. Then she flees with Jason in order to escape her father's wrath.

The myth of the Argonauts is only rarely found in artistic images and was primarily depicted during the Renaissance. The episodes connected to Jason's adventures mostly appeared on nuptial chests that contained brides' dowries, which were often decorated with mythological scenes.

Greek Name
Jason

Relatives and Mythic Origins
Son of Aeson, king of Iolcus

Characteristics and Activity
Famous hero who leads the Argonauts on the quest for the Golden Fleece

Special Devotions
He was venerated near the Isthmus of Corinth, where, according to legend, he died

Related Myths
Medea marries Jason and later, blinded by jealousy, murders their children; Hylas, companion of Hercules, is abducted by nymphs during the quest for the Golden Fleece

► Salvator Rosa School, *Jason and the Dragon.* From a private collection.

135

Full sails are a symbol of luck, which can change like the wind.

The lion skin identifies Hercules, who participates in the first part of the Argonauts' quest but then stops in Cios.

The Argo is depicted here as a traditional fifteenth-century ship.

The club is a symbol of Hercules.

▲ Lorenzo Costa, *The Sailing of the Argonauts*, 1484–90. Padova, Museo Civico degli Eremitani.

Jealous, violent, and vengeful, Jupiter's wife often appears crowned with a diadem with a scepter in hand, emphasizing her position as queen of Olympus.

Juno

Juno, Saturn and Cybele's daughter, is devoured by her father and then freed thanks to Metis and Jupiter. Her mother then gives her to Oceanus and Tethys to be raised at the world's edge. She is the sister and wife of Jupiter and is considered the protector of women, marriage, and childbirth. Her union with the king of the gods bears four children: Vulcan, Mars, Lucina (Eleithyia), and Hebe.

Juno is remembered above all as wife of the father of the gods, and she is usually portrayed as such by artists. Homer speaks of Juno as a jealous, stubborn, and quarrelsome goddess whom even Jupiter fears. She is often furious with her husband for his repeated infidelities and inevitably persecutes her husband's lovers and their children. These lovers are frequently victims of Jupiter's love—which they often do not reciprocate—and the terrible jealousy of his wife.

The goddess is usually portrayed as a stern woman. She may wear a diadem or crown and hold a scepter. Peacocks, sacred animals for Juno, pull her carriage and are considered her most characteristic symbol. In many of the illustrations of Jupiter and his lovers, she can be seen in the background, hidden by clouds.

Greek Name
Hera

Relatives and Mythic Origins
Daughter of Saturn and Cybele

Characteristics and Activity
The most important of all female Olympian gods; wife and sister of Jupiter; protector of women, marriage, and childbirth

Special Devotions
Worshipped in most areas of Greece

Related Myths
She persecutes Io, instills madness in Hercules, and indirectly causes Semele's death when she advises her to make Jupiter show himself in all his splendor; she is one of the candidates at the Judgment of Paris and partly responsible for the Trojan War, when she sides with the Achaeans

Tintoretto, *The Origins of the Milky Way* (detail), circa 1575. London, National Gallery.

Ambrogio Giovanni Figino, *Jupiter and Juno* (detail), 1599. Pavia, Pinacoteca Malaspina.

137

The Milky Way is created when Hercules, suckling the sleeping Juno's breast, cannot keep all the milk in his mouth.

According to the myth, Mercury places little Hercules on Juno's breast, although here there are no signs to show this is Mercury.

The eagle holding lightning bolts in its talons is a symbol of Jupiter, Hercules' father.

The peacock is one of Juno's symbols.

▲ Tintoretto, *The Origins of the Milky Way* (detail), circa 1575. London, National Gallery.

upiter is often depicted as a solemn and majestic figure surrounded by the other gods of Olympus; he holds a scepter and is accompanied by an eagle, a symbol of power.

Jupiter

upiter is lord of the heavens and all the other gods. He rules with wisdom and guarantees power, order, and law. Homer labels him the "thunderer," armed with thunder and lightning bolts that he can use to unleash violent storms or scatter the clouds.

He is saved from the cruelty of his father, Saturn, who devoured all his other children. According to tradition, Jupiter is raised on Mount Ida by nymphs, who nourish him with honey and milk from Amalthea the goat. Once an adult, Jupiter faces his father. After a number of battles, he reestablishes order in the universe. Hesiod records that after the struggle, Jupiter and Juno are married in a solemn ceremony. Vulcan, Mars, Hebe, and Eleithyia are born from their union. Jupiter still has innumerable love affairs with mortal and immortal women, often appearing to them in disguise. Juno invariably punishes his lovers afterward; she is a jealous wife who is constantly humiliated.

The king of the gods is often depicted as an impressive, bearded man. He may hold lightning bolts in his hands or a scepter, and an eagle is usually at his side.

Greek Name
Zeus

Relatives and Mythic Origins
Son of Saturn and Cybele

Characteristics and Activity
Lord of heaven and king of the gods, supreme judge in human and divine matters

Special Devotions
Worshipped in all the main Greek and Roman cities

Related Myths
The stories of Callisto, Danae, Europa, Io, Latona, Leda, Semele, Proserpina, and many other divine and human female characters are linked to Jupiter

Andrea Appiani, ▲
Olympus (The Crowning of Jupiter) (detail), 1806. Milan, Pinacoteca di Brera.

Jean Raon ◄
(from a model attributed to him), *Jupiter*, 1660–80. Los Angeles, The J. Paul Getty Museum.

Pouring water from an urn is a symbol for the spirit of the river, who is generally portrayed as a god with shrubs for hair. In this case it is a goddess, and therefore a nymph of the spring.

A nymph gathers honey from the trunk of a tree to feed little Jupiter.

The goat that Jupiter suckles is Amalthea, who at times is described as a nymph.

▲ Nicolas Poussin, *The Nurture of Jupiter,* circa 1636. London, Dulwich Picture Gallery.

The lion skin, together with a club, suggests that this standing god is Hercules.

Lightning bolts identify Jupiter. The Cyclopes gave them to him after he freed them from Tartarus, where Saturn had imprisoned them.

The god with a helmet and spear is Mars, the god of war.

Venus is shown nude, surrounded by cherubs.

A crown of grape vines is an attribute of Bacchus, the god of wine.

A winged cap is a distinctive characteristic of Mercury.

The eagle is a symbol of Jupiter.

The peacock is one of Juno's emblems.

The Titans, children of the earth, rebel against the gods and are defeated by Jupiter with the help of Hercules and Minerva.

▲ Perino del Vaga, *Jupiter Destroys the Titans*, 1531–33. Genoa, Palazzo Doria di Fassolo.

The man with two heads is
Janus Bifrons—the "two-
headed"—generally considered
the gatekeeper of heaven.

Mars, the god
of war, is
dressed as a
warrior with a
spear in hand
and a shield at
his feet.

The caduceus is
one of Mercury's
symbols. One
day the god saw
two snakes fight-
ing and used a
stick that Apollo
had given him to
separate them.
They coiled
around it and
stayed attached
there forever.

The club is one of Hercules'
distinguishing signs.

▲ Raphael, *Council of the Gods*,
1515–17. Rome, Villa Farnesina.

The trident is a symbol of Neptune, the god of the sea.

In line with tradition, Venus is only partly dressed and accompanied by Cupid.

The crescent moon is an attribute of Diana, the goddess of the hunt.

The warrior goddess wearing a helmet is Minerva.

The peacock is one of Juno's symbols. She is Jupiter's sister and wife.

The three-headed dog is Cerberus, guard dog of Hades and symbol of Pluto, god of the Underworld.

The eagle distinguishes the king of the gods.

The winged child is Cupid, son of Venus.

143

This scepter is a symbol of Juno.

Jupiter can be holding lightning bolts in his hand or, in this case, a scepter, an emblem of his power.

The eagle is a symbol of Jupiter. This bird has always been held to be the king of birds and has become a sign of the power of nobility for its special traits: its acute vision and ability to withstand the intensity of the sun's rays.

▼ Jean-Auguste-Dominique Ingres, *Jupiter and Thetis*, 1811. Aix-en-Provence, Musée Granet.

Latona is often shown transforming peasants who had ridiculed her into frogs; her two children, Apollo and Diana, are at her side.

Latona

Different versions of myths are told regarding Latona, mother of Apollo and Diana. Artists most often illustrated episodes taken from Ovid's *Metamorphoses*, especially during the seventeenth century.

Jupiter's love for Latona unleashes Juno's wrath against the goddess, and Juno ceaselessly persecutes her. While wandering from one place to another to flee the torments inflicted by the mother of the gods, Latona, exhausted and parched, reaches Lycia and sees a tiny lake in the distance. Drawing near, she is prevented by a number of working peasants from refreshing

Greek Name
Leto

Relatives and Mythic Origins
Daughter of Titans
Coeus and Phoebe

Characteristics and Activity
A Titan and mother of
Apollo and Diana

Special Devotions
Delos, where Apollo
and Diana were born,
became the main
center of worship
for the goddess

herself despite her continued pleas. Not satisfied, they spoil her chances further by paddling in and stirring up the waters, making them muddy. Latona punishes their impudence by changing them into frogs.

Latona is often portrayed together with her two tiny children near a lake. The peasants, who are about to change into frogs, are a short distance away. Sometimes these characters are confused with actual depictions of frogs in a work, which obviously just refer to the episode.

Cecco Bravo, ◀ ▲
*Latona and the Peasants
of Lycia* (details), circa
1640. From a private
collection.

Ever since antiquity, parrots have been a symbol of those who speak inutilely, such as these peasants who ridicule Latona.

Latona punishes the peasants by transforming them into frogs. This prevents them from quenching their thirst because they would never want to see themselves in a mirror of water.

The crescent moon is a symbol of Diana, shown here as a child next to her mother.

▲ Anton Maria Vassallo, *The Fable of Latona*. Genoa, Palazzo Reale.

Leda is commonly portrayed embracing a swan, a disguise of Jupiter, who attempts to seduce her. The eggs that rest at her feet, from which Castor and Pollux are born, are a fruit of her union with Jupiter.

Leda

Leda is usually considered the daughter of King Thestius of Aetolia and Eurythemis. She marries Tyndareus, king of Sparta, and after they are expelled from his kingdom, they find refuge at her father's court. One day Jupiter discovers Leda bathing in a river and falls in love with her, appearing to her in the form of a swan. Two eggs hatch from their union; Castor and Pollux, the famous twins called the Dioscuri, are born from the first, and Helen and Clytemnestra are born from the second. Other versions of the myth, instead, tell how only Castor and Pollux are born from Jupiter and Leda, while Helen and Clytemnestra are born from Leda and Tyndareus, implying they are mortal.

In traditional imagery Leda is often shown standing as she embraces a swan beside her. She faces away from the swan as a sign of bashful modesty. The eggs that the twins will be born from are at her feet. The young woman can also appear lying on a soft pallet hugging the swan.

Greek Name
Leda

Relatives and Mythic Origins
According to the most common tradition, daughter of Eurythemis and Thestius, king of Aetolia

Characteristics and Activity
Loved by Jupiter, who disguised himself as a swan

Related Myths
The abduction of Helen, Leda's daughter, was a cause of the Trojan War

Ridolfo Ghirlandaio, ▲
Leda, 1557–65. Rome,
Galleria Borghese.

Cesare da Sesto, ◄
Leda and the Swan,
after 1515. Salisbury,
Wilton House.

Mars

Greek Name
Ares

**Relatives and
Mythic Origins**
One of the twelve gods
of Olympus, son of
Jupiter and Juno

**Characteristics
and Activity**
God of war

Special Devotions
In Rome he was con-
sidered the father of
Romulus and Remus,
and festivals in his
honor were celebrated
there in March and
October

Related Myths
Venus loves Mars;
Vulcan discovers the
two lovers; Mars
punishes Cupid, who
instilled passion in
him for Venus

*The god of war is usually depicted as a virile youth or man. His
symbols are the helmet and shield or, in traditional works, a
spear, sword, or halberd.*

The aggressive and violent character of Mars, the god of war,
makes him quite unpopular with the rest of the gods, including
Jupiter and Juno, his parents. Most of the myths in which he
appears are linked to battles. However, Mars is not always
the victor, and he is often bested by Minerva's wisdom. In the
Renaissance the image of the two gods together became an alle-
gory of wisdom, a virtue that conquers the destructive violence
of war by using arms to keep peace. Only Venus falls in love
with the god, and the episode of the two lovers being caught in
Vulcan's net is one of the most famous. Mars and Venus are
often shown together with Cupid, and such images have been
interpreted by some as an allegory of the warrior spirit being
won over by love.

Mars does not have consistent features; he
appears sometimes as a young man and other
times as a mature, virile one. He usually
wears a helmet and holds a shield and
spear—or a sword—yet rarely wears a
breastplate. His sacred animal is the
wolf, which often appears at his side.

▲ Lambert Sustris,
*Venus with Cupid
and Mars,* circa
1540. Paris, Musée
du Louvre.

◀ Diego Velázquez, *Mars,* circa 1640.
Madrid, Prado.

Swans are a symbol of Venus;
either swans or doves can pull
her carriage.

Roses also
symbolize
the goddess.

The enchanted warrior in front of
Venus is Mars, who, according to the
code of courtly love, is portrayed
kneeling at the lady's feet.

▲ Francesco del Cossa, *April*, 1469–70.
Ferrara, Palazzo Schifanoia, Hall of the
Months.

Here Venus is portrayed as a young bride dressed elegantly according to Renaissance custom. The image of Venus opposite Mars alludes to the power of love over violence and war.

The helmet on the head of the satyr child is a symbol of Mars, who has fallen asleep under Venus's gaze.

▲ Sandro Botticelli, *Venus and Mars*, circa 1483. London, National Gallery.

The armor that the satyr child pops out of is another attribute of Mars.

Mars

Mars is in full armor.

The child shooting an arrow is Cupid, who is commonly held to be the offspring of Venus and Mars.

According to Renaissance mythographers, Venus is shown nude either because those who dedicate themselves to pleasure often lose their riches or because love affairs are soon unveiled.

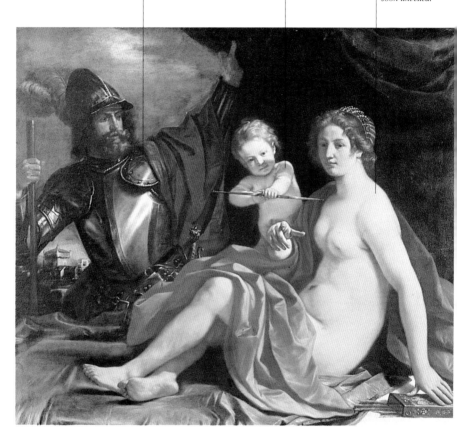

▲ Il Guercino, *Venus, Mars, and Cupid,* 1633. Cento, Pinacoteca Civica.

► Costantino Cedini, *Venus and Mars Surprised in the Net.* Padova, Palazzo Emo Capodilista.

Vulcan made the
net that these
cherubs are hold-
ing to ambush
Venus and Mars
and unmask their
hidden love.

The dove is
one of Venus's
symbols.

The shield is
an emblem
of Mars.

*He is portrayed either competing with Apollo or being flayed
alive by the god himself. In the scene of his punishment,
Marsyas is shown hanging upside down from a tree.*

Marsyas

Greek Name
Marsyas

**Relatives and
Mythic Origins**
Son of Olympus

**Characteristics
and Activity**
A satyr commonly held
to be the inventor of
music for the oboe or
other double-reed
instruments

Apollo, the god of music, is offended by the arrogance
of Marsyas, who boasts of being an excellent reed
player. The god challenges the satyr to a musical con-
test, the winner of which can do whatever he pleases to
the loser. The Muses judge Apollo victorious, and the god pun-
ishes Marsyas's insolence cruelly, tying the satyr to a tree and
skinning him alive. Some versions of the myth say that Apollo
regrets his excessive anger and destroys the instrument that he
used to defeat his opponent.

The musical contest and Marsyas's punishment are usually
shown separately. In the first episode, Marsyas plays the oboe
while Apollo watches in silence, or Apollo plays while the satyr
looks on. Sometimes a panpipe or another wind instrument is
substituted for the satyr's oboe. Due to the fact that ever since
antiquity the flute had been thought to unleash the passions
while the lyre uplifted the spirit, the episode can be interpreted
allegorically as the conflict between emotion and reason. In the
punishment scene,
Marsyas appears hang-
ing upside down as
Apollo prepares to flay
him. The god can be
alone or with others.

▲ Luca Giordano, *Apollo and
Marsyas* (detail), circa 1670.
Naples, Capodimonte.

▶ Perugino, *Apollo and Marsyas*,
1483. Paris, Musée du Louvre.

This playing figure has been identified either as Apollo or Orpheus.

Here the double-reed instrument of Marsyas has been replaced by a syrinx, or panpipe.

Satyrs are part human and part animal and live in the forest. They especially like sensual pleasure and wine.

The laurel crown is an emblem of Apollo.

Being tied upside down to a tree is a typical representation of Marsyas's punishment.

The thinking man sitting is perhaps Midas, who judged another of Apollo's contests. The myth of Marsyas is often mistaken for that of Midas; they are confused because of their similarities.

Titian, *The Flaying of Marsyas*, 1570–76.
Kromeriz, Archiepiscopal Museum.

Medea

Greek Name
Medea

Relatives and Mythic Origins
Daughter of Aeetes, king of Colchis; grand-daughter of Sol

Characteristics and Activity
Magician wife of Jason, he rejected her in favor of Glauce

Related Myths
Medea helps Jason capture the Golden Fleece, plots and kills Jason's uncle Pelias, and restores Jason's father, Aeson, to youth

Medea, the daughter of King Aeetes of Colchis and grand-daughter of the sun god Sol, is commonly held to be an enchantress. Mythological tradition recalls Medea as the jealous and proud wife of Jason, who led the Argonauts; she runs away with him after helping him capture the Golden Fleece. Later on, Jason deserts her in order to marry Glauce, or Creusa, the daughter of the king of Corinth. Medea gets her revenge by killing her rival (she gives her a burning wedding dress) and then her own children.

The character of Medea has always fascinated artists, especially because she is a sorceress. They often dwell on the episode when she restores Aeson, Jason's father, to youth or as she kills Pelias using his own daughters (she convinces them that she will restore his youth if they tear him to pieces so she can extract his blood). Medea is often shown next to a smoking cauldron while Aeson rests nearby or as she watches Pelias's daughters slaughter their father. At times Medea appears alone as she creates her spells, in a chariot pulled by dragons, or in the act of slaying her children.

▲ Ludovico Carracci, *The Enchantments of Medea* (detail), 1584. Bologna, Palazzo Fava.

► Eugène Delacroix, *The Fury of Medea*, 1838. Lille, Musée des beaux-arts.

This is the Argonauts' ship; it was named the Argo after its builder, Argus.

The famous Golden Fleece is hanging from the tree with the ram's head showing. This was the fleece of the ram that Phrixus and Helle used to flee from their stepmother Ino's plot to kill Phrixus.

This coral, which was formed from the dripping blood of Medusa, is considered a good-luck charm.

▲ Anthony Sandys, *Medea*, 1868. Birmingham, Museum and Art Gallery.

Medea prepares to put her magic into action.

Standing before the altar of Hecate, goddess of the Underworld, and Hebe, goddess of eternal youth, Medea lights the sacrificial fire.

This cauldron is where Medea will prepare the magic potion that will replace Aeson's blood, giving him back his youth.

Under Medea's direction, Aeson is brought nude to the altar.

Dragons pull Medea's carriage.

Medea is preparing her enchantments that will restore Aeson, Jason's father, to his lost youth. This scene is described in detail in Book VII of Ovid's Metamorphoses.

▲ Ludovico Carracci, *The Enchantments of Medea*, 1584. Bologna, Palazzo Fava.

A frightening creature for humans and gods alike, Medusa usually appears as a monster with a human head, snake hair, bronze hands, and golden wings.

Medusa

Medusa is often called the Gorgon, yet she is actually one of three famous Gorgons, daughters of Phorcys and Ceto, and the only mortal among them. The ancients describe them as monsters with hissing snakes on their heads, bronze hands, and golden wings. Their terrifying gaze is so powerful that whoever looks on them immediately turns to stone. Thanks to Mercury and Minerva's help, Perseus is able to find Medusa's lair and slay her. Pegasus, the famous winged horse, and the giant Chrysaor are born from her severed head. The myth also tells how, even after being detached from her body, Medusa's head still kept its peculiar ability to turn whoever looked at it to stone. Perseus gives the head to Minerva, who places it on her breastplate or, according to later versions, her shield. Ovid also recounts how coral was born from Medusa's blood.

Regarding her symbolic representation, artists—especially those from the Baroque period—primarily depicted Medusa's head, at times by itself, at times being held by Perseus as a sign of victory.

Greek Name
Medusa

Relatives and Mythic Origins
Daughter of sea gods Phorcys and Ceto

Characteristics and Activity
A monster feared by gods and humans; she is so hideous to behold that whoever looks at her turns to stone

Related Myths
Perseus, the legendary Argive hero, destroys Medusa thanks to the help of Mercury and Minerva; Perseus slays Phineus by turning him to stone; Bellerophon kills the Chimaera with the help of Pegasus

Caravaggio, ▲
Medusa, circa 1596–98.
Florence, Uffizi.

Peter Paul Rubens, ◄
Head of Medusa, circa
1617–18. Vienna,
Kunsthistorisches Museum.

The head of Medusa rests on tiny branches that Perseus found in the water. Ovid recounts how these sticks, which were immersed in Medusa's blood, became hardened and red in color.

The winged horse is Pegasus, who was born from Medusa's severed head.

The winged cap, or petasus, is one of Mercury's symbols.

The sea nymphs gather the twigs and multiply them, throwing them back into the water. This was how coral was born.

▲ Scarsellino, *The Discovery of Coral*, circa 1590. London, Matthensen Gallery.

A young hunter, this hero is often identified by the presence of a boar. Atalanta appears with him, and Meleager offers her the boar's hide as a gift.

Meleager

Meleager's father, Oeneus, offers sacrifices to the gods in thanksgiving for a good harvest but forgets to honor Diana. The goddess is offended and sends a ferocious wild boar to terrorize the region. Atalanta is among the most courageous heroes of the time that Meleager calls on to help him rid the kingdom of the devastating creature. Meleager is in love with her, and after he kills the beast he offers her its hide as a gift.

The hunt is one of the most often illustrated. The boar is typically at the base of a tree, threatening as hunters surround it. Atalanta shoots her bow and Meleager is about to strike the animal. The episode of Meleager giving the beast's hide to Atalanta is also often rendered, and a cherub is frequently included in the scene. This myth can also be a context for landscape paintings.

Greek Name
Meleager

Relatives and Mythic Origins
Son of Althaea and Oeneus, king of Calydon

Characteristics and Activity
Slays the boar that terrorizes Calydon

Domenico ◀
Antonio Vaccaro,
Meleager Kills the Boar,
circa 1700. Neuilly, The
Riechers Collection.

Appearing as an athletic youth, the messenger of the gods wears a winged cap called a petasus and winged shoes. He holds a caduceus.

Mercury

Greek Name
Hermes

Relatives and Mythic Origins
One of the twelve gods of Olympus; son of Jupiter and Maia

Characteristics and Activity
Traditionally considered the messenger of the gods and protector of commerce and wayfarers

Special Devotions
The worship of Hermes spread from Arcadia to all of Greece; in Rome the God was celebrated each year in May

Related Myths
Conducts Juno, Venus, and Minerva before Paris; frees Io from Argus; brings Proserpina back to Ceres; and guides Pandora to earth

The son of Jupiter and Maia, Mercury is an extraordinarily precocious child. As soon as he is born, he frees himself from his swaddling clothes and steals the bulls of Admetus that Apollo is guarding. The sun god later leaves the bulls to Mercury in exchange for the lyre that the clever child has made out of a tortoise shell. From then on, Apollo becomes the god of music. Jupiter, struck by Mercury's surprising energy, appoints him messenger of the gods. In many myths Mercury appears as message bearer to both gods and humans.

Mercury is generally portrayed as a young athlete; his attributes include winged shoes, which allow him to move extremely quickly, and a winged cap called a petasus. He brandishes a caduceus, a rod with two snakes coiled around it that sometimes has wings. It has the power to put people to sleep. From an allegoric point of view, Mercury is the educator, and he instructs Cupid. He is reason and eloquence.

▲ Giambologna, *Mercury,* from the seventeenth century. Venice, Ca' d'Oro.

◄ Sandro Botticelli, *La Primavera* (detail), circa 1482–83. Florence, Uffizi.

The winged cap, called a petasus, is
one of Mercury's symbols. The
messenger of the gods is stealing
bulls that Apollo is guarding.

A violin or another stringed
instrument can often substitute for
the lyre as an emblem of Apollo.

The bulls that Apollo is guarding belong
to Admetus, king of Thessaly. The god,
in fact, served the king for a whole year
as cattle herder in order to atone for
offending Jupiter.

▲ Claude Lorrain, *Landscape with
Apollo Guarding the Herds of Admetus*,
645. Rome, Galleria Doria Pamphili.

Lightning bolts are a symbol of Jupiter.
The Cyclopes, in gratitude for having
been set free, gave them to him.

The winged hat, or petasus, is one
of Mercury's symbols. Renaissance
mythographers felt that quills should
be attributed to Mercury, since words
can fly through the air as though they
had wings.

Wings, which allow Mercury to move
rapidly, are one of the god's distinctive
signs. The chemical element mercury
was given its name because of its
ability to flow swiftly.

The caduceus is another emblem of
Mercury. The myth tells how he placed
a rod between two fighting snakes, which
coiled around it.

▲ Dosso Dossi, *Jupiter, Mercury, and*
Virtue, circa 1522–24. Vienna,
Kunsthistorisches Museum.

► Jean-Baptiste-Marie Pierre, *Mercury*
Turning Agraulos to Stone, 176
Paris, Musée du Louvr

Here the caduceus appears to identify
Mercury. The god is working magic:
Agraulos, Herse's sister, is trans-
formed into a statue because she is
envious and tries to stop the god
from joining her sister.

This young woman is Herse, one
of the daughters of King Cercops
of Athens. Mercury falls in love
with her. She does not have any
identifying characteristics here, but
her identity can be assumed after
analyzing this scene.

Mercury wears the petasus,
his characteristic winged hat.

Agraulos is changed into a dark-colored
statue—not a white one—since envious
thoughts are dark ones.

Midas

Midas is usually depicted on his knees before Bacchus or bathing in the river Pactolus. Other times he is shown with donkey ears, which Apollo gave him as punishment.

Greek Name
Midas

Relatives and Mythic Origins
Son of the goddess Cybele and Gordius; king of Phrygia

Characteristics and Activity
Remembered most of all as the famous king who asked that everything he touch be turned to gold; he is also a judge of the contest between Pan and Apollo

In order to thank Midas for bringing back the lost Silenus, Bacchus grants the king of Phrygia one wish. Midas requests that anything he touch turn to gold, but he soon realizes his mistake when even his food turns into the precious metal. Frantic, the king begs Bacchus to free him from the spell, and the god of wine takes pity on him, ordering him to bathe in a spring of the Pactolus River. This frees him from the insidious power.

The Phrygian king is usually shown on bended knee thanking Bacchus or bathing in the Pactolus with the god of wine watching. Silenus can also appear nearby. In other instances, artists depict Midas with donkey ears standing between Pan and Apollo, evoking another legend that features the king. Midas, in fact, judges a musical contest between the two. The mountain god Tmolus, the referee of the contest, awards Apollo the victory, yet Midas honestly prefers Pan. To punish him for such impertinence, Apollo makes the king's ears grow into a donkey's.

▲ Domenichino and students, *The Judgment of Midas* (detail), 1616–18. London, National Gallery.

▶ Cima da Conegliano, *Apollo and Marsyas*, circa 1510. Parma, Galleria Nazionale.

166

This old man who sleeps with a mug in hand is Silenus, Bacchus's teacher. He is typically portrayed as a flabby, bald man who is always drunk.

The crown of vine branches is one of the symbols of Bacchus, the god of wine.

The crown on this man before Bacchus suggests this is King Midas. The king is thanking the god of wine for freeing him from the curse of transforming anything he touches into gold.

Midas bathes in a spring of the river Pactolus to lose his fatal power.

The leopard is one of Bacchus's attributes and represents the spread of his cult to Asia Minor. According to the Renaissance mythographers, however, tigers symbolized the aggression that wine can bring out in people.

▲ Nicolas Poussin, *Midas and Bacchus*, circa 1629–30. Munich, Alte Pinakothek.

Midas

*The laurel
crown
identifies
Apollo.*

*This character,
half man and
half animal
with horns
and pointed
ears, is Pan,
god of flocks
and shepherds.*

*Pan is considered the inventor of the
syrinx, a wind instrument made by
joining reeds together side by side. The
nymph Syrinx, whom Pan loved, was
changed into these reeds.*

*The lyre is another emblem of
Apollo, who in addition to being
the sun god is also the god of music.*

▲ Domenichino and students, *The
Judgment of Midas*, 1616–18. London,
National Gallery.

168

Goddess of wisdom, Minerva appears dressed as a warrior, wearing a helmet, shield, and breastplate. The sacred animal of the goddess is a symbol of wisdom, the owl.

Minerva

Minerva, the warrior goddess, is one of the most important gods of Olympus. Jupiter's daughter is born from his head—with the help of Vulcan, the god of fire—completely armed. She is a wise and crafty goddess and avoids the passions of love. She was initially considered the goddess of war but later assumed the role of protector of the arts and sciences.

After having helped Perseus slay Medusa, Minerva receives the horrible monster's head from the hero as a gift, which she places on her breastplate. The Gorgon's head later appears on her shield. As the warrior goddess, Minerva fights to maintain law and order, and because of this she often opposes Mars, the god of brutal and violent war.

She also watches over certain domestic activities, such as spinning and weaving. There is the famous episode when she changes Arachne, the spinner who dares to challenge the goddess, into a spider. Nevertheless, Minerva is primarily the goddess of wisdom, and she was revered as such by Renaissance humanists. She is primarily depicted as a woman armed with a helmet, spear, and shield. An owl, sacred bird of the goddess and symbol of wisdom, often appears with her.

Greek Name
Athena

Relatives and Mythic Origins
One of the twelve gods of Olympus; daughter of Jupiter and Metis; she is born fully armed from her father's head

Characteristics and Activity
Commonly considered the goddess of wisdom, Minerva presides over all intellectual activity

Special Devotions
Protector of the city of Athens, her worship was widespread throughout Greece; in Rome she was venerated on Capitoline hill with Jupiter and Juno

Related Myths
Minerva challenges Arachne to a weaving contest; the goddess was one of the three candidates in the Judgment of Paris; she protects Perseus and helps him slay Medusa; during the Trojan War she sides with the Achaeans; she protects Ulysses on his return home

▲ Sandro Botticelli, *Minerva and the Centaur* (detail), circa 1485. Florence, Uffizi.

◄ Rembrandt, *Athena,* circa 1655. Lisbon, Museu Calouste Gulbenkian.

169

Minerva

Minerva is shown here being born from
Jupiter's head. She is dressed as a warrior,
armed with a helmet, shield, and spear.

Together with the helmet, the spear
and shield are emblems of Minerva.
The shield is sometimes shown with
the head of Medusa on it, which
Perseus gave her as a gift.

This multibreasted
goddess is an ancient
goddess of fertility.

Lightning bolts are
symbols of Jupiter.

The hammer is one of the symbols
of Vulcan, the fire god. He helps
Jupiter give birth to Minerva by
striking the head of the immortal
king of the gods with an axe.

▲ Paolo Fiammingo, *The Birth of Athena
from the Head of Jupiter*, circa 1590.
Prague, Národní Galerie.

The shield, together with the spear, is an emblem of Minerva.

The helmet is a symbol of Minerva.

The winged cap, called a petasus, is one of Mercury's symbols.

The caduceus identifies Mercury. When brandished, this rod halts any disagreement.

Some see the rooster as a symbol of Minerva, since a wise person must always be vigilant.

The owl, sign of wisdom, is a symbol of Minerva. Sometimes this bird appears on a pile of books, representing knowledge.

Winged feet are also attributes of Mercury, the messenger of the gods.

Bartholomeus Spranger, *Mercury and Minerva*, circa 1585. Prague Castle, White Tower.

The shield and
spear identify
Minerva.

The female
character being
transformed
into a tree is
Daphne, who
was able to
evade Apollo's
advances
thanks to this
metamorphosis.

The helmet is
one of the
emblems of
Minerva, who
is ejecting the
Vices from the
garden of the
Virtues.

▲ Andrea Mantegna, *Allegory of Vice
and Virtue*, circa 1499–1502. Paris, Musée
du Louvre.

The figure
without arms is
an image of
Idleness.

Sloth is portr…
as a female
character, tou…
Idleness by a …

The figure holding the sword is Justice, one of the four cardinal virtues.

The female figure wearing Hercules' lion skin and holding his club while holding a column in her other hand is Fortitude, another cardinal virtue.

The character with two pitchers is Temperance, yet another cardinal virtue. Someone who does not excessively drink is temperate, and this Virtue pours one pitcher into another, mixing water with wine.

The crowned figure personifies Ignorance, who is carried by Avarice and Ingratitude.

The character with monkey traits is immortal Hate.

This half-dressed woman being carried by a Centaur is Venus, who in this case personifies lust.

This figure that is half man and half animal is a Centaur, a symbol of lust.

Here the halberd has replaced the spear as a symbol of Minerva. The artist has set this scene in his own period.

In this context, Minerva represents wisdom prevailing over ignorance, also personified by the Centaur.

▲ Sandro Botticelli, *Minerva and the Centaur*, circa 1485. Florence, Uffizi.

The sumptuous clothing that Minerva is about to put on recalls her role as goddess. She is protector of the arts and industry, including weaving.

In portraying Minerva nude, perhaps the artist intended to accent the goddess's femininity, which is usually hidden by armor, and allude to her chastity.

The owl is a sign of wisdom and is a sacred bird of Minerva.

Lavinia Fontana, *Minerva Dressing,* 1613. Rome, Galleria Borghese.

The cherub is playing with a helmet, a symbol of Minerva.

The Minotaur is a monstrous being with the head of a bull and a human body. It typically appears with Theseus, the hero who defeats it with the help of Ariadne.

Minotaur

Greek Name
Minotaur

Relatives and Mythic Origins
Son of Pasiphae, wife of Minos, and a bull sent by Neptune

Characteristics and Activity
Seven Athenian youths and seven maidens were sacrificed to this horrible monster each year

Related Myths
Daedalus is locked in the Labyrinth and escapes with Icarus

The Minotaur, the legendary monster with a bull's head and a human body, is the offspring of Pasiphae, the wife of King Minos of Crete, and a bull sent by Neptune. Instead of sacrificing the bull to the god, the king keeps it for his own herds. As punishment for such an insult, Neptune makes Pasiphae fall in love with the animal. Hidden inside a fake cow that Daedalus makes for her, the queen comes together with the bull and later gives birth to the terrible Minotaur. Minos, frightened by the hideous creature, commissions Daedalus to build the Labyrinth, an immense building with an intricate web of halls and rooms. He then locks the Minotaur inside, and every year (or every three or nine years, depending on the version) seven young men and seven maidens from Athens are handed over to the creature as sacrifice.

Theseus, the son of the Athenian king Aegeus, comes forward to slay the monster. Ariadne, Minos's daughter, falls in love with the hero and gives him a ball of thread that the hero unravels in the Labyrinth to help him exit.

The Minotaur is traditionally represented as a being that is half bull and half human. It is associated with Theseus, who either challenges it or stands next to its fallen body.

▲ Antonio Canova,
Theseus on the Minotaur
(detail), 1781–83. London,
Victoria and Albert Museum.

► George Frederick Watts,
The Minotaur, 1885.
London, Tate Gallery.

The emblems of the Muses, the nine sisters who preside over artistic inspiration, are trumpet, tablet, and stylus (Calliope); books, scroll, and trumpet (Cleio); musical instruments (Polyhymnia); flute or other instruments (Euterpe); lyre or other stringed instruments (Terpsichore); stringed instruments and tambourine (Erato); tragic mask, horn (Melpomene); scroll, mask, crown of ivy, staff (Thalia); and globe or compass (Urania).

Muses

The Muses are the daughters of Jupiter and Mnemosyne, or Memory, who watch over poetic inspiration and all intellectual activity. They are also considered goddesses of song and are linked to Apollo, the god of music, who directs them in chorus. In the Classical period there were nine: Calliope, epic poetry; Cleio, history; Polyhymnia, heroic hymns; Euterpe, lyric poetry; Terpsichore, dance; Erato, romantic poetry; Melpomene, tragedy; Thalia, comedy and idyllic poetry; and Urania, astronomy.

They are often shown without any particular attributes, holding hands. According to Renaissance mythologists, this symbolizes how closely connected the sciences and liberal arts are. Traditional representations of the Muses are based on the writings of Fabius Fulgentius, a Christian author who wrote that the goddesses correspond to nine divisions of human knowledge.

Greek Name
Muses

Relatives and Mythic Origins
Daughters of Jupiter and Mnemosyne

Characteristics and Activity
They preside over artistic inspiration

Raphael, ▲ *Parnassus* (detail), 1508. Vatican City, Palazzi Vaticani.

Andrea Mantegna, ▼ *Mars and Venus (Parnassus)*, 1497. Paris, Musée du Louvre.

Muses

This thoughtful young woman is
Melpomene, whom Fulgentius
considered constant meditation.

According to
Fulgentius, Thalia
symbolizes the
ability to reap
what is learned.

This beautiful girl
is Euterpe, who
represents joy for
Fulgentius, a state
of being that is
indispensable in
order to learn.

▲ Raphael, *Parnassus* (detail), 1508.
Vatican City, Palazzi Vaticani.

The "tube of fame" is
one of the attributes of
Cleio, who, according to
Fulgentius, represents the
desire to learn doctrine.

The book can be a symbol of Polyhymnia. According to Fulgentius, this goddess was assigned the task of keeping everything learned in memory.

The pointing Muse is Terpsichore. In Fulgentius's view, she had the task of judging a work's artistic component.

Urania is the Muse with her back turned. She chooses the best of the poets climbing up the hill. In fact, according to Fulgentius, she is the Muse destined to choose the best of human works of human ingenuity.

The mask alludes to the human ability to create after being inspired by learning. According to the Christian writer Fulgentius, this would be the Muse Erato.

This stringed instrument, which belongs to the violin family, can sometimes replace the lyre as a symbol of Apollo. Cosmic harmony emerges from the sound of the god playing the lyre. This harmony symbolizes the creative abilities of humans, and the Muses are the personifications of these talents.

The seven-string lyre evokes heavenly harmony, which poetry tends toward. The instrument is in Calliope's hands. She is the Muse who, according to Fulgentius's theory, has the task of offering Apollo the best products of knowledge.

Narcissus

Narcissus is often depicted pining for his reflection in a pool of water. The flower that carries his name is beside him.

The myth of Narcissus is told in a variety of ways. The most famous is by Ovid in his *Metamorphoses*.

Narcissus is a youth of incomparable beauty who is sought after by young men and women alike. He does not care at all, however, preferring to spend his days in solitude hunting. The nymph Echo, condemned by Juno to repeat only the last words she hears, falls in love with Narcissus, but he refuses her. She takes shelter in the forest, so consumed by her unrequited love that eventually only her voice remains. She begs the gods to punish the young man for not returning her love, and Nemesis, the god of revenge, hears her plea and grants her wish. One day Narcissus is tired after a hunt and stops near a spring to refresh himself. As soon as he sees his reflection, he falls in love with it. Uselessly pining for his love, Narcissus wastes away, completing Echo's revenge. His body disappears, and a flower with his name takes its place.

Narcissus is frequently portrayed watching his reflection in a pond or spring. The flower that shares his name can be pictured nearby. Echo, too, can sometimes be seen.

Greek Name
Narcissus

Relatives and Mythic Origins
According to Ovid, Narcissus is the son of the river god Cephisus and the nymph Leiriope

Characteristics and Activity
A beautiful youth who falls in love with his own reflection

▶ Caravaggio, *Narcissus*, 1599–1600. Rome, Galleria Nazionale d'Arte Antica, Palazzo Corsini.

*This almost transparent girl lean-
ing on a rock is Echo. The myth
tells how, when Juno searches for
Jupiter—who cheats on her with
nymphs—Echo detains her with
useless words, allowing the lovers
to escape. As a result, Juno con-
demns her to repeat only the last
words she has heard.*

*The torch that the cherub holds recalls
Narcissus's death. Torches were used to
illuminate funeral processions and light
funeral pyres.*

*The flowers
allude to
Narcissus's
eventual
transformation.*

*Narcissus lies
lifeless next to
the spring.*

▲ Nicolas Poussin, *Echo and Narcissus*,
1625–27. Paris, Musée du Louvre.

Neptune resembles an old man with a beard and long hair and typically holds a trident; he rides on a conch shell pulled by either horses or dolphins.

Neptune

Greek Name
Poseidon

**Relatives and
Mythic Origins**
One of the twelve gods
of Olympus; son of
Saturn and Cybele;
Jupiter's brother

**Characteristics
and Activity**
God of the sea

Special Devotions
Each year in July the
Neptunalia was cele-
brated in Rome; during
the Imperial period
sporting contests were
added to the festival,
including sea battles
and horse races

Related Myths
The Cyclops killed by
Perseus, Polyphemus,
is the son of Poseidon
and a nymph; during
the Trojan War,
Neptune intervenes
to favor the Achaeans;
when Aeneas flees
Troy, Neptune halts
the storm that
Aeolus—the god
of the winds—has
created at Juno's
request

Neptune, the god of the sea, has the ability to unleash violent storms or calm them. Sailors invoke his protection to guarantee safe voyages. Tradition holds that the god has a number of lovers, although sometimes evil divinities can spring from these unions. In certain tales, Neptune and Medusa come together and generate the famous winged horse Pegasus and the giant Chrysaor. The god's official partner, instead, is Amphitrite, a Nereid who first flees from him, but whom he later persuades to be his wife.

The god of the sea is frequently portrayed with a long beard and flowing hair. He holds a trident with points that are sometimes hooked. His carriage is usually made of a huge conch shell pulled by dolphins or sea-horses. Sometimes he is shown riding a dolphin. His image is often linked with Amphitrite in the so-called "triumph of Neptune," where she is at his side riding a dolphin or sitting on a shell pulled by sea creatures. Neptune rests in his own carriage nearby, and their court of sea divinities, tritons and Nereids, usually accompanies them.

◀ Gian Lorenzo Bernini, *Neptune and Triton*, circa 1621. London, Victoria and Albert Museum.

This horn made of a conch shell is one of the attributes of tritons, sea gods who are part of Neptune's court.

The drapery that Amphitrite waves overhead is typical of sea divinities from antiquity. It is generally considered a symbol of Aura, the goddess of breezes.

The cherubs shooting arrows allude to the amorous nature of the scene.

The trident is a symbol of Neptune.

Hippocampi, mythical creatures that are part horse and part fish, pull Neptune's carriage.

▲ Felice Giani, *The Marriage of Neptune and Amphitrite*, 1802–5. Faenza, Palazzo Milzetti.

Niobe

Greek Name
Niobe

**Relatives and
Mythic Origins**
Daughter of Tantalus
and wife of Amphion,
king of Thebes

**Characteristics
and Activity**
Punished by Diana
and Apollo for having
dared to malign their
mother Latona

*Niobe is often shown panic-stricken: she raises her arms to
heaven as Apollo and Diana murder her children.*

According to the most common tradition, Niobe is the wife of
Amphion and gives birth to seven sons and seven daughters.
Proud of her numerous progeny, who are direct descendants of
the gods (Tantalus, Niobe's father, is Jupiter's son), she declares
that she is superior to Latona, mother of Apollo and Diana,
since Latona only has two children. Niobe then prohibits the
women of Thebes from honoring the goddess.

Latona's revenge is not long in coming. Diana and Apollo,
hidden by a cloud, go directly to Thebes and shoot all Niobe's
children down with arrows, one by one. Diana kills the girls
and Apollo the boys. Amphion commits suicide out of des-
peration, and Niobe, petrified by pain, is transformed into a
rock. Homer says that the Niobids, her children, lie unburied
for ten days, until the gods take pity on them and give them a
proper burial.

Artists generally illustrate the episode of Niobe's children
being slain; some of her children attempt to flee the divine
arrows, while others fall lifeless to the ground. Niobe is shown
frantic, with her arms flailing toward heaven, or weeping.
Apollo and Diana bend
their bows from a
cloud on high.

▶ Domenico Antonio Vaccaro,
Apollo Shoots Niobe's Children
(detail), circa 1700. Neuilly, The
Riechers Collection.

Niobe raises her
arms to heaven
in desperation.

The laurel crown is an
attribute of Apollo, the god
of the sun and music.

Apollo and Diana avenge
their mother by slaying
Niobe's children from a high
cloud shelf.

The quiver
and bow
are symbols
of Diana,
goddess of
the hunt.

◣ Abraham Bloemaert, *The Death of
Niobe's Children*, 1591. Copenhagen,
Statens Museum for Kunst.

Oedipus does not have any specific iconographic traits; he is usually portrayed in the presence of the Sphinx or with his daughter Antigone.

Oedipus

Greek Name
Oedipus

**Relatives and
Mythic Origins**
Son of Laius, king of
Thebes, and Jocasta

**Characteristics
and Activity**
One of the most noted
figures in mythology,
he is famous for having
solved the riddle of the
Sphinx; he also mur-
ders his father and
marries his mother

Related Myths
His daughter,
Antigone, disobeys
King Creon's orders
and buries her brother
Polyneices; for this she
is condemned to death

As an oracle predicted, Oedipus kills Laius without actually knowing the man is his father. Afterward, along the road to Thebes, he meets the famous Sphinx that Juno had sent to punish Laius. Sitting on a rock at the gate of the city, the monster forces everyone who passes to solve a riddle: which animal has four legs in the morning, two in the afternoon, and three in the evening? Whoever does not know the answer is thrown into a deep chasm. Oedipus solves the riddle: the animal is man, who during infancy crawls on all fours, walks on two legs when mature, and uses a cane in old age. After he answers, the Sphinx kills itself by jumping off the cliff. Since the grateful city is now free of the monster, Oedipus is given Queen Jocasta to be his wife; he does not know she is really his mother. The oracle, in fact, had predicted that the young man would marry his mother after killing his father. Their children are Antigone, Eteocles, Ismene, and Polyneices. After the two learn the truth, Jocasta kills herself and Oedipus blinds himself.

Oedipus is often depicted reflecting on the riddle in front of the Sphinx, which is half woman and half animal. The bones of those who were not able to solve the riddle are strewn all around.

▲ Gustave Moreau, *Oedipus and
the Sphinx* (detail), 1864. New
York, The Metropolitan Museum
of Art.

▶ Jean-Auguste-Dominique Ingres,
Oedipus and the Sphinx, 1808.
Paris, Musée du Louvre.

Olympus is found in the heavens above a thick bed of clouds. Jupiter, king of the gods, presides over the divine court there.

Mount Olympus is the highest mountain in Greece, located at the border of Macedonia and Thessaly. It was thought that its peaks reached heaven and that the gods lived there in a dwelling built by Vulcan. Ever since Homeric times, the mountain has been considered the residence of the twelve main gods: Jupiter, Juno, Mars, Mercury, Minerva, Venus, Diana, Apollo, Ceres, Neptune, Vulcan, and Vesta. A thick bed of clouds hides the doors to Olympus, making them invisible for humans. On the mountain, the divine lords come together for their banquets. Here Jupiter, the supreme judge, decides the destinies of humans and gods alike.

Olympus

Greek Name
Olympos

**Characteristics
and Activity**
A mountain in
Thessaly and home
of the Greek gods
and goddesses

Over the course of centuries, poets and artists transferred the divine dwelling into the highest heavens. The gods are portrayed in art upon a bed of clouds, gathered around Jupiter, who is preeminent on his throne. Minor gods often appear around the twelve principal deities. The subject of Olympus was quite popular with Baroque painters in decorating the vaulted ceilings of villas and residences of the nobility.

Luigi Sabatelli, ▲
Olympus, circa 1850.
Florence, Palazzo Pitti.

Antonio Maria Viani, ◄
Council of the Gods,
from the beginning of the
seventeenth century.
Mantua, Palazzo Ducale.

Olympus

The trident belongs to Neptune, god of the sea.

The eagle is Jupiter's symbol. He is king of the gods.

The scythe is an attribute of Saturn, god of time.

The lions are a symbol of Cybele, an ancient Phyrgian goddess who was considered Mother Earth.

The helmet and spear are attributes of Mars, god of war.

The lyre is one of the distinctive elements of Apollo, god of music.

The partly nude goddess is Venus, accompanied by Cupid.

Dogs are the faithful companions of Diana, goddess of the hunt.

The caduceus a symbol of Mercury, the messenger of the god.

The hammer signifies Vulcan god of fire.

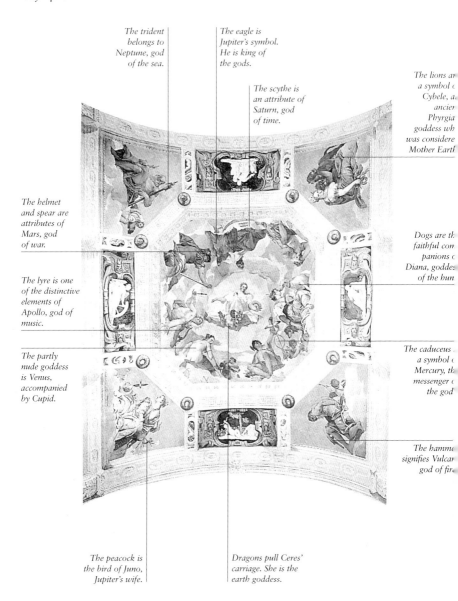

The peacock is the bird of Juno, Jupiter's wife.

Dragons pull Ceres' carriage. She is the earth goddess.

▲ Veronese, *Olympus*, 1560–61.
Maser (Treviso), Villa Barbaro.

Orpheus is portrayed as a young man crowned with laurel who plays the lyre or another stringed instrument. Numerous animals often surround him listening.

Orpheus

According to legend, Orpheus's melodious voice and music calms even the most ferocious animals or men. The most famous myth of Orpheus tells of his descent into the Underworld. When his young wife, Eurydice, dies after being bitten by a snake, Orpheus frantically decides to descend into the kingdom of the dead to search for her. He manages to move the gods of the Underworld with his extraordinary songs, and they agree to let the girl go as long as Orpheus does not try to look at her until they reach the light of the sun. Nearly there, the poet gives in to his desire to see her again and turns. Eurydice suddenly disappears into the mists of the Underworld, and Orpheus sadly returns above ground by himself. The myth tells how the poet dies at the hands of the bacchants (followers of Bacchus), although it is not clear why. According to one of the most common versions, they consider his faithfulness to Eurydice even after she dies an insult.

The poet is often depicted in the Underworld as he begs Pluto and Proserpina to give him back his beloved wife, when he is about to turn back to see Eurydice, or at the time of his death.

Greek Name
Orpheus

Relatives and Mythic Origins
Son of the river god Oeagrus and the Muse Calliope

Characteristics and Activity
Legendary singer and poet

Special Devotions
The island of Lesbos was the land of lyric poetry; an Orphic doctrine was created around the myth of Orpheus and his descent into the Underworld

Related Myths
Orpheus took part in the Argonauts' expedition

► William Blake Richmond, *Orpheus Returns from the Underworld*, 1885. London, Royal Academy of Arts.

Antonio Canova, ▲ *Orpheus* (detail), 1775–76. Venice, Museo Correr.

According to tradition, a unicorn—similar to a horse, but with a single horn on its head—can only be captured by a girl who is pure.

The lyre is a symbol of Orpheus.

The most ferocious animals become tame at the sound of Orpheus's lyre, even this lion and tiger.

▲ The Circle of Jan Brueghel, *Orpheus*, 1690–1700. Rome, Galleria Borghese.

Clotho, one of the Fates, spins the thread that measures out the length of human life.

The crowned god is Pluto, the king of the Underworld, and at his side sits Proserpina.

The violin is a symbol of Orpheus.

Atropos, another Fate, is about to cut the thread of human life.

Lachesis, here shown concentrating on spinning, is one of the three Fates, goddesses who establish the length of people's lives.

▲ Jean Raoux, *Orpheus and Eurydice,* circa 1718–20. Los Angeles, The J. Paul Getty Museum.

The ivy vine wrapped around a staff—a thyrsus—is an instrument of the bacchants. Here they are shown killing Orpheus.

The violin and bow are symbols of Orpheus.

▲ Gregorio Lazzari, *Orpheus Being Massacred by Bacchian Worshippers*, circa 1698. Venice, Ca' Rezzonico.

Pan is depicted as a partly human creature with a goatlike face and pointed ears. One of the symbols of the god is a syrinx, or panpipe, an ancient instrument made from reeds of different lengths that are linked together.

Pan

The god of shepherds, flocks, and forests, Pan spends his time hunting and playing throughout the valley of Arcadia. Travelers fear him as the forest god, since he tends to appear suddenly and terrorize them. The abrupt fear called "panic" was derived from people's reactions to this inclination of his.

The god falls in love with the nymph Syrinx, who escapes his advances by fleeing. Coming to the banks of the Ladon River, however, she realizes she cannot keep running and asks her sister Naiads to transform her. By the time Pan manages to catch the nymph, he realizes he is holding only marsh reeds. As the wind blows through the reeds, it produces a delightful sound, and the god decides to cut some and link them together to make a musical instrument. He calls it a "syrinx" in her honor.

It is also told that Pan especially favored sensual pleasure, and for this reason during the Renaissance his character was associated with lust.

In art, the god is often shown pursuing the nymph Syrinx, but, unfortunately for him, she has already reached the Ladon's banks.

Greek Name
Pan

Relatives and Mythic Origins
Commonly held to be Mercury's son

Characteristics and Activity
Shepherd god

Arnold Böcklin, ▲
Pan Whistling to a Blackbird
(detail), 1854. Hannover,
Staatsgalerie.

Annibale Carracci, ◄
Pan and Diana, circa
1597–1604. Rome,
Palazzo Farnese.

193

The image of cherubs goes back to ancient images from Greek eroticism that were incorporated into Pompeian painting.

Pan, god of the forests and shepherds, is shown with goatlike features.

Perhaps the woman lying down is Echo, the nymph whom Narcissus ignored.

The syrinx, or pan-pipe, is a symbol of the god.

▲ Dosso Dossi, *Mythological Scene,* circa 1524. Los Angeles, The J. Paul Getty Museum.

*The nymph
fleeing from Pan's
clutches is Syrinx.*

*Pan has a partly
savage face.*

▲ Jan Brueghel, copied by Peter Paul
Rubens, *Pan and Syrinx*. Milan, Pinacoteca
di Brera.

Pandora is generally shown as a young woman of rare beauty. She opens a large vase or box containing all the human calamities sent by the gods.

Pandora

In order to punish people for receiving the gift of fire from Prometheus, Jupiter orders Vulcan to mold a feminine figure who is similar to the gods and as beautiful as they are. Each god is to give her special qualities and virtues. Minerva teaches her to weave, Venus gives her beauty, and Mercury offers her eloquence and cleverness. The young woman is named Pandora, "she who has received all gifts" (or "she who carries all gifts"). The gods send Pandora as a gift to Epimetheus, Prometheus's brother, who takes her in and makes her his wife, forgetting his brother's advice not to take any gifts from Jupiter. The young girl brings with her—or, according to other versions, she finds it in the house of Epimetheus—a large box containing all the plagues of humanity. As she opens it, all the evils escape and spread throughout the world. Only hope remains inside and Pandora, by Jupiter's orders, shuts it in before it can escape.

Poets have defined this mythological episode as the end of the Golden Age.

Greek Name
Pandora

Relatives and Mythic Origins
Created by Vulcan and Minerva

Characteristics and Activity
The first woman, she is put on earth to punish men

▲ John William Waterhouse, *Pandora*, circa 1896. From a private collection.

▶ Francesco del Cairo, *Pandora*, 1640–45. Pavia, Pinacoteca Malaspina.

Pegasus, the famous winged horse, is frequently shown
together with Perseus as they free Andromeda or with
Bellerophon as he slays the Chimaera. Other times the horse
is together with Aurora.

Pegasus

According to some sources, the mythological winged
horse Pegasus is the offspring of Neptune and Medusa.
The horse is born from the Gorgon's head as she is slain
by Perseus. Later the hero rides Pegasus to save the beautiful
Andromeda from a threatening sea monster.

Pegasus is also featured in myths regarding the Corinthian
hero Bellerophon, who is able to defeat a monster called the
Chimaera thanks to the horse's help. The hero is able to mas-
ter the horse with a golden bridle he receives as a gift from
Minerva.

According to different traditions, Bellerophon finds Pegasus
near the spring Peirene, where the horse is drinking. Pindar
tells how, after the battle with the Chimaera, the hero attempts
to fly up to heaven with the horse, trying to reach Olympus.
However, Pegasus loses the hero from the saddle during the
journey and, continuing
upward toward heaven
alone, is transformed into
the constellation of the
same name.

The myth also tells how
the horse created the spring
of Hippocrene—held sacred
by the Muses—by striking
his hooves on the ground.
According to some medieval
mythographers, Pegasus is
the symbol of fame because
both are flighty.

Greek Name
Pegasos

**Relatives and
Mythic Origins**
Commonly held to
be the offspring of
Neptune and Medusa

**Characteristics
and Activity**
Helps a number of
heroes defeat monsters

Related Myths
Perseus frees
Andromeda with
the help of Pegasus;
Bellerophon slays
the Chimaera

Peter Paul Rubens, ▲
Perseus and Andromeda
(detail), circa 1622. Saint
Petersburg, Hermitage.

Andrea Mantegna, ◄
Parnassus (detail), 1497.
Paris, Musée du Louvre.

197

Pegasus

The shield is an
attribute of
Minerva.

Mercury wears
his winged cap,
called a petasus.

The caduceus
is one of
Mercury's
symbols.

Perseus holds
Pegasus, the
winged horse.

Pegasus is born
from the severed
head of Medusa.

▲ Filippo Falciatore, *The Birth of
Pegasus,* 1738. Naples, Museo Duca
di Martina.

Minerva is placing the golden bridle on Pegasus, the only thing that can control him.

The helmet is a symbol of Minerva, warrior goddess.

The head of Medusa appears on Minerva's shield. According to tradition, the goddess placed it there after receiving it as a gift from Perseus.

▲ Theodor van Thulden, *Athena and Pegasus,* 1644. Los Angeles, The J. Paul Getty Museum.

Perseus is portrayed as an armed young man who holds a curved sword that Mercury gave him; he is often wearing winged shoes or riding Pegasus.

Perseus

Greek Name
Perseus

Relatives and Mythic Origins
Son of Jupiter and Danae

Characteristics and Activity
A Greek hero famous for having destroyed Medusa and freeing Andromeda

Related Myths
Jupiter unites with Danae in the form of golden rain; Bellerophon defeats the Chimaera with the help of Pegasus

Perseus is the child of Jupiter and Danae; the king of the gods falls in love with the woman and comes together with her in the form of golden rain. Danae's father, Acrisius, whom an oracle predicted would be killed by his grandson, orders Danae and Perseus closed in a wooden chest and thrown into the sea. Reaching the island of Seriphus, the two are saved by the fisherman Dictys, who is the brother of Polydectes, the king of the island. The king falls in love with Danae, and to rid himself of the inconvenient presence of Perseus, he forces Danae's son to bring him the head of the horrible Medusa. Thanks to the help of Mercury and Minerva, Perseus is able to slay the monster. Returning from his adventure, Perseus sees Andromeda, the daughter of an Ethiopian king, chained to a cliff as a sacrifice to a sea monster. He falls in love with her and defeats the beast. After eliminating another suitor, Phineus, by turning him and his companions to stone, Perseus marries Andromeda.

The scene of Minerva and Mercury arming Perseus is often illustrated in traditional imagery. Nevertheless, the episode of Perseus freeing Andromeda is the scene that has primarily captured artists' imagination.

▲ Luca Giordano,
Perseus Battles Phineus and His Companions
(detail), circa 1680. London, National Gallery.

▶ Antonio Canova, *Perseus with the Head of Medusa,* 1797–1801. Possagno, Gipsoteca Canoviana.

The inhabitants
of Seriphus
discover Danae
and Perseus.

Danae and Perseus are
placed in a trunk and
thrown into the sea
according to King
Acrisius's orders.

Giacomo Berger, *Danae and the Child
Perseus Rescued Near the Island of
Seriphus,* 1805–6. Milan, Pinacoteca
di Brera.

Perseus is often
portrayed either
completely
armed or in a
short tunic.

Mercury places the
winged cap on Perseus.

The helmet
identifies
Minerva.

Minerva arms
Perseus.

▲ Paris Bordone, *Perseus Armed by
Mercury and Minerva*, 1540–45.
Birmingham, Museum of Art.

Medusa's head is literally petrifying; it has the power to turn whoever looks at it to stone.

Phineus's companions are changed to statues.

Perseus displays Medusa's head to defend himself against the companions of Phineus, one of Andromeda's suitors.

▲ Luca Giordano, *Perseus Battles Phineus and His Companions*, circa 1680. London, National Gallery.

Perseus brandishes a curved sword
that Mercury gave him as a gift.

The young girl
tied to a tree
trunk is
Andromeda.
Artists more
typically portray
her chained to
a rock.

Neptune sends the monster to punish
Andromeda's mother, Cassiopeia,
who presumed to boast of being the
most beautiful Nereid.

▲ Piero di Cosimo, *Perseus Freeing
Andromeda*, circa 1513–15.
Florence, Uffizi.

The armed Perseus is shown flying.

At times Perseus wears winged shoes; here the hero is depicted fully armed as he goes to free Andromeda.

Laurel, symbol of wisdom and virtue, is triumphantly carried to celebrate Perseus's victory over the monster.

Perseus, having freed Andromeda, restores her to her father, Cepheus.

The young Phaethon is either shown asking Sol's permission to drive the sun chariot, or, more frequently, as he falls to ruin from the sky.

Phaethon

According to Hesiod, Phaethon is the son of Aurora and Cephalus. Other versions of the myth, however, such as one told by Ovid, indicate that he is the son of Sol and Clymene the Oceanid. The famous episode featuring this young god traces back to this second tradition.

When he reaches adolescence, Clymene reveals to Phaethon that his true father is Sol himself. For proof, the boy goes to Sol and asks him to let him drive his sun chariot. Although his father warns him against it, Phaethon gets what he wants. Getting into the chariot, he tries to follow the path that Sol advised, but he is frightened and has no experience in driving it, so he soon finds himself in grave difficulty. Coming too close to earth, he sets fire to it, and even the stars are at risk of burning. To keep everything from blazing, Jupiter intervenes and hurls one of his lightning bolts, striking the youth and plunging him into the Eridanus River.

In works of art, Phaethon is often shown kneeling before Sol, asking permission to drive his chariot. His fall is illustrated even more frequently, especially by Renaissance and Baroque artists in decorating ceilings.

Greek Name
Phaethon

**Relatives and
Mythic Origins**
Son of Sol or Apollo
and Clymene the
Oceanid

**Characteristics
and Activity**
Asks his father to let
him drive his sun
chariot

Related Myths
Phaethon's mother and
sisters, crying over his
grave, are transformed
into poplar trees;
Cycnus, lamenting
the loss of a friend,
is transformed into
a swan

◀ Joseph Heintz the Elder, *The Fall of Phaethon*, 1596. Leipzig, Museum der Bildenden Künste.

▶ Daniel Gran, *Phaethon Asks Apollo for the Sun Chariot*, circa 1720. Seitenstetten, Pinacoteca dell'Abbazia Benedettina.

Phaethon plunges with the sun chariot.
According to a medieval allegorical
interpretation of Ovid's Metamorphoses,
Phaethon represents Lucifer, who
rebelled against God.

Thunderbolts are an attribute of
Jupiter, king of the gods. Here he
hurls lightning at Phaethon.

Sebastiano Ricci, *The Fall of*
aethon, 1703–4. Belluno, Museo
vico.

The common rendering of this story features Jupiter and Mercury being served by two farmers. At times one of the gods may be preventing the couple from killing their goose.

Philemon and Baucis

Philemon and Baucis welcome two traveler into their poor hut who had been refused hospitality at much richer houses. During the frugal dinner, the married couple realizes that the pitcher of wine continually refills by itself, and they understand that they are in the presence of the gods. They therefore decide to kill the only goose they have in honor of the gods, but the two travelers stop them from making such a sacrifice. Showing their true identities, Jupiter and Mercury take the two to a shelter on a mountainside and unleash a violent storm below in order to punish those who had not respected the rules of hospitality. Their poor dwelling becomes a magnificent temple. When Jupiter invites the couple to make a wish, Philemon and Baucis ask to be assigned the roles of priests and to die at th same time so as never to be alone. Upon their death, the two farmers are transformed into trees next to each other.

Greek Names
Philemon; Baucis

Relatives and Mythic Origins
Elderly Phyrgian couple living in Bithynia

Characteristics and Activity
They are the only ones to give hospitality to Jupiter and Mercury, who are disguised as foreigners

▲ Giuseppe Bacigalupo, *Philemon and Baucis* (detail), before 1790. Genoa, Palazzo Durazzo Pallavicini.

▶ Johann Carl Loth, *Jupiter and Mercury Are Guests of Philemon and Baucis,* circa 1659. Vienna, Kunsthistorisches Museum.

The winged cap, or petasus, is an attribute of Mercury. According to the Renaissance mythographers, the image of the messenger god with wings recalls words, which fly through the air as he does.

The gods have unleashed a storm to punish those who have not followed the rules of hospitality.

Thunderbolts are symbols of Jupiter.

▲ Peter Paul Rubens, *Jupiter and Mercury with Philemon and Baucis*, circa 1625. Vienna, Kunsthistorisches Museum.

Philemon and Baucis

▲ Adam Elsheimer, *Jupiter and Mercury in the House of Philemon and Baucis*, 1608. Dresden, Gemäldegalerie.

The portions shown in close-up illustrate the frugal meal that Philemon and Baucis offer, and their poverty.

This is the goose that Philemon and Baucis are ready to sacrifice in honor of their guests. In some depictions of this story, Jupiter can be seen staying Philemon's hand from killing the bird.

211

Pluto

Greek Name
Hades

**Relatives and
Mythic Origins**
Son of Saturn and
Cybele; Jupiter's
brother

**Characteristics
and Activity**
God of the
Underworld

Special Devotions
Worship of the god
particularly spread in
connection with the
Eleusinian Mysteries

Related Myths
Orpheus begs the
god to return his wife
Eurydice; Hercules
descends into the
Underworld on the
last of his twelve
labors to capture
the dog Cerberus

▲ Agostino Carracci,
Pluto (detail),
1557–1602. Modena,
Galleria Estense.

▶ Gian Lorenzo Bernini,
Pluto and Proserpina,
1621–22. Rome, Galleria
Borghese.

*Pluto is depicted as a man with a full beard and black hair;
he frequently wears a crown and brandishes a two-pronged
pitchfork. He rides his chariot as he abducts Proserpina, and
Cerberus can often appear at his side.*

The son of Saturn and Rhea, Pluto divides the universe with his
brothers Jupiter and Neptune after their battle with the Titans.
Jupiter asserts his rank as lord of heaven, while Neptune reigns
over the sea. Pluto is assigned the world of the dead. The god
watches over his kingdom with severity and with the help of
numerous creatures, such as Charon, the famous ferryman of
souls, and Cerberus, the monstrous three-headed dog who
guards the Underworld entrance. Pluto abducts Proserpina, the
daughter of Jupiter and Ceres, from the land of the living and
she becomes his wife. The king of the gods, however, giving in
to the pleas of the young girl's mother,
rules that Proserpina should stay two-
thirds of the year on earth and the last
third in the kingdom of the dead.

In Greek tradition, Pluto's name is
Hades. The ancients mention him
only rarely, since they
believed that just saying
his name would anger the
god. They referred to him using
epithets, the most popular of which was
"Pluton," from the Greek *ploúton*,
meaning "the rich." This referred to
the richness of the cultivated earth
and the mines of treasures held
underground. The name Pluto was
adopted by the Romans and ended
up becoming the god's actual name in
common language.

The winged child who is about to shoot one of his arrows is Cupid.

This partly nude goddess is Venus. Ovid tells how the goddess commands Cupid to shoot one of his arrows at Pluto so that love can also shine in the shadowy kingdom of the dead.

Pluto is shown in the Underworld in his chariot.

The two-pronged pitchfork is a symbol of Pluto.

▲ Joseph Heintz the Younger, *Pluto Reaches Tartarus*, circa 1640. Mariánské Lázne, Mestské Muzéum.

This Titan is usually portrayed chained to a rock as an eagle devours his liver. A lighted torch can also appear in the scene, a symbol of his guilt and punishment.

Prometheus

Greek Name
Prometheus

**Relatives and
Mythic Origins**
According to Hesiod,
the son of the Titan
Iapetos and the
Oceanid Clymene

**Characteristics
and Activity**
Creates people by
modeling them from
clay; he steals fire to
give it to them

Special Devotions
In Athens festivals
called Prometheia
were celebrated in his
honor; one included a
race with torches

Related Myths
The Centaur Cheiron
offers Prometheus his
immortality; Hercules
frees him from his
torment; Prometheus
advises Deucalion to
build an ark to save
himself from a flood
caused by Jupiter

▲ Gustave Moreau,
Prometheus (detail), 1868.
Paris, Musée Gustave
Moreau.

Prometheus, son of the Titan Iapetos, is famous for having created humans and given them fire. The myth tells how he molds men from clay and gives them features that resemble the gods'. Later, with Minerva's support, he steals fire from the sun chariot and gives it to mortals as a gift. According to another version, he steals it from Vulcan's furnace. Jupiter is furious (he hoped to keep fire hidden) and punishes humans by sending the beautiful Pandora down to earth, who opens a box filled with evils. Prometheus is chained to the Caucasus by Vulcan, where an eagle devours his liver. Since his liver grows back each night, his punishment is eternal. However, Hercules eventually frees this human benefactor.

Prometheus is usually depicted being punished. More rarely, the hero is shown in front of a statue with human features, which he places on a pedestal. In another version, the hero, after stealing fire, touches a statue with a lighted torch to give it life. The two episodes of creating humans and giving them fire combined—once they were independent of each other—have been read allegorically: the statue represents a human being touched by divine grace.

◀ Luca Giordano, *Prometheus*, circa
1660. Budapest, Szépművészeti
Múzeum.

Prometheus
steals fire from
the sun chariot.

Prometheus
gives life to the
statue using a
lighted torch.

The eagle was sent
by Jupiter to devour
Prometheus's liver.

The woman in the
background has been
identified as Pandora.

The man tied
to the tree is
Prometheus, who
suffers his peren-
nial punishment
to atone for hav-
ing given fire to
humans.

▲ Piero di Cosimo, *The Story of
Prometheus*, 1515–20. Strasbourg,
Musée des beaux-arts.

Proserpina is generally shown being carried away by Pluto in his chariot. The young girl raises her arms to heaven in desperation.

Proserpina

Proserpina, the daughter of Jupiter and Ceres, is queen of the Underworld. Pluto, the lord of that kingdom of shadows, falls in love with the girl and abducts her to be his wife. Hearing where her daughter has been taken, Ceres is enraged and withdraws her bounty from the earth, causing drought and famine everywhere. Jupiter orders Pluto to return the girl to her mother, but the girl has eaten a pomegranate seed in the Underworld, and that is enough to link her permanently with the afterlife. In fact, according to tradition, whoever reaches the kingdom of the dead and eats something there is not ever allowed to return. The king of the gods, however, orders the girl to spend two-thirds of the year on earth and the other third with Pluto in the Underworld.

Proserpina's return to the land of the living is often illustrated in imagery. She can be accompanied by Mercury, the messenger of the gods, to whom some attribute the role of psychopompus ("guide of souls"). Since it was linked to the myth of Proserpina, the pomegranate has been a symbol of resurrection since medieval times.

Greek Name
Persephone

Relatives and Mythic Origins
Daughter of Jupiter and Ceres

Characteristics and Activity
Goddess of the Underworld and wife of Pluto

Special Devotions
Proserpina was celebrated in the context of the Eleusinian Mysteries, which were also in honor of Ceres; worship of Proserpina was particularly widespread in Sicily, where her abduction was thought to have taken place

▲ Luca Giordano, *The Return of Persephone* (detail), circa 1660–65. Chalon-sur-Saône, Musée Vivant.

◄ Dante Gabriel Rossetti, *Proserpina*, 1877. From a private collection.

Abducted by Pluto,
Proserpina raises
her eyes and arms
toward heaven.

Pluto holds Proserpina
tightly as he carries her
away in his chariot.

The young girls gathering flowers
are Proserpina's maidservants.

According to tradition, Pluto's horses
are black, although artists have not
consistently kept this detail.

▲ Hans von Aachen, *The Rape of
Proserpine*, 1589. Sibiu, Museo Nazionale
Brukenthal.

The crown of wheat is an attribute of Ceres.

The crown of flowers identifies the goddess Flora.

Cherubs carry Proserpina as she returns to the land of the living.

The peacock is a symbol of Juno.

The trident is a symbol of Neptune, who is shown on his chariot.

Cerberus, the three-headed dog who guards the Underworld, is always near Pluto, who carries a two-pronged pitchfork.

▲ Luca Giordano, *The Return of Persephone*, circa 1660–65, Chalon-sur-Saône, Musée Vivant.

The scene most often depicted by artists shows Psyche, armed with a dagger, watching Cupid sleeping by candlelight.

Psyche

A girl of extraordinary beauty, Psyche unleashes the terrible jealousy of Venus, who orders Cupid to instill passion in Psyche for a depraved man. Cupid, however, falls in love with the girl himself and brings her to a fabulous palace, where he comes to visit her each night. He does not allow her to see him face to face, asking her to not attempt to find out who he is, or he will leave her. Nevertheless, one night Psyche—instigated by her evil, envious sisters—arms herself with a dagger and approaches the god with a lamp. A drop of oil falls from the lamp onto Cupid's shoulder. He wakes, is disillusioned at her lack of trust, and abandons her. During the subsequent search for her lost lover, Psyche reaches Venus's palace. The goddess is moved by anger and tests the girl a number of times, yet Psyche manages to overcome each hurdle thanks to the gods' help. Cupid, in the meantime, misses her deeply and goes in search of his lover; he finds her and asks Jupiter's permission to marry. The king of the gods orders Mercury to bring Psyche among the immortals at Olympus.

Greek Name
Psyche

Relatives and Mythic Origins
According to the narrative by Apuleius, this maiden was the daughter of a king

Characteristics and Activity
A beautiful maiden loved by Cupid and hated by Venus, she had to endure a number of trials to regain her lover

The story of Cupid and Psyche especially fascinated Renaissance artists, who portrayed the various episodes while decorating palaces of the nobility.

Antonio Canova, ▲
Cupid and Psyche Standing
(detail), 1796. Possagno,
Gipsoteca Canoviana.

François Baron Gérard, ◄
Cupid and Psyche, 1797–98.
Paris, Musée du Louvre.

*Psyche is often shown with a lamp.
A drop of oil from it falls on Cupid,
who wakes and is disappointed with
her. He then deserts her.*

*The bow and arrows are
symbols of Cupid.*

▲ Andrea Appiani, *Cupid Sleeping*,
1810–12. Monza, Villa Reale.

The young woman holding a dagger is Psyche. Goaded by her sisters, she disobeys Cupid's orders in order to learn her lover's true identity.

An army of ants run to help Psyche, who must separate the different kinds of seeds in one night.

Psyche is shown here exhausted among piles of seeds. Venus gave her the seemingly impossible task of separating the different types.

▲ Giulio Romano and helpers, *Trial of the Seeds,* circa 1526–28. Mantua, Palazzo Te.

The source of the river Styx is located at
the top of a high and inaccessible cliff
that is guarded by ferocious dragons.

young woman giving the urn to the
e is Psyche, whom Venus ordered to
it with water from the Styx, river of
the Underworld.

The eagle, a symbol of Jupiter, arrives to
help Psyche. The bird manages to gather
water from the river by holding an urn in
its beak.

Peter Paul Rubens, *Landscape with Jupiter
d Psyche*, 1610. Madrid, Prado.

As a final task, Venus gives Psyche an urn, ordering her to go to the Underworld and ask Proserpina for some of her beauty.

After returning from the Underworld, Psyche is curious about what is inside the urn. She opens it and is surrounded by a Stygian vapor that causes her to fall into eternal sleep. Cupid, who gets permission from Jupiter to marry the young woman, wakes her.

▲ Padovanino(?), *Psyche Receives a Vase from Venus to Be Filled with Persephone's Ointment*. Bologna, Palazzo Durazzo Pallavicini.

Juno, queen of
Olympus, sits at
Jupiter's side.

The helmet is
an attribute
of Mars.

Jupiter unites
Cupid and
Psyche in
marriage.

The eagle is
one of Jupiter's
symbols.

Andrea Schiavone, *The Marriage of Cupid
and Psyche*, circa 1550. New York, The
Metropolitan Museum of Art.

The two are often shown at the moment Thisbe discovers Pyramus's body and drops lifeless to the ground. A lioness can appear in the background.

Pyramus and Thisbe

Pyramus and Thisbe are deeply in love with each other, yet their parents disapprove and block any hopes of marriage. Despite this, the two young people resort to all kinds of schemes in order to meet, and they communicate through a crack in the wall that separates their two houses. One day they decide to run away and meet the following night at a spring located outside the city near a tree with white mulberries. Thisbe reaches the appointed place first, but as she is waiting, a lioness comes to the spring to drink. Thisbe is frightened and runs to safety in a nearby cave. As she flees, she drops her veil. The lioness, returning to the forest, finds the veil and shreds it with her teeth, which still carry traces of blood from cattle she had previously devoured. Pyramus arrives and, seeing his lover's veil in tatters and bloodstained, believes that Thisbe has been slain. He kills himself with a dagger in desperation.

Thisbe then returns to find her lover's lifeless body and takes her life as well. The spilled blood of the two lovers turns the white mulberries forever red.

Greek Names
Pyramus; Thisbe

Relatives and Mythic Origins
According to Ovid, they are two lovers who are natives of Babylonia

Characteristics and Activity
Their families oppose their love and forbid them to marry

▲ Nicolas Poussin, *Landscape with Pyramus and Thisbe*, circa 1650. Frankfurt, Städelsches Kunstinstitut.

▶ Hans Baldung (Grien), *Pyramus and Thisbe*, circa 1530. Berlin, Gemäldegalerie.

▶ Domenico Beccafumi, *The Story of Deucalion and Pyrrha*, 1520. Florence, Museo Horne.

The couple is portrayed preparing to throw rocks that humans will originate from. The temple of the oracle can at times appear in the painting's background.

Legends of a flood sent by

Pyrrha and Deucalion

the gods to punish people for their evil ways belong to the traditions of a number of peoples.

In Greek mythology it is told that Jupiter decides to send a violent flood in order to annihilate an entire generation of humans who had become degenerate. Only Deucalion and his wife, Pyrrha, have not been corrupted and remain pious. They are saved thanks to advice given by Deucalion's father, Prometheus, who suggests his son build an ark to bring him and his wife to safety. The two sail for nine days until the storm calms and then realize that they are the only ones left on the entire earth. An oracle suggests they cover their heads and throw the "bones of the Great Mother" behind them. After overcoming their initial bewilderment, Deucalion realizes that the bones of the Great Mother are simply the rocks of the earth. The couple carries out what the oracle ordered, and men rise up from the rocks that Deucalion throws over his shoulder, while those thrown by Pyrrha bring forth women.

Greek Names
Pyrrha; Deucalion

Relatives and Mythic Origins
The myth of Pyrrha and Deucalion is linked to the birth of different generations of mortals; Deucalion is the son of Prometheus and Hesione (or Pronoea), and Pyrrha is the daughter of Epimetheus and Pandora

Characteristics and Activity
Deucalion and Pyrrha bring forth a new race of mortals

Saturn

Greek Name
Kronos

**Relatives and
Mythic Origins**
Son of Coelus and
Terra; father of Ceres,
Juno, Pluto, Neptune,
Jupiter, and Vesta

**Characteristics
and Activity**
Ancient god of agricul-
ture; later he became
the personification of
time

Special Devotions
In Rome festivals in
Saturn's honor called
Saturnalia were cele-
brated toward the end
of December; the
festivities included
exchanges of gifts and
private ceremonies;
during the same festi-
val, there existed the
custom of masters
serving their slaves

Related Myths
Saturn castrated his
father, Coelus (Uranus),
in order to avenge his
mother

▲ Francisco de Goya,
*Saturn Devouring One
of His Sons* (detail),
1820–23. Madrid, Prado.

*The most illustrated scene of Saturn, an old and gray man,
shows him devouring his children. As the god of time, Saturn
can also be portrayed with wings.*

To foil the prophecy that declared his children will dethrone
him, the terrible Saturn devours them one by one as they are
born from his union with Cybele. Nevertheless, she manages
to give birth to the last, Jupiter, in secret. An arduous battle
ensues, and Jupiter defeats his father and succeeds him after
freeing his immortal brothers and sisters.

Saturn was originally the god of agriculture, but throughout
the centuries he took on the role of the god of time. A number
of scholars have demonstrated how the word *chronos*—or
"time" in Greek—is very similar to Kronos, the Greek name of
this god who devours his own children. Saturn is a Latin name.
As the god of agriculture, Kronos-Saturn held a scythe. After a
while, the two names became one, and the scythe, originally
made for harvesting, began to be considered an instrument that
cuts down the life of humans. The image of Saturn devouring
his children was assimilated with the image of time, which
devours everything it creates. Later on, other symbols for
Saturn were added to the sickle, such as the hourglass and the
serpent that bites its own tail, a sign of eternity.

◀ Giovanni Battista Tiepolo, *Time
Discovers Truth*, 1734. Vicenza, V
Loschi-Zileri dal Verme.

The old and gray man devouring his son is Saturn.

Saturn is often portrayed as an old man leaning on a staff.

▲ Peter Paul Rubens, *Saturn Devouring One of His Sons,* 1636. Madrid, Prado.

Satyrs

Satyrs are depicted as beings that are part human and part animal, with pointed ears, tiny horns on their foreheads, shaggy legs, and goat hooves. They are often shown with a pitcher or thyrsus or as they play the flute.

The satyrs are creatures linked to the worship of Bacchus and are commonly considered images of fertility. Lovers of wine and sensual pleasures, they accompany Bacchus's court, dancing with the bacchants and holding either a thyrsus, bunches of grapes, or pitchers of wine. Sometimes they are shown drunk, immersed in deep sleep, or chasing after nymphs. It was this last trait that caused the image of satyrs to be associated with lust in medieval and Renaissance allegories, and it seems that Satan's horns and goat hooves were inherited from these creatures.

Satyrs are often shown in imagery flirting with or spying on nymphs bathing in a stream. At times this can allude to the triumph of lust over chastity.

Aesop tells how one day a satyr asks a farmer why he blows on his hands when they are cold and his soup when it is hot. The farmer responds that he blows on his hands to warm them and his soup to cool it. The satyr reproaches the duplicity of

humans, and, after scolding the farmer, he walks away fuming. This episode was especially popular in seventeenth-century Flemish painting.

Greek Name
Satyrs

Relatives and Mythic Origins
Children of Hermes and the Naiads, the nymphs of fountains and lakes

Characteristics and Activity
Demons of nature commonly held to be personifications of fertility

Special Devotions
The worship of satyrs was closely connected to that of Bacchus

Related Myths
Apollo punishes the satyr Marsyas for his arrogance

► Lorenzo Lotto, *Allegorical Scene,* 1501. Washington, D.C., National Gallery.

The farmer blowing on his soup to cool it had just blown on his hands to warm them.

The fable of the farmer and the satyr is often set in a kitchen.

The satyr scolds the farmer for being two-faced.

▲ Jacob Jordaens, *The Satyr and the Peasant Family*, circa 1625. Budapest, Szépmüvészeti Múzeum.

The satyr is a creature who is half man and half animal with goat hooves.

Semele

Greek Name
Semele

**Relatives and
Mythic Origins**
Daughter of Cadmus,
founder of Thebes, and
Harmonia

**Characteristics
and Activity**
Loved by Jupiter, she
gave birth to Bacchus,
the god of wine

Semele is generally shown as a young girl lying lifeless. Armed with lightning bolts, Jupiter appears in the sky together with his eagle. At times Juno is recognizable among the clouds.

Semele, one of Jupiter's lovers, conceives a child. The terrible Juno is enraged and blinded by jealousy, and she decides to immediately punish the girl for the insult. Changing into Semele's elderly nurse, Beroe, the queen of the gods appears to Semele. Thinking Juno is her nurse, Semele begins to talk with her, until the conversation comes to the king of the gods. Beroe then makes the girl doubtful, urging her to test if it really is him. She suggests that Semele ask Jupiter to show himself to her just as he would to Juno. After some time, Semele, remembering the old woman's words, asks Jupiter for a gift, and he promises to grant any wish she has. She asks the king of the gods to show himself in all his power. Jupiter is apprehensive, but he is forced to carry out her request because of his promise and appears before her armed with his thunderbolts. The girl cannot stand the tremendous flash and is instantly incinerated. Jupiter, however, manages to save the child she was carrying by taking him from her womb and sewing him in his side. After the appropriate time, Bacchus is born, and for this reason he is called "twice born."

▲ Tintoretto, *Semele
Incinerated by Jupiter*
(detail), 1541–42. Modena,
Galleria Estense.

▶ Sebastiano Ricci, *Jupiter
and Semele,* circa 1695.
Florence, Uffizi.

Silenus appears as an old, bald, and plump man; on his head he wears a crown of ivy or grape vines. He is constantly drunk on the back of his donkey, which struggles to support him.

Silenus

Sileni are beings that are quite similar to satyrs; they are almost indistinguishable from each other. The true Silenus, however, is the one who appears at Bacchus's side. Legend has it that Silenus raised and educated the god of wine.

Ovid tells how one day, wandering drunk among the hills of Thrace, Silenus is captured by some farmers and brought before their king, the famous King Midas. The king immediately recognizes Silenus and returns him to Bacchus.

Silenus is also famous for his wisdom, and he has certain divine abilities. It is said that while he lies drunkenly asleep people can get him to predict the future by circling him with garlands of flowers.

Silenus is usually depicted in the company of satyrs as he abandons himself to the joys of wine. He can also guide the triumphal court of Bacchus riding his donkey, propped up by satyrs.

Greek Name
Silenos

Relatives and Mythic Origins
Sources give different versions of his origins; some say he was the son of Pan, Mercury, or perhaps a nymph

Characteristics and Activity
Commonly held to be Bacchus's teacher

Related Myths
Midas discovers Silenus and returns him to Bacchus, who as a sign of gratitude grants Midas's wish of being able to turn everything he touches to gold; Silenus also fights in the battle against the Giants

Annibale Carracci, ▲
Bacchus and Silenus (detail), circa 1599. London, National Gallery.

Jusepe de Ribera, ◄
The Drunken Silenus, 1626. Naples, Capodimonte.

233

Theseus usually wears a short garment, shoes, and at times a helmet. He does not feature any special emblems but typically holds a club, like Hercules. He is frequently shown battling the Minotaur.

Theseus

Theseus is the son of King Aegeus of Athens and Aethra, the daughter of the king of Troezen. Aegeus lies with the girl, and, before leaving, he buries his sword and shoes under a heavy rock, telling Aethra that when their son is able to lift the weight, he should take the objects stored there and come to Athens to present himself. After turning sixteen, Theseus is brought to the rock and, lifting it, he takes the shoes and sword. The hero reaches Athens, where his father recognizes him.

After this, Theseus takes a lead role in a number of adventures. The most famous is when he slays the Minotaur—the monster locked in the Labyrinth—with the help of Ariadne. She is King Minos's daughter, and she gives Theseus a ball of thread, advising him to tie one end to the Labyrinth entrance and never let go of the other. After slaying the horrible creature, the Athenian hero easily finds his way out by following the thread backwards.

In art, Theseus can either appear at the Labyrinth entrance as Ariadne gives him the ball of thread, actually battling the beast, or in a victorious stance next to the fallen monster.

Greek Name
Theseus

Relatives and Mythic Origins
Son of Aegeus and Aethra; according to another tradition, son of Neptune and Aethra

Characteristics and Activity
Athenian hero especially famous for having defeated the Minotaur

Special Devotions
Considered the Athenian hero par excellence, Theseus was celebrated in a festival called the Theseia, which was held annually in Athens

Related Myths
Theseus took part in the Argonauts' quest and the hunt for the Calydonian boar; he intervened to help his friend Peirithous in the Battle of the Lapiths and Centaurs; after his battle with the Minotaur he brought Ariadne away with him but then deserted her on Naxos

▲ The Master o
Campana Casso
*Theseus and the
Minotaur* (detai
1510–20. Avign
Musée du
Petit-Palais.

According to Aegeus's orders, as soon as his son Theseus is able to lift this heavy stone, he can gather the objects buried under it and join his father in Athens.

Aegeus buried shoes and a sword under the stone, objects that will allow him to recognize his son.

Aethra, Theseus's mother, shows him the stone.

◀ Antonio Canova, *Theseus Overcomes
the Minotaur*, 1805. Possagno,
Gipsoteca Canoviana.

▲ Laurent de La Hyre, *Theseus and
Oethra*, circa 1640. Budapest,
Szépmüvészeti Múzeum.

*The young
woman holding
a ball of thread
is Ariadne.*

*Here Crete has been
transformed into an
imaginary city of
the Renaissance.*

*The armed
knight receiving
the ball of thread
is Theseus.*

▲ The Master of the Campana Cassoni,
Theseus and the Minotaur, 1510–20.
Avignon, Musée du Petit-Palais.

The sails of Theseus's ship are black. The hero is supposed to raise white sails as he returns to Athens victorious, but he forgets. Upon seeing the black sails in the distance, Aegeus believes his son has been slain and kills himself.

Theseus defeats the Minotaur inside the Labyrinth.

The captured Minotaur is being brought into the Labyrinth.

Theseus is shown here as a knight in armor. Artists commonly set myths in their contemporary periods, dressing the gods and heroes according to the fashions of their time.

Theseus brings Ariadne, and perhaps her sister Phaedra, with him. Certain mythographers, distorting the original texts, held that Theseus brought Ariadne and Phaedra with him and that he deserted Ariadne on Naxos in order to marry her sister.

Part of Neptune's retinue, tritons and Nereids are often portrayed as beings that are half fish and half human and ride sea creatures.

Tritons and Nereids

In his *Theogony*, Hesiod writes that Triton was the only child of Neptune and Amphitrite. Later writers, instead, speak of this divinity in the plural, as tritons. Tritons have a role in the sea world similar to that of satyrs or Centaurs in the earthly realm, and they are portrayed this way in Hellenistic and Roman imagery. They live among the waves of the sea, and with the sound of a horn—a conch shell—they have the power to stir up or calm the waves. Together with the Nereids, tritons are a part of Neptune's court.

Nereids are specific deities, the daughters of Nereus, from whom they get their name, and Doris, the daughter of Oceanus. They are sea nymphs, to be distinguished from Naiads, who are river nymphs, and Oceanids, who are ocean nymphs. Generally considered benevolent deities, Nereids live in the depths of the sea in Nereus's palace, seated or golden thrones.

Poets portray them as extremely beautiful divinities playing amidst the waves or accompanying Neptune. Their number can vary from fifty to a hundred. Among them are Galatea, whom Polyphemus loved; Thetis, Achilles' mother; and Amphitrite, Neptune's wife.

Greek Names
Tritons; Nereids

Relatives and Mythic Origins
Tritons derived their image from Triton, the son of Neptune and Amphitrite; the Nereids are daughters of Nereus and Doris, granddaughters of Oceanus

Characteristics and Activity
As sea divinities, tritons have the power to stir up and calm the sea with the sound of their horns; the Nereids, so-called sea nymphs, are protectors of sailors

Special Devotions
The Nereids were especially venerated along the coast of Greece

Related Myths
Thetis, the Nereid mother of Achilles, often intervenes to help her son; Amphitrite, Neptune's wife, is a Nereid

▲ Luca Giordano, *Triumph of Galatea* (detail), 1670–80. From a private collection.

◀ Gian Lorenzo Bernini, *The Fountain of Triton*. Rome, Barberini Square.

A triton and Nereid are portrayed in a sensual embrace. Love between these divinities has no foundation in the ancient sources; this is the artist's reinterpretation of the myth.

A Nereid is a female goddess who is half woman and half fish.

▲ Arnold Böcklin, *Triton and a Nereid*, 1895. Florence, Villa Romana.

Venus

The most common symbols of Venus, who is typically shown nude, are the rose, myrtle, and apple. Animals can accompany the goddess, including doves, sparrows, rabbits, and swans.

Greek Name
Aphrodite

Relatives and Mythic Origins
According to Homer, she is the daughter of Jupiter and Dione; more frequently she is born from the waves of the sea

Characteristics and Activity
Goddess of beauty and love

Special Devotions
In Greece the most famous festivals celebrated in honor of the goddess were held in Cyprus and Cythera; in Rome Julius Caesar, claiming his descent from Aeneas, was a great promoter of the worship of Venus

Related Myths
Cupid is born from her union with Mars; Venus also loves Adonis and Anchises, from whom Aeneas—the Trojan hero whom the goddess of beauty protects—is born; Venus wins the golden apple in the Judgment of Paris

There are a number of versions regarding the origins of Venus, goddess of beauty. According to Homer she is born from the union of Jupiter and Dione. Hesiod, on the other hand, claims that the goddess is the daughter of Uranus, born from the sea where Saturn threw his father's sexual organs after having castrated him. Venus is then brought by a sea breeze to the shores of Cythera and Cyprus, islands that later become the two main sites of worship for the goddess.

The goddess of love—who is the wife of Vulcan, god of fire—had numerous lovers, according to the myths. Venus and Mars, the god of war, are caught in trap that Vulcan sets, and this is a source of general glee in the divine court.

The love between Venus and Mars enjoyed a notable amount of success in art. The two lovers are often depicted as they lie together or as Vulcan catches them. Cupid often appears with

them, and he is generally considered their child. In Renaissance paintings, two lovers or newlyweds can be portrayed as the two gods. Another famous lover of Venus is Adonis, who has a lead role in a myth that has fascinated artists and poets of every period.

◄ Lucas Cranach the Elder, *Venus and Cupid*, 1520. Bucharest, Muzeul National de Artă al României.

The winged girl
with Zephyrus
could be Aura,
goddess of
breezes.

The winged figure in
the light blue cape is
Zephyrus, the spring
wind, who brings
Venus toward the
island.

Venus's pose here recalls the ancient
figure of Venus Pudica, an example of
which is the Venere Capitolina statue
held in Rome's Musei Capitolini.

According to
some stories,
Venus is born
from a shell.

This maidservant who places a cape
on Venus has been identified as either
one of the Graces or one of the
Horae (Seasons).

Sandro Botticelli, *The Birth of Venus*,
484–86. Florence, Uffizi.

Venus

Venus is
generally
shown nude.

A winged cherub fixes the goddess's
hair. The theme of the preening goddess
became quite developed in Venetian
painting during the Renaissance and
later became one of the typical ways
to portray the goddess.

▲ François Boucher, *The Dressing Room of
Venus*, 1751. New York, The Metropolitan
Museum of Art.

The rose is also
a symbol of
Venus.

The dove
identifies the
goddess Venus.

The armed god
with a helmet,
shield, and
breastplate
walking toward
Venus is Mars.

The dove is one
of the animals
that symbolize
Venus.

The quiver and bow belong to
Cupid, who is generally held to
be the child of Venus and Mars.

Lambert Sustris, *Venus with Cupid and
Mars*, circa 1540. Paris, Musée du Louvre.

This cave represents Vulcan's forge, where the god is making an invisible net to catch Venus and Mars.

Here the dove appears again as a symbol of Venus.

Venus is depicted mostly nude because, according to Renaissance mythographers, those who abandon themselves to sensual pleasure often end up devoid of all good, or because love affairs are quickly unveiled.

▲ Maerten Van Heemskerck, *Venus and Cupid*, 1545. Cologne, Wallraf-Richartz-Museum.

Cupid is a
winged child
armed with bow
and arrows.

Vulcan is
bringing the
net to trap
Venus and
Mars.

Venus

The winged
child being held
by a nymph is
Cupid.

Once again the
rose symbolizes
Venus.

Running after Adonis, Venus's foot is
pierced by a thorn. Her blood falls on the
roses, which were originally white, and they
become red.

▲ Auguste-Barthélemy Glaize, *The Blood of
Venus*, 1845. Montpellier, Musée Fabre.

246

The winged
cap, or petasus,
identifies this
god as Mercury.

The crown is a
symbol for Juno.

Paris awards Venus the famous
golden apple, which is also called
the Apple of Discord. This episode
is the cause of the Trojan War.

Cupid, the
winged child,
is shown at
Venus's side.

The shield is one
of Minerva's
attributes.

▲ Peter Paul Rubens, *Paris Awards the
Golden Apple to Venus (The Judgment of
Paris)*, circa 1602. London, National Gallery.

This god is frequently shown as an old man next to Pomona, the fruit goddess. A cornucopia or fruit composition can appear close to Vertumnus.

Vertumnus

Vertumnus is an ancient Italic deity who transforms flowers into fruit and presides over the change of seasons. In his *Metamorphoses*, Ovid tells how the god falls in love with Pomona and how he manages to conquer her heart.

Pomona, whose name derives from the Latin *pomum*, meaning "fruit," is the goddess of fruit trees and gardens. The goddess is completely dedicated to her work in the gardens and flees the advances of a number of suitors. Vertumnus falls in love with her and, thanks to his ability to change, courts the girl by presenting himself as a harvester, a vine pruner, an ox driver, a soldier, and a fisherman, enjoying her beauty under a variety of disguises. One day he manages to approach Pomona by taking on the features of an old lady and, after having praised the girl for her skilled work, begins to plead his case by numbering the infinite merits of Vertumnus. Since his words have no effect, the god decides to reveal himself and take her by force. The girl, however, upon seeing Vertumnus in all his splendor, is already won over.

Relatives and Mythic Origins
Ancient Italic god who was probably Etruscan in origin

Characteristics and Activity
Vertumnus is the personification of the change of vegetation from flowers to fruit and the change of seasons; as a god of change, he has the ability to transform into any shape he likes

Special Devotions
In Rome his festivals, called the Vertumnalia, were organized toward the end of October in order to celebrate the change from summer to autumn

▲ Antonio Carneo, *Vertumnus and Pomona* (detail). Udine, Credito Romagnolo/Banca del Friuli.

◀ Giuseppe Arcimboldi, *Emperor Rudolf II as Vertumnus,* 1591. Stockholm, Skoklosters Slott.

*This partly nude young woman is
Pomona. The story of Vertumnus and
Pomona was especially popular with
Dutch artists during the seventeenth
century.*

*Vertumnus disguises himself
as an elderly woman in order
to get close to Pomona.*

*The winged child armed with a bow
and arrow is Cupid. His presence
suggests that the theme of this
painting is amorous.*

*The composition of fruit next
to Pomona suggests her identity.*

▲ Anthony van Dyck, *Vertumnus and
Pomona*, circa 1625. Genoa, Galleria di
Palazzo Bianco.

Vulcan is usually depicted at his forge working metals. The hammer and anvil are his symbols, and he is often surrounded by a number of Cyclopes, who help him.

Vulcan

Greek Name
Hephaistos

Relatives and Mythic Origins
Son of Jupiter and Juno

Characteristics and Activity
God of fire and blacksmith of the gods

Special Devotions
The worship of Vulcan was especially developed on the island of Lemnos, where it was said that Jupiter threw him in a fit of rage; he was also honored on volcanic islands such as Sicily; worship of Vulcan in Rome goes back to ancient times

Related Myths
Vulcan helps Jupiter in the battle against the Titans, imprisons Prometheus in the Caucasus mountains, creates and models Pandora from clay, and forges weapons for Achilles and Aeneas

▲ Pompeo Batoni, *Vulcan* (detail). Como, Musei Civici.

Vulcan, the son of Jupiter and Juno, is the god of fire. Nevertheless, in certain myths he is remembered as a crippled and sickly god from birth. Because of this, Juno is ashamed of him and throws her swaddled child from Olympus. Falling into the ocean, Vulcan is taken in by Tethys, who raises him for nine years. According to another version of the myth, Vulcan's deformity is caused by Jupiter, who in a fit of rage takes him by the foot and hurls him from Olympus. The god falls to the island of Lemnos, where he is taken in and cured by the local people.

Vulcan marries Venus, who cheats on him with Mars. When Apollo tells him of his wife's infidelity, the god prepares an invisible net that he lays on their wedding bed. As soon as the two lovers lie together, they become entangled. Vulcan then calls and gathers all the gods as witnesses of his betrayal.

This last episode captured the imagination of many artists,

who in turn reworked the myth and incorporated their own original adaptations into their paintings. Vulcan also appears alone with Venus at his forge, when the goddess of beauty asks him for weapons for Aeneas. He also gives Thetis arms for Achilles.

◄ Bartholomeus Spranger, *Venus at the Forge of Vulcan*, circa 1610. Vienna, Kunsthistorisches Museum

*The young women around Vulcan
are nymphs, not the local people of
the myths. Experts think this error
occurred because sources were
mistakenly interpreted.*

*This boy having a hard time getting
up is Vulcan. Jupiter hurled the god
from Olympus in a fit of rage.*

*A nymph helps
Vulcan stand.*

◣ Piero di Cosimo, *The Finding of Vulcan,*
1485–90. Hartford, Wadsworth Atheneum.

A Cyclops,
one of Vulcan's
helpers, is
working with
his tools.

The bow and quiver
are symbols of
Cupid.

Vulcan sharpens one of Cupid's
arrows, unaware that one of these
will hit his wife, Venus, and cause
her to fall in love with Mars.

The hammer is a symbol of Vulcan. Here, out of love, he gives in to Venus's urging and gives her armor for Aeneas.

The presence of Cupid, who is ready to shoot one of his arrows, recalls that love is the theme of this episode.

Venus holds Aeneas's armor close to her breast. Virgil tells how the goddess, inspiring divine love, asks her husband to forge armor for her son.

◄ Alessandro Tiarini, *Vulcan Forges Cupid's Arrows*, circa 1621–24. Reggio Emilia, Fondazione Cassa i Risparmio di Reggio Emilia.

▲ Anthony van Dyck, *Venus at the Forge of Vulcan*, circa 1630–32. Vienna, Kunsthistorisches Museum.

The winged child
holding an arrow
is Cupid.

▲ Tintoretto, *Venus, Vulcan, and Mars,*
1545–50. Munich, Alte Pinakothek.

Vulcan, whom Venus cheats on, checks the sheets of their nuptial bed.

The scene is reflected on a shield, a symbol of Mars.

The armed knight hiding under the table is Mars. Tintoretto reworks the scene— the discovery of the liaison between Venus and Mars—in an original way.

The dog barks in Mars's direction and uncovers the two lovers' deceit.

On the following pages: Jean-Auguste-Dominique Ingres, *The Apotheosis of Homer,* 1827. Paris, Musée du Louvre.

The Homeric Poems

The Trojan Cycle

The hero par excellence, Achilles is usually portrayed dressed as an armed warrior. Nevertheless, artists have also chosen to depict the episode when Ulysses discovers the hero hiding among the daughters of King Lycomedes.

Achilles

Achilles is the main character of the *Iliad*, the poem by Homer that narrates events during the tenth year of the Trojan War. Other episodes of Achilles' birth, youth, and death can be found in later tales, which often conflict with one another.

After his birth, Thetis immerses her son in the river Styx (or fire, according to some) in order to make her child immortal. She holds her son by his foot while doing this, so Achilles' heel is the only part of him that remains vulnerable. Later on, when an oracle predicts that Achilles will die before the walls of Troy, Thetis hides her son among the daughters of King Lycomedes at Scyros dressed as a girl. Ulysses still manages to unmask Achilles through a clever trick and brings him along to Troy with him. During the tenth year of the war, Achilles has a furious argument with Agamemnon and decides to withdraw from combat. The war begins to go better for the Trojans, until Hector, a Trojan prince, kills Achilles' friend Patroclus. This forces Achilles to return to battle and kill Hector in a duel.

The various versions of Achilles' death all concur that an arrow hit him in the heel, the only vulnerable part of his body.

Greek Name
Achilles

**Relatives and
Mythic Origins**
According to Homer,
the son of Thetis and
Peleus, king of Phthia

**Characteristics
and Activity**
Legendary Greek
hero, main character
of the *Iliad*

Special Devotions
Achilles was especially
worshipped in Pontus,
where his tomb was
traditionally located

On the opposite page:
Giovanni Domenico Tiepolo,
*The Procession of the Trojan
Horse into Troy* (detail), 1773.
London, National Gallery.

Felice Giani, ▲
*Achilles Drags the Body of
Hector Along the Walls of
Troy* (detail), 1802–5.
Faenza, Palazzo Milzetti.

Giovanni ◄
Battista Tiepolo,
*Thetis Consoling
Achilles* (detail),
1757. Vicenza,
Villa Valmarana.

259

The woman immersing the child in the pool of water is Thetis, Achilles' mother.

Achilles' heel is the only vulner-able part of his body, since his mother held him by his foot while immersing him in the waters of the Styx.

The bearde god who lean upon a tilte urn represents personificatio of the rive Styx, th famou river of th Underworl

▲ Giacomo Franceschini, *Thetis Sub-merges the Child Achilles into the River Styx*, 1719–20. Bologna, Palazzo Durazzo Pallavicini.

The creature that is half man and half horse is Cheiron, the wisest of all Centaurs and educator of famous heroes such as Achilles and Peleus.

The young boy busy shooting his bow is Achilles, who is learning the art of hunting on Cheiron's back.

▲ Eugène Delacroix, *The Education of Achilles*, circa 1862. Los Angeles, The J. Paul Getty Museum.

Ulysses disguises himself as a merchant. He is sure that Achilles will be moved by his warrior instinct and choose military items for sale, thus revealing his identity.

Achilles is here disguised as a woman, yet he draws a sword without hesitation. He has been hiding among the daughters of King Lycomedes.

▲ Hendrik van Limborch, *Achilles and the Daughters of Lycomedes*. Rotterdam, Museum Boijmans Van Beuningen.

Ulysses brings weapons and jewelry to Lycomedes' daughters in order to unmask Achilles.

These girls who concentrate on choosing jewels are the daughters of Lycomedes.

Minerva, the goddess of wisdom and protector of Achilles, wears a helmet, shield, and cuirass. Juno sent her to end the clash between Agamemnon and the hero.

This armed warrior is Agamemnon. Having renounced his own trophy of war—the daughter of a priest—he now claims Achilles' concubine Briseis as compensation.

Minerva takes Achilles by the hair and demands that he cease quarrelling.

Provoked by Agamemnon, Achilles unsheathes his sword. The hero withdraws from battle for a long time after this dispute.

▲ Giovanni Battista Tiepolo, *Minerva Keeps Achilles from Killing Agamemnon*, 1757. Vicenza, Villa Valmarana.

The ghost who appears in Achilles' dream is his friend Patroclus, who asks the hero to bury him and give peace to his troubled spirit.

Achilles tries to embrace Patroclus one last time, but his friend's ghost dissolves like smoke.

▲ Johann Heinrich Füssli, *Achilles Searching for the Shadow of Patroclus*, circa 1805. Zurich, Kunsthaus.

The fallen Hector tries in vain to defend himself from the wrath of Achilles.

This armed goddess is Minerva, who watches the duel from heaven.

Achilles beats Hector, a Trojan prince, in a duel. After his quarrel with Agamemnon, the king of Mycenae, and withdrawal from the war, the hero returns to combat to avenge the death of his loyal friend Patroclus, who had been killed by Hector.

▲ Jacopo Amigoni, *The Battle between Hector and Achilles,* 1724–26. Schleisseim Castle.

Achilles, triumphant in his chariot, succeeds in avenging Patroclus's death.

The winged figure between the two horses is a personification of Fame, who holds the crown of victory.

After having killed Hector, Achilles strips his enemy and ties him to his chariot by passing leather strips through holes in the tendons of Hector's ankles.

Achilles drags Hector's body around the walls of Troy.

Hector's weapons lie abandoned on the ground.

▲ Felice Giani, *Achilles Drags the Body of Hector along the Walls of Troy,* 1802–5. Faenza, Palazzo Milzetti.

Hector is depicted as a warrior. One particular episode that artists have preferred is the hero's farewell to his wife, Andromache, at Troy's Scaean Gate.

Hector

Hector, the celebrated Trojan hero, fights against all the bravest Greek warriors. At one point he slays Patroclus, Achilles' close friend. Achilles returns to combat and avenges the death of Patroclus, killing Hector in a duel. Still not satisfied, the Greek commander ties the lifeless body of his enemy to his chariot and drags it around the city walls of Troy, until he drops it in the Greek camp. The gods, moved to compassion by such slaughter, convince Achilles to return Hector's body to his father, Priam.

Artists frequently portray Hector bidding farewell to his wife, Andromache. Homer narrates that the hero takes leave of his wife and son, Astyanax, at Troy's famous Scaean Gate before going out to battle. The child is frightened at seeing his father in full armor and hides in his nurse's arms. Hector takes off his shining feathered helmet and takes the child in his arms, hoping that one day his son will surpass him in strength.

Greek Name
Hektor

**Relatives and
Mythic Origins**
Son of the Trojan king
Priam and Hecuba;
brother of Paris

**Characteristics
and Activity**
A Trojan leader, he
was killed by Achilles

Giuseppe Bazzani, ▲
Hector and Andromache (detail).
Bergamo, Galleria Previtali.

Luca Ferrari, ◄
Hector and Andromache.
Venice, Palazzo Pisani Moretta.

Hector's body
lies lifeless on
their marriage
bed.

Hector's head is
crowned with
laurel, a symbol
of glory.

The sculptural
relief here por-
trays Hector's
farewell to his
wife and son.

Andromache,
Hector's wife,
mourns and
keeps watch
over her hus-
band's corpse.

The sculptural
relief on the
bed depicts
Hector's death
at the hands
of Achilles.

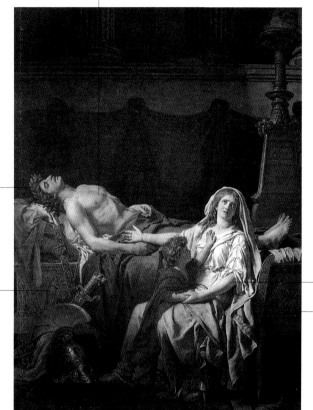

Hector's weapons and armor, including
the famous helmet that frightened the
tiny Astyanax, lie on the ground.

▲ Jacques-Louis David, *The Pain of
Andromache*, 1783. Paris, Musée du
Louvre.

Helen is often depicted being abducted by Paris, a scene often set in a port. Paris is shown grasping Helen tightly, as she frantically tries to free herself.

Helen

Helen is the daughter of Leda and Jupiter. She is so famously beautiful that Homer compares her to immortal goddesses.

She marries Menelaus, the king of Sparta, and a daughter named Hermione is born to them. Later on, Venus promises Paris, a Trojan prince, that she will give him Helen, the most beautiful woman in the world, if he awards her the famous golden apple. Paris does so and travels to Sparta, where the unknowing Menelaus welcomes him with all the honors due to guests. Then, taking advantage of his host's temporary absence for a trip to the island of Crete, Paris carries Helen away and brings her to Troy. Enraged by such an insult, the king of Sparta calls his brother, Agamemnon, who summons all the Greek princes and incites them to declare war on Troy.

According to some sources, Helen returns home with Menelaus after the war. Before reaching Sparta, however, for eight years the husband and wife wander the Mediterranean, as did most of the heroes who took part in the expedition against Troy.

Artists also show her—although rarely—being brought before Priam, Paris's father, or during the wedding between the Trojan prince and this Greek queen.

Greek Name
Helen

Relatives and Mythic Origins
According to Homer, she is the daughter of Jupiter and Leda

Characteristics and Activity
The most beautiful of all mortal women and wife of Menelaus, she was abducted by Paris

Special Devotions
Helen was especially worshipped in Sparta, where she was venerated as protector of newly-weds and adolescents

Jacques-Louis David, ▲
Paris and Helen (detail), 1789. Paris, Musée des arts décoratifs.

Gustave Moreau, ◄
Helen at the Scaean Gate, 1885. Paris, Musée Gustave Moreau.

Paris's companions keep
the Greeks from coming
near the boat.

Helen tries in vain to
free herself from the
hands of her abductor.

This creature,
half human and
half fish, is a
Nereid, a sea
nymph.

Paris is carry-
ing off Helen.

▲ Sebastiano Ricci, *The Rape of Helen*,
1700–1704. Parma, Galleria Nazionale.

Laocoon, a Trojan priest, is usually portrayed on the shore at Troy, as he and his sons struggle in the coils of terrifying snakes.

Laocoon

After the Trojan Horse is built, the Greeks set sail from the coast to give the idea that they have withdrawn. The next day, the Trojans come to the deserted shore. They are impressed by the imposing statue and discuss what to do with it. The priest Laocoon, who had been preparing to carry out a sacrifice to Neptune, throws a spear against the enormous animal's stomach and attempts to convince his countrymen to destroy it. Meanwhile, a Greek named Sinon is brought before Priam, saying that the Greeks built the horse in thanksgiving to Minerva. The Greek—who is really a decoy—continues by saying that if the Trojans bring the horse into their city, they will secure the goddess's favor and become invincible. At Sinon's words, suddenly two monstrous serpents spring from the sea. They spring toward Laocoon's sons and coil around their bodies. The priest runs to help his children and tries to kill the horrible creatures, but he also is enveloped in their powerful coils and dies. Then the snakes quickly wind their way toward the temple of Minerva and disappear. Laocoon's death is interpreted as divine punishment and proof of Sinon's truthfulness. Thus the Trojans bring the horse into the city, signaling their downfall.

Greek Name
Laocoon

Relatives and Mythic Origins
The origins of Laocoon are contradictory and not very specific; according to some he is the son of Antenor

Characteristics and Activity
Trojan priest

El Greco, *Laocoön* ▲ (detail), 1610–14. Washington, D.C., National Gallery.

Laocoon, from the ◄ second century B.C. Vatican City, The Vatican Museums.

The wooden horse is being
brought into the city; it will
be Troy's downfall.

This young
man is one of
Laocoon's sons.
He tries to
defend himself
from a snake.

The fortified
city is Troy.

The cause of Laocoon's tragic end
is having offended a deity, Minerva,
who is here avenged.

▲ El Greco, *Laocoön*, 1610–14.
Washington, D.C., National Gallery.

Paris does not have any special identifying symbols. He is frequently shown in the story of the Judgment of Paris holding a golden apple. In this scene he finds himself in the presence of Venus, Juno, and Minerva, and Mercury is often at his side.

Paris

Just before Paris is born, his mother, Hecuba, is told that the child in her womb will someday cause Troy's downfall. Fearful, the queen deserts the swaddled child on Mount Ida, where shepherds raise him. Later on, Paris goes to meet his father, who welcomes him and reinstates him as prince.

Paris is especially remembered for judging the beauty contest that led to the Trojan War. The legend tells how, during Peleus and Thetis's wedding banquet, Eris, the goddess of discord, offended for not having been invited, throws on the table a golden apple with "for the fairest" written upon it. Immediately, Juno, Minerva, and Venus begin to quarrel and compete for the prize. To settle the quarrel, Jupiter charges Mercury with giving the Apple of Discord to Paris on Mount Ida so he can judge which of the three rivals is the most beautiful. The goddesses appear before Paris and try to bribe him to receive the apple. Juno promises the young man that he will rule over all of Europe and Asia; Minerva promises him glory in battle; and Venus guarantees him the love of Helen, the most beautiful woman in the world. Paris chooses Venus and gives the apple to the goddess of beauty. This was the real reason for the Trojan War.

Greek Name
Paris

Relatives and Mythic Origins
Son of Hecuba and Priam, king of Troy; brother of Hector

Characteristics and Activity
Having a lead role in the Judgment of Paris, he awards the golden Apple of Discord; responsible for abducting Helen

Jacopo Amigoni, ▲ *The Judgment of Paris* (detail). Strà, Villa Nazionale Pisani.

Annibale Carracci, ◄ *Mercury and Paris*, circa 1597–1604. Rome, Palazzo Farnese.

Cupid aims his
bow at Venus
and helps
identify her.

Minerva, the
chaste goddess,
wears her hair
down like young
women in the six-
teenth century.

Juno wears a
wide-brimmed
hat instead of her
traditional crown.

Paris wears typi-
cal sixteenth-
century armor.
By setting the
scene during the
period in which
he lived, the
artist intended to
give an allegori-
cal message. A
good prince—
as opposed to
Paris—must
abstain from
choosing only
glory, power, or
love in order to
maintain balance
between all these
divine gifts.

Venus's identity
is shown through
Cupid.

The Apple of Discord is depicted
as a sphere. Mercury, who is also
shown in armor, has not yet given
the apple to Paris.

▲ Lucas Cranach the Elder, *The
Judgment of Paris*, 1528. Basel,
Kunstmuseum.

*The commander from Thessaly frequently appears on the
island of Lemnos with his foot bound, holding the bow and
poisoned arrows that Hercules gave him. He is also shown near
the funeral pyre of that celebrated hero.*

Philoctetes

Events connected with Philoctetes, a native of
Thessaly, are narrated by a number of authors.
It is told that he is a loyal friend of Hercules,
who gave him his bow and poisoned arrows for lighting his
funeral pyre on Mount Oeta. Philoctetes is also one of the com-
manders in the Trojan War. During the voyage to the enemy
city, the Greeks disembark on the island of Lemnos, where a
snake bites Philoctetes. The wound does not heal, and since it
is infected, it emits a terrible odor. The Greek generals decide
to leave Philoctetes on the deserted island, where the Thessa-
lonian commander stays for ten years. However, an oracle pre-
dicts that the Greeks cannot conquer Troy without the help of
Hercules' arrows, so Ulysses sails to retrieve Philoctetes. Arriv-
ing at Troy, Philoctetes is cured by Asclepius (or, according to
other versions, Podalirius or Machaon). He then kills Paris and
a number of Greek heroes. After Troy is taken, he is one of the
fortunate few, Homer says, who has a peaceful, problem-free
voyage home.

Greek Name
Philoctetes

**Relatives and
Mythic Origins**
Son of Poeas and
Demonassa

**Characteristics
and Activity**
Friend of
Hercules; fights
in the Trojan War

Related Myths
Philoctetes lights
Hercules' funeral
pyre on Mount Oeta

Achille Etna Michallon, ▲
Landscape with Philoctetes
(detail), 1822. Montpellier,
Musée Fabre.

Jean-Germain Drouais, ◀
*Philoctetes on the Island of
Lemnos*, 1788. Chartres,
Musée des beaux-arts.

Polyxena is often portrayed kneeling near Achilles' tomb as Neoptelemus, the hero's son, draws near to sacrifice her.

Polyxena

Greek Name
Polyxena

Relatives and Mythic Origins
Daughter of Priam and Hecuba; sister of Hector and Paris

Characteristics and Activity
Polyxena is sacrificed on Achilles' tomb

Polyxena, the daughter of Hecuba and Priam, is the sister of Hector and Paris. She does not appear in the *Iliad* but is remembered in later legends. Ovid tells how a number of women are taken prisoner after Troy falls, including Hecuba and her daughter Polyxena. During the return voyage to Greece, Agamemnon's fleet stops on the coast of Thrace to wait for favorable winds. Suddenly, an abyss opens in the earth and the majestic figure of Achilles appears. The hero accuses the Greeks of forgetting him and orders them to honor his grave by sacrificing Hecuba's daughter on his grave. Achilles' companions bring the girl before the tomb to be sacrificed. Polyxena, knowing that her end is near, declares to Neoptelemus, Achilles' son, that she is ready to be sacrificed and prefers to die rather than be sold as a slave. She asks the Greeks to give her body to her mother without asking anything in return, since Hecuba, who is a prisoner herself, cannot pay. After her speech, the girl stays silent. The chosen priest, Neoptelemus, slays her with a single sword stroke.

▲ Giovanni Battista Pittoni, *The Sacrifice of Polyxena* (detail), circa 1735. Munich, Alte Pinakothek.

◄ Giovanni Battista Pittoni, *The Sacrifice of Polyxena*, circa 1730–35. Prague, Národní Galerie.

Thetis can be seen next to Achilles in Trojan War episodes, at her wedding banquet with Peleus, or immersing her son in the river Styx to make him invincible.

Thetis

Achilles' mother, Thetis, is perhaps the most famous of the Nereids. According to one legend, Jupiter and Neptune both fall in love with this sea nymph, but an oracle warns the two gods that her son will be greater than its father. Thetis is therefore given in marriage to the mortal Peleus, king of Phthia, in Thessaly. All the gods are invited to her wedding banquet except Eris, the goddess of discord. She is offended and gets her revenge by throwing the famous golden Apple of Discord on the gods' table, which eventually leads to the Trojan War.

Thetis primarily appears in the *Iliad*. After learning from an oracle that her son will die in combat at Troy, she tries in every way possible to protect him. After Achilles and Agamemnon quarrel, the goddess urges Jupiter to cause bad luck for the Greeks in battle until they honor her son once again. After Achilles gives away his armor to his friend Patroclus, who is slain by Hector, Thetis goes to Vulcan's workshop and asks the god of fire to forge new weapons for her son. In the end, she tries to distract Achilles from seeking revenge against Hector, knowing that the hero will die soon after.

Greek Name
Thetis

Relatives and Mythic Origins
Daughter of Nereus and Doris; granddaughter of Oceanus

Characteristics and Activity
Sea nymph

Related Myths
Thetis looked after Vulcan after the god was evicted from Olympus as a child by Juno

Giovanni Battista Tiepolo, ▲ *Thetis Consoling Achilles* (detail), 1757. Vicenza, Villa Valmarana.

Agostino Carracci, ◀ *Thetis and Peleus,* circa 1600. Parma, Palazzo del Giardino.

Thetis

The winged cap is an emblem of Mercury.

Eris throws the Apple of Discord on the banquet table.

Jupiter, the king of the gods, wears a crown.

Minerva wears her helmet.

The crown of grain is one of Ceres' attributes.

The laurel crown is a symbol of Apollo.

▲ Abraham Bloemaert, *The Wedding Feast of Peleus and Thetis*, 1638. The Hague, Mauritshuis.

The Trojan Horse is generally depicted as it is being built, being brought into the city, or when the Greeks spring from its side.

Homer only briefly hints at the story of the wooden horse and the fall of Troy in the *Odyssey*. Virgil takes up the subject again, and Aeneas describes it in detail in the *Aeneid*.

Trojan Horse

After many long years of war, the Achaeans realize that they will never storm Troy. Then Ulysses thinks of a way to conquer the city by trickery. He suggests building a huge wooden horse and hiding the bravest warriors in its stomach. Then the Greeks leave the horse behind and desert the coast, giving the false idea that they have withdrawn from their siege. However, they land at an island near Troy. The Trojans decide to take the horse into their city, and since the wooden statue cannot pass through the city gates because of its huge dimensions, they knock part of their defensive wall down. The fall of Troy draws near.

Relatives and Mythic Origins
Ulysses advised Epeius, a Greek leader, to build the wooden horse, which was created with Minerva's help

Characteristics and Activity
The Trojan Horse episode signaled the end of Troy

El Greco, *Laocoön* ▲ (detail), 1610–14. Washington, D.C., National Gallery.

Giulio Romano, ◄ *The Construction of the Wooden Horse*, circa 1538. Mantua, Palazzo Ducale.

The wooden horse is built
by Epeius, a Greek general,
with Minerva's help.

Homer narrates how the horse is brought
into the city with the help of wheels or
rollers that the Trojans made.

▲ Giovanni Domenico Tiepolo, *The Procession
of the Trojan Horse into Troy*, circa 1760.
London, National Gallery.

▶ Pellegrino Tibaldi, *Ulysses Flees from
the Blind Polyphemus*, 1554. Bologna,
Palazzo Poggi.

The Odyssey

Calypso

Scenes that portray Calypso are set within a grotto. Ulysses can be seen with the nymph or outside the cave, facing the sea.

Greek Name
Calypso

**Relatives and
Mythic Origins**
Daughter of Atlas
and Pleione

**Characteristics
and Activity**
Calypso is a nymph
who fell in love with
Ulysses when he was
shipwrecked on her
island home

The nymph Calypso, Atlas's daughter, lives on the island of Ogygia, which Homer calls the "navel of the sea." Ulysses is shipwrecked there after having wandered in a storm at sea for nine days. Calypso welcomes him to her home and soon falls in love with him, hoping that the king of Ithaca will become her husband and stay forever. However, Ulysses cannot forget his wife and country. Not even the promise of immortality lures him. The Greek hero lives on the island for seven years, sleeping with her by night, yet nostalgically pining for his previous life by day. Finally Jupiter sends Mercury to the nymph, ordering her to let her lover go. The messenger tells Calypso to allow Ulysses to leave, since the hero's destiny does not lie with her but in his return to his homeland. She reluctantly submits to the will of the gods and gathers the necessary items for Ulysses to build a raft. In the end, she provides a favorable wind for the hero's departure.

▲ Arnold Böcklin, *Odysseus and Calypso* (detail), 1883. Basel, Kunstmuseum.

▶ Jan Brueghel, *Imaginary Landscape with Odysseus and Calypso*. London, Johnny van Haeften Gallery.

The sorceress Circe is typically shown changing Ulysses' companions into pigs. She can also appear alone or surrounded by her animals.

Circe

The daughter of Sol, the sun god, Circe is remembered by virtue of her magical arts, especially her power to change people into animals.

Fleeing the land of the Laestrygones, Ulysses and his shipmates reach the island of Aeaea, where the sorceress lives. The king of Ithaca sends a few of his men, led by Eurylochus, to scout the region. The sailors cross a large valley and find Circe's palace, which she invites them to enter. The treacherous enchantress makes her guests at home by offering them food and drink, but as soon as they finish their drinks, she changes them into pigs by touching each one on the head with her wand. Eurylochus remains hidden and then hurries back to Ulysses to tell what has happened. Ulysses decides to go to Circe and confront her. He is almost to her palace when Mercury meets him and gives him a beneficial herb that makes him immune to the sorceress's spells. Facing Circe, Ulysses manages to overcome her and convince her to restore his companions to human form.

Greek Name
Circe

Relatives and Mythic Origins
According to Homer, she is the daughter of Sol and Perseis

Characteristics and Activity
A sorceress who transformed Ulysses' companions into pigs

Special Devotions
In Italy she was venerated up until the Imperial period on Mount Circeo

Related Myths
Circe welcomes Medea and Jason after their flight from Colchis with the Golden Fleece

Giuseppe Bottani, ▲ *Circe and Ulysses* (detail), 1760–70. From a private collection.

Giovannni Battista Trotti, ◄ *Circe Brings Ulysses' Companions Back to Human Form*, circa 1600. Parma, Palazzo del Giardino.

The pitcher probably alludes to magic potions that Circe is able to brew.

Circe usually holds her wand, which she uses to change people into animals.

▲ Giovanni Benedetto Castiglione (Il Grechetto), *Circe the Sorceress*, circa 1650. From a private collection.

*The bust of a satyr,
a creature that is
half man and half
animal, perhaps
signifies Circe's
spells, which
change people into
animals, although
they retain their
human memory.*

*The animals
around Circe
are people who
had by chance
come to the sor-
ceress's palace
and were trans-
formed by her.*

Ulysses is immune from Circe's sorcery.
He draws his sword to force the treach-
erous enchantress into transforming his
companions back to human form.

▲ Giuseppe Bottani, *Circe and Ulysses*,
1760–70. From a private collection.

Circe tries to
change Ulysses
into a pig, just as
she did with his
shipmates.

Penelope is usually shown weaving the famous shroud. Either her suitors or Ulysses, who has finally returned to Ithaca, appears next to her.

Penelope

Penelope is the legendary wife of Ulysses. Six years after the Trojan War, while Ulysses is detained by Calypso on the island of Ogygia, the princes of nearby islands come to visit her. They are convinced that Ulysses has died and attempt to make Penelope marry one of them. The clever queen, faithful to the memory of her husband, informs her suitors that she will decide whom to marry after she finishes weaving a huge funeral shroud for Laertes, Ulysses' father. Each night, however, she unravels her previous day's work. This deceit is prolonged for six years before it is finally discovered. The princes order the queen to make a definitive decision. There is about to be a serious dispute when Ulysses returns to Ithaca in disguise. With the help of his son Telemachus and the elderly Eumaeus, Ulysses slays all the suitors.

Greek Name
Penelope

Relatives and Mythic Origins
Commonly considered the daughter of Icarius and Periboea; wife of Ulysses and mother of Telemachus

Characteristics and Activity
Ulysses' wife

Joseph Wright of Derby, ▲ *Penelope Unravels Her Web* (detail), 1783–84. Los Angeles, The J. Paul Getty Museum.

Francesco Primaticcio, ◄ *Ulysses and Penelope.* Toledo, Museum of Art.

Penelope

Argus, Ulysses' loyal dog, is the only one to immediately recognize the hero when he returns to his kingdom in disguise.

Telemachus, Penelope and Ulysses' son, sleeps as his mother watches over him.

The statue in the shadows evokes Ulysses' memory.

Penelope rewinds the thread from the shroud that she secretly unravels each night.

▲ Joseph Wright of Derby, *Penelope Unravels Her Web*, 1783–84. Los Angeles, The J. Paul Getty Museum.

The bow and arrows belong to Ulysses.
Once her shroud trick is uncovered,
Penelope declares she will marry anyone
who can shoot Ulysses' bow and place
an arrow through twelve rings in a row.

Ulysses enters
Penelope's room.

▲ Pinturicchio, *The Return of Odysseus,*
circa 1509. London, National Gallery.

Polyphemus is generally shown devouring Ulysses' companions or being blinded by the Greek hero.

Polyphemus

Greek Name
Polyphemus

**Relatives and
Mythic Origins**
Son of Neptune and
the nymph Thoosa

**Characteristics
and Activity**
A Cyclops, a giant
with a single eye

Related Myths
Polyphemus, in love
with Galatea, kills the
shepherd Acis

Polyphemus is a legendary giant with a single eye. Ulysses lands on the island where the monster lives, and he and his shipmates find themselves in Polyphemus's cave. Toward evening, the giant returns from shepherding and notices the strangers. He asks them who they are and where they come from. Then, disrespectful of the sacred rules of hospitality, he suddenly devours two of Ulysses' companions. The next morning he does the same, eating two more. After locking the remaining foreigners in his den, he goes out to tend his flocks.

Ulysses finds a huge olive tree in the cave, and he and his shipmates cut it down, sharpen its point with fire, and hide it under a manure pile. That evening when the Cyclops returns, he again takes two sailors and eats them. The king of Ithaca then offers the giant some wine that he brought. Polyphemus enjoys himself and drinks until he is drunk, falling into a deep sleep. Ulysses then takes the sharpened tree trunk and heats it red hot in the fire. He punctures the monster's eye. The next morning they are able to flee by hiding themselves under the fleeces of the rams that exit the den to graze.

▲ Odilon Redon, *The
Cyclops* (detail), circa
1898–1900. Otterlo,
Kröller-Müller Museum.

▶ Giulio Romano,
Polyphemus, 1526–28.
Mantua, Palazzo del Té.

In order to flee the terrible Polyphemus, Ulysses hides under a ram that is exiting the cave to graze.

The giant at the cave entrance is Polyphemus, who has been blinded by Ulysses.

The blind Polyphemus touches one of his rams, thinking that Ulysses and his companions are trying to flee by riding his animals.

▲ Johann Heinrich Füssli, *The Blind Polyphemus, Seated at the Entrance of His Cave, Touches the Ram that Ulysses is Hidden Under,* 1803. From a private collection.

Sirens

Sirens are commonly depicted as women whose upper halves are human shaped and whose lower parts are in the form of a fish. They are shown either on the shore or nearing Ulysses' ship.

Sirens are dreadful sea creatures that owe their legendary fame to Homer's tale. They live on a Mediterranean island and are able to seduce sailors who pass nearby with their enchanted singing, drawing them toward themselves to kill. The sorceress Circe, whom Ulysses stayed with for a year, warns the hero about these horrible creatures and advises him how to avoid their deadly attraction.

Ulysses sets off to sea, and a short distance from the island of the Sirens, he orders his crew to plug their ears with wax and tie him to the mast of the ship. He also orders them to pull the knots of the ropes that bind him even tighter if he asks them to free him. The ship begins to move, gliding by the cursed island, and the Sirens begin to sing their bewitching song. They try in every way possible to bring the ship to shore. Ulysses is irresistibly attracted by the sweet melody and tries to free himself at any cost. His shipmates, following the hero's orders, tighten his bindings further. After having passed the island and escaped danger, they continue their voyage.

▲ Arnold Böcklin, *The
Game of the Sirens* (detail),
1886. Basel, Kunstmuseum.

▶ John William Waterhouse,
Mermaid, 1900. London,
Royal Academy of Art.

292

Ulysses' shipmates tie him to the
mast so that he will not succumb to
the irresistible songs of the Sirens.

Sirens are commonly portrayed
as beautiful women whose lower
half is shaped like a fish.

▲ Herbert James Draper, *Ulysses and
the Sirens*. Hull, Farens Art Gallery.

Ulysses

Artists who depict the adventures of Ulysses are inspired by the Odyssey. Renaissance painters often portrayed the hero's story in cycles of frescoes that adorned residences of the nobility.

Greek Name
Odysseus

Relatives and Mythic Origins
Son of Laertes and Anticleia; husband of Penelope; father of Telemachus

Characteristics and Activity
Legendary Greek hero, one of the most famous participants in the Trojan War

Related Myths
Ulysses discovers Achilles hidden among the daughters of Lycomedes

Ulysses is one of the many rulers who participate in the Greek expedition against Troy. After the war, the nymph Calypso detains the hero on the island of Ogygia until the gods decide to help him return home. After he leaves Ogygia on a raft, a storm hurls him toward the land of Phaeacia. There Nausicaa, the daughter of King Alcinous, discovers him and guides him to the palace, where he is generously welcomed by the king.

During a banquet the hero reveals who he really is, telling of the numerous adventures he has survived. He tells of raiding the Ciconians; arriving in the land of the Lotus-eaters; outwitting Polyphemus; meeting Aeolus; and fleeing the land of the Laestrygones, giants who eat human flesh. He recalls how he lands on the island of the sorceress Circe and visits the Underworld. Back at sea, he passes the Sirens and fights the terrible monster Scylla. Later he and his shipmates land on the island

of Sol, where they kill some of the god's sacred herd. Finally after nine days of wandering in a storm at sea, he lands on Calypso's island alone.

Alcinous is moved by Ulysses' tale and gives him a ship to return to Ithaca. Upon returning to his native land, the hero decides to appear in disguise at the royal palace, which is occupied by his wife's would-be suitors. They soon lose their lives.

▲ Gustave Boulanger, *Ulysses Recognized by His Nurse Eurycleia* (detail), circa 1849. Paris, École nationale supérieure des beaux-arts.

▶ Arnold Böcklin, *Odysseus and Calypso* (detail), 1883. Basel, Kunstmuseum.

*After having been shipwrecked with-
out supplies on the island of Sol,
Ulysses' companions slaughter some
cattle from Sol's sacred herd despite
their commander's orders not to.*

*The oxen were born from the union
of Hyperion and his wife, Theia. Circe
advises Ulysses not to harm them if he
wishes to enjoy a calm return home. If
he and his friends do, she predicts, his
companions will perish and he will
reach home a long time afterward.*

▲ Pellegrino Tibaldi, *Ulysses' Companions
Steal the Oxen of Sol,* 1554. Bologna,
Palazzo Poggi.

Nausicaa's maidservants wash linen at the mouth of the river.

This armed goddess is Minerva, protector of Ulysses. One night the goddess appeared to Nausicaa in a dream, suggesting that she go to the beach the following day at the river mouth to wash linen together with her maidservants.

Nausicaa, daughter of king Alcinous, finds Ulysses near the riverbank.

▲ Alessandro Allori, *Ulysses and Nausicaa*, 1579–82. Florence, Palazzo Salviati.

Ulysses was washed up on the beach completely nude. Here he covers himself with a cloth as he sees the girl. Homer, on the other hand, narrates that he covers himself with a branch from a nearby bush.

Ulysses orders Eurycleia to be silent about who he is.

This armed goddess is Minerva. She is the protector of Ulysses, who does not let Penelope see Eurycleia's surprised expression.

Penelope's maid-servant unravels thread as her mistress gazes out the window.

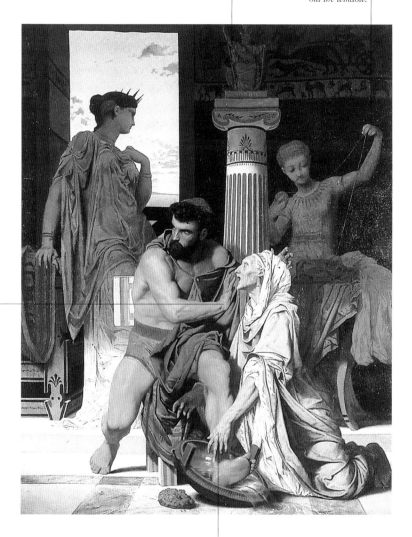

Gustave Boulanger, *Ulysses Recognized by His Nurse Eurycleia*, circa 1849. Paris, École nationale supérieure des beaux-arts.

Eurycleia, Ulysses' nurse, recognizes the king while washing him. She sees the scar that he has on his leg from when a boar wounded him in his youth.

Characters and History from Ancient Greece

Alexander is typically shown dressed as a general; he is often portrayed in the scene where Darius's wife and children kneel before him after the Battle of Issus.

Alexander the Great

Alexander the Great (356–323 B.C.) is the most famous general of all time. His deeds have been related by poets and illustrated by painters, and those who saw him as a model to aspire to often commissioned artistic works. Artists immortalized the most famous episodes of the general's life on their canvases or on walls of the residences of the nobility. These episodes included the scene where the young Alexander tames the terrifying horse Bucephalus, the moment he slices clean through the Gordian knot, and his legendary defeat of Darius's army on the plain of Issus and his generosity toward the Persian king's family afterward.

The myth of Alexander continued throughout the Middle Ages and beyond. Christianity viewed the Macedonian general in contradictory ways; on one hand, he was seen as the personification of the sin of pride and an example of the presumption of someone whose intention is to accomplish things that

go beyond human capabilities. On the other, the Macedonian was also seen in a positive light, and his exploits were interpreted in line with religious thought. During the Renaissance, Alexander was greatly admired and considered an example of magnanimity, courage, and profound humanity.

Relatives and Origins
Son of Philip II of Macedonia

Characteristics and Activity
Legendary general and great conqueror, earning him the name Alexander the Great

Related Episodes
Alexander meets the philosopher Diogenes, who asks Alexander to move because he is blocking the sun

On the preceding pages:
Raphael, *The School of Athens,* 1508. Vatican City, Palazzi Vaticani.

▲ Veronese, *The Family of Darius before Alexander* (detail), 1565–70. London, National Gallery.

▶ Rembrandt, *Alexander the Great,* 1655. Glasgow, Art Gallery and Museum.

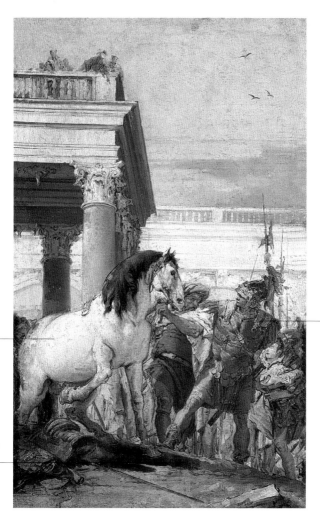

This horse was
offered for sale
to Alexander's
father, Philip,
yet no one is
able to tame the
wild animal.

Alexander is
portrayed here
as a proud war-
rior. He tames
Bucephalus by
facing him
toward the sun.

Alexander real-
izes that the
horse is afraid
of his own shift-
ing shadow.

Giovanni Battista Tiepolo, *Alexander
and Bucephalus*, circa 1760. Paris,
Musée du Petit-Palais.

*Not being able
to untie the
Gordian Knot,
Alexander cuts
through it with
his sword.*

*Gordius, king of Phrygia, tied a knot
around his chariot that is extremely
difficult to undo. It was said that
whoever could untie the knot would
conquer the entire world.*

▲ Jean-Simon Berthélemy, *Alexander
Cuts the Gordian Knot,* circa 1767.
Paris, École des beaux-arts.

▶ Albrecht Altdorfer, *Battle of
Alexander at Issos,* 1529. Munich,
Alte Pinakothek.

The artist depicts the famous Battle of Issus with a wonderful background from the sixteenth century. This painting was commissioned at a time when Europe was the setting for numerous wars. Alexander's battles with the Eastern king were interpreted as metaphors for wars against the Turks.

Darius attempts to flee on his chariot.

Dressed in golden armor, Alexander pursues Darius.

The kneeling characters are Darius's wife and daughters.

*The woman fac
Alexander is
Sisygambis,
Darius's mothe*

▲ Veronese, *The Family of Darius before Alexander*, 1565–70. London, National Gallery.

The character in red is Alexander, who
points to Hephaestion to explain the
queen's error. Or perhaps the Macedon-
ian gestures toward Sisygambis; in that
case, the scene may be portraying the
moment when the general assures the
queen that although she is a prisoner,
she will be treated with honor.

Hephaestion is next to his friend
Alexander. It is said that Darius's
mother prostrated herself in front
of Hephaestion, mistaking him for
the valorous general, and then was
embarrassed because of her error.
Rising above this, Alexander
showed himself to be benevolent
on her behalf.

*The woman sitting in
front of Alexander is
Roxane, the daughter of
an Eastern governor.*

*Sitting opposite Roxane, Alexander
celebrates their wedding. According
to tradition, the Macedonian
admired the girl during a banquet
and consequently made her his wife.*

▲ Giovanni Battista Crosato, *The Marriage
of Alexander and Roxane,* circa 1752–58.
Levada, Villa Marcello.

Apelles is often depicted painting Campaspe's portrait. At times the presence of Cupid or cherubs signals this painter's love for her. Alexander also appears in the scene and is recognizable because of his helmet.

Apelles

Apelles (fourth century B.C.) is a famous Greek painter. Pliny the Elder tells in his *Naturalis Historia* how the artist once asked advice from a shoemaker on how to paint sandals. When the craftsman criticized the artist's rendering of the painted figure's legs, Apelles told him not to judge anything above shoe level!

Another story that enjoyed much success, especially during the Baroque period, was Apelles' love for Campaspe. In painting the girl, the artist falls in love with her, and Alexander realizes Apelles' infatuation and gives the girl to him.

Paintings of this subject sparked the interest of a number of art buyers, not only because they alluded to control over the passions for a noble cause. The episode also portrayed Alexander—and therefore the prince paying for the work—as a protector of the arts.

Relatives and Origins
Native of Colophon, then Ephesus

Characteristics and Activity
Famous Greek painter from antiquity; Alexander the Great's portraitist

Giovanni Battista Crosato, ▲ *Apelles Paints Campaspe in the Presence of Alexander* (detail), circa 1752–58. Levada, Villa Marcello.

Giovanni Battista Tiepolo, ◄ *Alexander and Campaspe in Apelles' Studio,* 1726–27. Montreal, Museum of Fine Arts.

Archimedes is a man of advanced years, often shown thinking. Nearby scrolls and books remind the observer of his studies.

Archimedes

Archimedes (287–212 B.C.) is one of the most celebrated mathematicians and physicists of antiquity, and there are a wide range of discoveries we owe to him: geometric theorems, the legendary Archimedes' principle, even war machines. The mathematician is frequently remembered as a man who is so dedicated to his studies that he forgets to satisfy even the most basic material needs. It is said that while he takes a bath or spreads perfumed ointment on his body, he continues tracing figures on the fireplace or in the ointment itself.

During the Second Punic War, General Marcellus besieges Syracuse. The city holds out for a long time thanks to the famous war machines that Archimedes invents, but in the end the Roman general occupies it. Despite the din of battle, Archimedes is deeply immersed in his studies of geometry and does not pay any attention to the Romans or the fall of the city. Unexpectedly, a soldier appears and orders him to follow him before Marcellus, but Archimedes answers that he will go with him only after having solved the problem he is studying. The soldier, irritated by such presumption, slays him.

Relatives and Origins
Native of Syracuse

Characteristics and Activity
Famous Greek mathematician and physicist

▲ Nicolò Barabino,
Archimedes (detail), circa
1876–79. Trieste, Civico
Museo Revoltella.

▶ Jusepe de Ribera,
Archimedes, circa 1630.
Madrid, Prado.

Aristotle is portrayed as an elderly man. He is identifiable because he often holds one of his most famous books.

Aristotle

Aristotle (384–322 B.C.), the illustrious Greek philosopher, was also Alexander the Great's tutor. In the Middle Ages a legend spread that said he was the famous ruler's teacher.

During the campaign in Asia, the Macedonian general falls in love with the beautiful Phyllis and takes her back home with him. Distracted by love, Alexander soon begins to neglect his state duties. Aristotle reproaches his disciple on the dangers that fascinating women can be for even the mightiest of men, convincing him to return to his sovereign duties. Phyllis is offended and gets her revenge by making the philosopher fall deeply in love with her, but once she has won his heart, she makes him prove his love: Aristotle must let her ride on his back. The wise man is blinded by his passion and agrees. The cunning Phyllis makes sure that Alexander watches in hiding. The king, troubled by seeing this, immediately summons his tutor and asks him to explain himself. Aristotle responds that he wanted to demonstrate to his pupil how important it is to distrust feminine seductions, which not even an old and wise man can resist.

Relatives and Origins
Originally from Stagirus, a Greek city on the border with Macedonia

Characteristics and Activity
Illustrious philosopher of antiquity

▲ Raphael, *The School of Athens* (detail), 1508. Vatican City, Palazzi Vaticani.

► North German, *Waterspout with Aristotle and Phyllis*, circa 1400. New York, The Metropolitan Museum of Art.

Diogenes, old and gray with a long beard, is often shown as he gestures and eloquently invites Alexander to move aside. His symbols are the lamp and barrel.

Diogenes

Diogenes of Sinope is one of the main proponents of the Cynic school of thought. The Greek writer Diogenes Laertius (third century A.D.) describes him in *Lives of Eminent Philosophers* as an austere man who disdains material goods.

The story of his meeting Alexander the Great is emblematic of this philosopher's thought. As Diogenes is lying basking in the sunshine near his barrel, he unabashedly asks the most powerful man on earth to stop blocking the sun. Diogenes considers Alexander's great power useless; one only needs the sun—something so natural and available to everyone—in order to be happy. The philosopher is aware of how futile power is, since, according to him, human happiness comes, not from the outside, but from deep within the soul.

Relatives and Origins
Native of Sinope, in
Asia Minor

**Characteristics
and Activity**
Cynic philosopher

▲ Sebastiano Ricci,
Diogenes and Alexander
(detail), 1684–85. Parma,
Galleria Nazionale.

310

The artist depicts this episode of Diogenes' search for man set in his own era, intending to demonstrate that the Greek philosopher's thought is always valid.

The lantern is a symbol of Diogenes, representing his search for virtue or truth.

It is said that Diogenes used to walk in crowded places in the full light of day with a lighted lantern saying, "I am looking for man." He was alluding to someone who knows how to be happy beyond external circumstances and popular opinion.

◀ Franz Anton Maulpertsch, *Allegory of the Sciences, Diogenes*, 1794. Prague, Library of the Strathov Monastery.

▲ Cesar van Everdingen, *Diogenes Looking for an Honest Man*, 1652. The Hague, Mauritshuis.

Diogenes

Alexander's insignia of the eagle of
Jupiter emphasizes the disparity of rank
between the general and the philosopher.

The barrel is
a symbol of
Diogenes, sig-
nifying how
little one
needs to live.

This proud, armed
warrior is Alexander
the Great.

Diogenes gestures to
Alexander to move
out of the way, saying,
"Leave me the sun."

The horse is
Bucephalus,
who was given
to Alexander in
his youth.

The vegetables on
the ground are a
clear reference to
Diogenes' modest
and frugal life.

▲ Gaspar de Crayer, *Alexander and
Diogenes*, circa 1618. Cologne,
Wallraf-Richartz-Museum.

Heraclitus has a sad or tearful expression and often wears a dark cape. Democritus, on the other hand, is always laughing. His symbol is the globe of the earth.

Heraclitus and Democritus

Heraclitus (circa 550–480 B.C.) was originally from Ephesus, and he is remembered by ancient sources as an irritable character. He is called the "weeper" because of his dark theories and black humor.

Democritus (circa 460–370 B.C.), a native of Abdera, in Thrace, was called the "laughing philosopher" by his contemporaries, not just because he made fun of other citizens but because of his positive view of things. This outlook is indispensable for inner peace, which is so necessary to reach the highest good.

Latin writers such as Seneca and Juvenal compared these two philosophers with one another. Since the fifteenth century, they have often been depicted together, probably to emphasize balance.

Relatives and Origins
Heraclitus was originally from Ephesus; Democritus came from Abdera, a city in Thrace

Characteristics and Activity
Philosophers

Anonymous, ▲ *Democritus* (detail), 1635. Bologna, Palazzo Durazzo Pallavicini.

Donato Bramante, ◄ *Democritus and Heraclitus,* circa 1480. Milan, Pinacoteca di Brera.

Milon

Relatives and Origins
Native of Croton

**Characteristics
and Activity**
Legendary Greek
athlete

*Milon is athletic and muscular. His hands are caught in a tree
trunk as a ferocious animal attacks him.*

Milon was an illustrious Greek athlete who lived in Croton, in
southern Italy, during the sixth century B.C. A number of leg-
endary anecdotes sprang up regarding this character, who was
renowned primarily for his great strength. It is told that he suf-
fered a horrible death.

One day as he is traveling, Milon notices a trunk of an oak
tree that a wedge has broken in two. Although he retired from
competition a long time ago, the athlete decides to try to break
the trunk completely open, perhaps as a way of testing his leg-
endary strength yet one more time. Nearing the stump, he
manages to remove the wedge from the cleft, yet the crack
suddenly closes and traps both of the athlete's hands. Milon
tries desperately to free himself, but his efforts are in vain.
Immobilized and unable to flee, he falls prey to ferocious
animals, which see him trapped and defenseless and tear
him apart.

▶ Pordenone, *Milon Torn to
Pieces by the Lion*, circa 1535.
Chicago, University of Chicago.

Seeing Milon caught, the ferocious beast rushes at him.

Milon is shown with one hand caught in a tree trunk.

▲ Pierre Pouget, *Milon of Croton,*
1670–83. Paris, Musée du Louvre.

Socrates is depicted as an elderly bearded man. His death is often illustrated; surrounded by his disciples, he prepares to drink poisonous hemlock.

Socrates

Socrates (469–399 B.C.) is the Athenian philosopher celebrated for his untiring search for truth. Diogenes Laertius narrates how Socrates advises children to often look at themselves in the mirror, telling them that if they are beautiful, they must become worthy of their beauty; if, on the other hand, they see themselves as ugly, they must compensate for what is lacking with virtue.

Baroque painters in particular derived allegorical images from this anecdote of the Athenian philosopher teaching children self-awareness using his famous motto "Know thyself." Artists generally depict Socrates surrounded by children, as he points to a mirror where one of them is reflected.

It seems that Socrates also had a wife, the terrible Santippe, who was famous for her difficult character and tendency to get angry. Each time her husband returns home, she reproaches him because he spends the whole day lounging about, discussing things. This makes no sense at all to her. One day she is exasperated and throws a pot full of dirty water over the philosopher's head. He is unmoved and affirms, "I knew it; after the thunder comes the rain."

When democracy is instated in Athens, the philosopher is denounced for impiety and corrupting the youth. Put on trial and condemned to death, he dies in prison after drinking hemlock.

Relatives and Origins
Native of Athens

**Characteristics
and Activity**
Philosopher

▲ *Bust of Socrates* (detail).
Rome Musei Capitolini.

This child is Alcibiades, the famous Athenian general who was one of Socrates' students in his youth.

The woman pouring water on Socrates' head is Santippe, the philosopher's wife.

◄ Giuseppe Diotti, *The Death of Socrates*, 1809. Cremona, Museo Civico Ala Ponzone.

▲ Cesar van Everdingen, *Socrates, His Two Wives, and Alcibiades*. Strasbourg, Musée des beaux-arts.

Socrates does not seem bothered by his wife's aggressive behavior at all.

*The elderly, bearded man is
Socrates, who directs these young
men toward self-knowledge.*

*The mirror is a symbol of
awareness and truth.*

▲ Pier Francesco Mola, *Socrates Teaches
Young Men Self-Awareness*. Lugano,
Museo Civico di Belle Arti.

Accused of impiety and corrupting youth, Socrates is imprisoned. His noble self-defense and the steadiness of soul with which he faces death have become an example for the entire Western world.

This man engaged in dialogue with Socrates could be Plato.

The boy offering the plate to Socrates could be Alcibiades. The famous Athenian general was the philosopher's student when he was young.

▲ Orazio Ferraro, *Socrates in Prison*, circa 1630. From a private collection.

Socrates

The philosopher
Plato is immersed
in thought with
his back toward
his teacher.

▲ Jacques-Louis David, *The Death of
Socrates*, 1787. New York, The
Metropolitan Museum of Art.

On the eve of the French Revolution, when the artist was painting this work, the character of Socrates was quite appreciated and contrasted with the deteriorating Old Regime.

Socrates raises his finger toward heaven and discusses the immortality of the soul.

One of Socrates' distraught disciples gives him the cup of hemlock.

Characters and History from Ancient Rome

Aeneas does not have any defining traits. Artists illustrate the hero's adventures by relying on Virgil's Aeneid, *portraying him in single paintings or in series of frescoes.*

Aeneas

Homer describes Aeneas as one of the most courageous generals of Troy. Aeneas is especially remembered as the main character in Virgil's *Aeneid*, the famous epic poem that celebrates the origins of the Roman Empire.

Fleeing Troy, Aeneas is forced to wander the Mediterranean. After stopping at Epirus and Sicily, he is driven by a storm to the coast of Africa, where he is welcomed by Dido, the queen of Carthage. The two fall in love. The queen hopes that Aeneas will become her husband and remain with her forever, but the Trojan's destiny is unchangeable. Urged on by Mercury, the hero puts out to sea again, leaving the despairing Dido to kill herself. Having set sail from the African coast, Aeneas lands in Italy near Cumae and questions the famous Sibyl there. She guides him to the Underworld. There the hero's destiny is confirmed: he will found a new homeland where the city of Rome will someday rise. Taking up his voyage once again, the Trojan hero reaches the mouth of the Tiber in Lazio, where King Latino welcomes him. He later fights a number of battles against hostile Italic populations. They are led by Turnus, who dies by Aeneas's hand in a duel.

On the preceding pages:
Peter Paul Rubens, *Romulus
and Remus and the Wolf,*
1615–16. Rome, Musei
Capitolini.

▶ Giovanni Battista Tiepolo,
Mercury and Aeneas, 1757.
Vicenza, Villa Valmarana.

Aeneas is often shown fleeing from Troy carrying Anchises, his elderly father.

Troy burns in the background.

The child at Aeneas's feet is Ascanius, or Iulus. He is the ancestor of the Iulia family (gens Iulia), of which the Roman emperor Augustus is a descendant.

Aeneas's wife, Creusa, follows her husband as they flee from the burning Troy. The woman is lost in the chaos and killed in the confusion of battle.

▲ Federico Barocci, *Aeneas's Flight from Troy*, 1586–89. Rome, Galleria Borghese.

This character with bow in hand is Venus, mother and protector of Aeneas. According to Virgil, she appears to the Trojan hero dressed as a huntress.

Cupid prepares to shoot one of his arrows at Aeneas, foreshadowing Aeneas's future passion for Dido.

The warrior to the left of Aeneas is Achates, the hero's loyal friend.

After landing on the African coast, Aeneas meets Venus. The hero hears from his mother that he will soon meet Dido and learns of their future love.

▲ Pietro da Cortona, *Venus Appearing to Aeneas*, 1630–35. Paris, Musée du Louvre.

Charon, the deity in charge of ferry-
ing souls to the Underworld, brings
Aeneas and the Sibyl of Cumae over
the Acheron River.

The Sibyl holds the Golden Bough that
Proserpina holds sacred, a necessary
object for entering the world of the dead.

The Sibyl brings Aeneas,
protected by the Golden
Bough, to the Underworld.

▲ Francesco Maffei, *Aeneas in Hades*,
1649–50. Rome, Galleria Corsini.

Caesar

Caesar is either depicted as a general at the head of his army, carried in triumph, or being assassinated near the Roman Forum. He can also appear with Queen Cleopatra.

Relatives and Origins
Descendant of the Iulia
family (*gens Iulia*), he
traced his origins to
Iulus (Ascanius),
Aeneas's son

**Characteristics
and Activity**
Roman general
and politician

Gaius Julius Caesar (100–44 B.C.), military commander and politician, is a descendant of the *gens Iulia*, the noble family whose roots go back to Iulus, Aeneas's son, more commonly known as Ascanius.

In 60 B.C. Caesar inaugurates the first triumvirate together with Pompey and Crassus. Later he fights in a civil war against Pompey, who, after being defeated at Pharsalus, flees to Egypt and is assassinated there.

Artists have often portrayed the episode when Pompey's head is presented to Caesar. The Roman commander, however, is far from thankful and appears shaken and horrified. Plutarch narrates that Caesar did not require such terrible homage. Upon seeing Pompey's seal moments later, he breaks into tears at the loss of his old friend and ally.

Returning to Rome, Caesar is elected dictator by the Roman Senate and subsequently dictator for life. Yet he holds this position for only a few years, until he is betrayed and assassinated through a conspiracy by Brutus and Cassius.

In art, stories featuring Caesar were rarely illustrated before the Baroque period.

▲ Andrea Mantegna, *Julius Caesar*, 1473. Mantua, Palazzo Ducale, Camera degli Sposi.

▶ Giovanni Battista Canal, *Caesar and Calpurnia* (detail), 1795. Venice, Palazzo Mangilli.

Caesar, shown
here dressed as
a general, rallies
his soldiers to
the attack.

The eagle, a
symbol of power
and victory,
appears as an
emblem of
Rome.

▲ Giovanni Demin, *Caesar Subdues
the Helvetians,* 1835. Conegliano,
Villa Gera.

Traditionally
white horses pull
the triumphal
chariot.

The sphere is a symbol
of sovereignty over the
entire world.

The laurel crown was
placed on winners'
heads during triumphal
processions in Rome.

The palm branch
signifies victory.
Thanks to the harmo-
nious arrangement of
its leaves, which are
similar to rays, the
plant was associated
with the sun and
evoked images of glory
and immortality.

▲ Andrea Mantegna, _The Triumph of
Caesar_, circa 1490. Hampton Court
Palace, Her Majesty the Queen Collection.

After arriving in Egypt, Caesar inter-
venes in the power struggles between
members of the Ptolemy family and
places Cleopatra on the throne.

It is said that Cleopatra, who
became Caesar's lover, had a child
by the general called Caesarion.

Mattia Bortoloni, *The Stories of Caesar and
Cleopatra: Cleopatra Sets Sail*, circa 1740.
irago di Lentate, Villa Raimondi.

*Caesar's assassination
occurs near a statue of
Pompey, his old rival.*

*As he falls, Caesar pronounces
the famous phrase "Even you,
Brutus, my son!"*

*Brutus, whom the dictator considered
his loyal friend and protector, draws
near to strike Caesar.*

▲ Vincenzo Camuccini, *The Death of
Caesar*, circa 1733–99. Bologna,
Galleria d'Arte Moderna.

Cato is often portrayed as he commits suicide after Pompey's defeat. He is usually shown nude at the end of his life, resting on a bed or chair. Next to him, a sword or book can appear.

Cato

Marcus Porcius Cato Uticensis (95–46 B.C.), also called Cato the Younger, was a Roman politician with rigid moral principles. He was quaestor (a public magistrate) and then assumed the position of praetor (civil magistrate) of Utica, a Roman province in Africa.

During the civil war between Caesar and Pompey, Cato sides with Pompey. After victories at Pharsalus and Thapsus, Caesar turns his forces against Pompey's followers in Spain and Africa. Hearing that the future Roman emperor is moving toward his province of Utica, Cato decides to take his life. According to Plutarch, one evening, after having eaten dinner with friends, the praetor retires to his rooms. Lying down, he concentrates on reading the *Phaedo*, the famous dialogue by Plato regarding the immortality of the soul, and then falls asleep. At dawn, while everyone is still asleep, he stabs himself in the chest. The blow, however, is not fatal. Shaking with spasms of pain, Cato faints and falls to the ground. Alarmed by the sound, servants run to his bedside. They desperately call a doctor, who tries to sew the deep wound. Coming to, Cato pushes the doctor away and reopens the wound with his bare hands and dies.

The character of Cato, who fearlessly faces death while remaining faithful to his principles, was considered a call to coherence and moral integrity.

Relatives and Origins
Called Uticensis, he is the great-grandson of Cato Censorius

Characteristics and Activity
This Roman politician sided with Pompey during the civil war between Pompey and Caesar

Antonio Carneo, ▲
The Suicide of Cato (detail).
From a private collection.

Johann Carl Loth, ◄
The Suicide of Cato,
1647–48. Copenhagen,
Statens Museum for Kunst.

The story of Cimon and Pero occurs in a prison; Cimon is usually old, gray, and chained. He is breastfed by his daughter Pero.

Cimon and Pero

The Roman historian Valerius Maximus (first century A.D.) tells the moving story of Cimon and Pero in his work entitled *Factorum ac dictorum memorabilium libri IX* (Memorable deeds and proverbs).

Cimon is in prison waiting to be executed. His daughter Pero is able to visit him each day, thanks to the generosity of a guard. Since Cimon has not been fed for a long time and is at the point of starving to death, his daughter nourishes him by offering him milk from her breast.

In Rome it was believed that the Temple of Pietas was located at the very spot where the story of Cimon and Pero was set.

In art, the two characters appear inside the prison, and sometimes a guard watches from behind the bars of a window, or a number of sentinels burst into the cell with swords drawn. The story is a typical example of filial respect and was quite popular, especially among Baroque artists from Italy and Holland.

Relatives and Origins
Cimon is an elderly man; Pero is his daughter

Characteristics and Activity
A prisoner in jail, Cimon is nurtured by his daughter Pero, who offers him milk from her breast

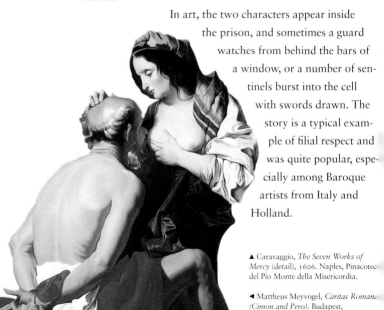

▲ Caravaggio, *The Seven Works of Mercy* (detail), 1606. Naples, Pinacoteca del Pio Monte della Misericordia.

◄ Mattheus Meyvogel, *Caritas Romana (Cimon and Pero)*. Budapest, Szépmüvészeti Múzeum.

Civilis is usually shown with one eye missing. He is defiant, and together with a number of Batavi he swears to become free of Rome's yoke.

Civilis

Civilis was a nobleman from Batavia (in present-day Holland) who lived during the first century A.D.

He decides to rebel against the yoke of the Roman Empire and organizes a banquet near a sacred forest, inviting the heads of nearby tribes and other active representatives of the Batavi. At the end of the banquet, he begins to exalt the valor of the various tribes. He claims that freedom can be achieved through the strength and military capabilities of their soldiers, inviting them all to swear loyalty to the cause of freedom according to custom. After obtaining the agreement of the various barbaric peoples, the Batavian general makes war on the Romans, achieving a number of victories. The Romans, however, are still able to quell the rebellion and impose a peace treaty to keep order in the area.

The swearing of the oath, a crucial moment in the history of the revolt, was primarily depicted by Dutch artists in the seventeenth century. In a way, by recalling this proud, freedom-loving character, they were exalting the noble origins of their people.

Relatives and Origins
Nobleman native of Batavia (present-day Holland)

Characteristics and Activity
Convinces the Batavi to rebel against the Romans

Rembrandt, ◄
The Conspiracy of Claudius Civilis, circa 1661–62.
Stockholm, Nationalmuseum.

335

Cleopatra

Cleopatra usually appears at the banquet that honored Mark Antony or at her death, seated on a throne or lying on a sofa.

Relatives and Origins
Daughter of Ptolemy
Auletes, king of Egypt

**Characteristics
and Activity**
Queen of Egypt

Cleopatra (69–30 B.C.) was the last queen of Egypt. The episodes of the sovereign's life that have been described by artists are based on legends that sprang up around this extremely beautiful and a bit extravagant character and on the love story between her and Mark Antony.

It is written that Mark Antony was quite taken with the luxuriousness of her court during a banquet held there in his honor. In order to demonstrate how little she cares for her riches, Cleopatra takes an extremely valuable pearl from an earring, dissolves it in her chalice of wine, and drinks it. The most famous story, however, which enjoyed huge success in painting and poetry, is the tale of the queen's tragic death. After his defeat at the battle of Actium, Mark Antony kills himself in order to not become Octavian's prisoner. Consumed by despair, and also not wanting to be brought in chains before the triumphal court of the future Roman emperor, Cleopatra also commits suicide, letting herself be bitten by an asp that was hiding in a fruit basket.

The subject of love, taken to the extreme consequences of self-sacrifice, was quite popular in painting, especially beginning in the seventeenth century.

▲ Anton Schoonjans,
Cleopatra (detail), 1706.
Bucharest, Muzeul National
de Artá al României.

◀ Lavinia Fontana,
Cleopatra, circa 1585.
Rome, Galleria Spada.

336

Here Cleopatra is shown as a noble lady from the eighteenth century. Inspired by Roman legends, the artist hopes to show the aristocratic virtues of his clients, the Labia family, by alluding to their extensive hospitality.

Mark Antony is protrayed as a gallant general being welcomed by Queen Cleopatra.

▲ Giovanni Battista Tiepolo, *The Banquet of Cleopatra*, 1747–50. Venice, Palazzo Labia.

Cleopatra

Cleopatra is about to place a pearl in a glass of wine. Primarily composed of calcium carbonate, the pearl dissolves upon contact with acid (wine vinegar) and produces foam.

This Roman soldier is Ahenobarbus, a companion in arms to Mark Antony. He later transfers into Octavian's service.

▲ Giovanni Battista Pittoni, *Cleopatra's Wager*, 1725–30. New York, The Stanley Moss Collection.

Mark Antony holds the chalice of wine for the queen. The artist did not intend to emphasize the banquet as much as the queen's indifference to her own riches.

Cleopatra puts an asp to her breast. The theme of suicide for love was often depicted as an example of suffering and heroism. Here it is portrayed with great visual and emotional impact.

A hysterical maidservant witnesses the queen's death.

The serpent was hidden in a bowl of fruit that a farmer brought to Cleopatra.

▲ Luca Giordano, *The Death of Cleopatra*, circa 1700. From a private collection.

*A Roman matron, Cornelia is portrayed proudly displaying her
sons as another woman, richly dressed, shows off her jewelry.*

Cornelia

Relatives and Origins
Daughter of Publius
Cornelius Scipio
Africanus

**Characteristics
and Activity**
Roman matron and
mother of Tiberius
and Gaius Gracchus

Cornelia (circa 189–110 B.C.) is the daughter of
Scipio Africanus, the famous Roman commander
who defeated Hannibal. The girl marries the consul
Tiberius Sempronius Gracchus, and two children are
born to them (or twelve, according to some). These
are the famous Tiberius and Gaius, commonly known as the
"Gracchae," promoters of a celebrated agrarian reform that
caused their death. Cornelia was left a widow at a young age
yet renounced another marriage in order to completely dedi-
cate herself to educating her children.

Valerius Maximus narrates that one day Scipio's daughter is
with her children visiting a Roman matron. When the woman
proudly displays her precious jewels and asks Cornelia to
show hers, Cornelia points to her sons and exclaims, "Here
are my jewels!"

▲ Domenico Beccafumi,
Cornelia (detail), circa 1519.
Rome, Galleria Doria Pamphili.

▶ Philipp Friedrich von Hetsch,
*Cornelia, Mother of the
Gracchae,* 1794. Stuttgart,
Staatsgalerie.

Decius Mus is dressed as a Roman commander. He can be portrayed consulting an oracle or sacrificing himself in battle.

Publius Decius Mus (fourth century B.C.) was a Roman consul who played a central role during the battle against Latin rebels near Mount Vesuvius in 340 B.C.

Decius Mus

Before the battle, the consuls consult oracles and make sacrifices to invoke the protection of the gods, according to tradition. A soothsayer cuts a slaughtered animal's liver in order to read the future. Although the priest sees a positive outcome for the battle, he shows Decius that the part of the liver that tells of the state's future does not look favorable for him. The battle begins, and everything seems to be going well for the Romans when suddenly the left flank of the company collapses from the pressure of the Latins and begins to retreat. At this point, Decius Mus intuitively realizes the soothsayer's meaning and immediately goes to ask how he might sacrifice himself for the legions. The priest dresses him in a special cloak and performs a solemn ritual, consecrating him to the gods of the Underworld. After the service, Decius Mus

Relatives and Origins
Father of a Roman consul who had the same name

Characteristics and Activity
Roman consul; he sacrifices his life to assure the Romans victory

takes up his arms and is slain after hurling himself into the midst of his enemies. The Romans win the battle, and the consul is buried with all the honors of someone who died gloriously.

Peter Paul Rubens, ▲ *The Death of Decius Mus* (detail), 1617–18. Vaduz, Sammlungen des Regiertenden Fürsten von Liechtenstein.

Tapestry made in Brussels, ◄ *Decius Mus Consults the Oracle, circa* 1616–42. Anvers, Municipal Museum.

Dido

Relatives and Origins
Daughter of Mutto,
king of Tyre

**Characteristics
and Activity**
Queen and founder
of Carthage

Dido often appears at Aeneas's side. Artists have especially preferred rendering the episode of this Carthaginian queen's death.

The myth of Dido dates back to ancient legends of Phoenician migrations throughout the Mediterranean. Virgil capitalizes on this tradition, bringing some important variations and making the queen one of the most defined and well-known characters of his *Aeneid*. Despite there being actually more than three centuries between the fall of Troy and the foundation of Carthage, the Latin poet imagines that Dido and Aeneas are contemporaries and that his hero, after leaving Troy in flames, lands on the African coast near Carthage after a storm. Dido welcomes him benevolently, and, at a banquet held in his honor, Aeneas tells of the many struggles he overcame after Troy was taken. The queen falls in love with him, and he with her. However, Aeneas cannot escape the destiny that the gods have reserved for the Trojan prince and his descendants. Urged by Mercury, Aeneas is forced to take up his voyage again despite the deep feelings that link him to Dido. The queen tries in vain to keep her lover from leaving in a heart-rending farewell, yet the Trojan commander departs. The despairing Dido gives the order to light a funeral pyre, on which she kills herself with Aeneas's sword.

▲ Il Guercino, *The Death of Dido* (detail), circa 1631. Rome, Galleria Spada.

▶ Anonymous, *Aeneas and Dido Help Build Carthage*. Rome, Palazzo Spada.

*After being driven from Tyre by her
brother, Dido lands on the African coast.
The natives agree that she can occupy as
much territory as she can cover with a
cow's hide.*

*Dido orders the hide cut into
extremely thin strips, which she
uses to circle the area that will be
the future city of Carthage.*

▲ Giovanni Battista Pittoni, *Dido
Founding Carthage*. Saint Petersburg,
Hermitage.

A servant brings a basin holding the
jewels of Illione, Priam's daughter.
Aeneas gives the precious items to
Dido as a gift.

Aeneas presents himself to Dido
and offers valuable gifts in homage
that he brought from Troy.

Virgil tells how Cupid appears to
Dido dressed as Ascanius, Aeneas's
son. Venus, in fact, asks her son to
disguise himself and shoot the queen
with one of his arrows, making Dido
fall in love with Aeneas.

A kneeling young man offers the queen
fine clothing that Helen had received
from her mother, Leda, as a gift.

▲ Francesco Solimena, *Dido Receiving Aeneas
and Cupid Disguised as Ascanius*, circa 1710.
London, National Gallery.

Juno sends a storm. She is Aeneas's enemy and hopes that the hero, after falling in love with Dido, will abandon his assigned task of founding a new city in Italy.

Dido and Aeneas enter a cavern to shelter themselves from the unexpected storm.

▲ Thomas Jones, *Landscape with Dido and Aeneas*, 1769. Saint Petersburg, Hermitage.

Dido

The desperate Dido attempts to keep Aeneas from his imminent departure.

Aeneas, on Mercury's orders, prepares to set sail. Although still deeply in love with the queen, the hero remains unmoved by her pleas.

▲ Francesco de' Mura, *The Departure of Aeneas*, circa 1750. From a private collection.

Cupid flies from the scene, recalling the beginning of Dido, *a tragedy by Ludovico Dolce (1508–68). In the prologue the winged cherub announces Dido's sorrowful end and the future destruction of Carthage.*

Anna, Dido's sister, expresses shock and fear at seeing the queen.

Aeneas's ship is now some distance from Carthage.

Dido kills herself on a funeral pyre, impaling herself on Aeneas's sword. She was considered a heroine and often portrayed together with other femmes fortes, *such as Judith, Esther, Artemisia, and Sophonisba.*

Il Guercino, *The Death of Dido*, circa 631. Rome, Galleria Spada.

Hannibal is often pictured as an armed general. He can appear as a young man taking an oath of hatred against the Romans or during the battle at Cannae.

Hannibal

Relatives and Origins
Son of Hamilcar Barca

Characteristics and Activity
Legendary general of Carthage

Hannibal (247–circa 183 B.C.) is the son of Hamilcar Barca, the Carthaginian general who fought against Rome in the First Punic War.

When Hannibal is still a child, his father brings him along on a military campaign in Spain. One day Hamilcar decides to make a sacrifice so the war will be successful. As he is about to carry out the ritual, he orders his son to swear eternal hate toward the Romans.

Hannibal goes on to become one of the most capable Carthaginian generals, and in 219 B.C. he occupies Saguntum, a Spanish city allied with the Romans. This begins the Second Punic War. The courageous general then marches from Spain to threaten Italy, crossing the Alps with elephants. Upon entering the country, he wins at Trebia, Lake Trasimene, and finally Cannae, where the Romans suffer their worst defeat ever. Instead of completely destroying Rome, however, Hannibal decides to create a small personal kingdom in southern Italy by allying himself with Capua. Rome's retaliation, however, led by Publius Cornelius Scipio, cannot be held off, and Hannibal is forced to turn back to his homeland. Scipio pursues him in Africa, scoring a number of victories. The two generals finally meet at Zama (202 B.C.), in the famous battle that definitively marks the fall of Carthage.

▲ Francisco de Goya, *Hannibal Crosses the Alps* (detail), 1771. From a private collection.

▶ Jacopo Ripanda (from the workshop of), *Hannibal in Italy* (detail), 1508–9. Rome, Palazzo dei Conservatori.

With an elegant gesture, the priest shows the young Hannibal a statue of a Roman soldier, to which Hannibal must swear eternal hatred.

The statue of the soldier evokes an image of Rome.

Hamilcar invites the young Hannibal to pledge his hatred of the Romans.

The young Hannibal listens to the priest in front of him.

Giovanni Battista Pittoni, *Hamilcar and Hannibal,* circa 1723. Milan, Pinacoteca di Brera.

A figure representing a personification of the Po River is shown with a bull's head. In traditional imagery, this river was depicted this way because it was said that the flowing water sounded like a bull bellowing or because the curve of the river seemed like a bull's horn.

At the Alps, Hannibal raises his helmet visor to look at Italy for the first time.

This personification of the Po River leans on an urn.

A winged sprite near Hannibal shows the Carthagian general the plain before him.

▲ Francisco de Goya, *Hannibal Crosses the Alps*, 1771. From a private collection.

Laelius, the commander of
the Roman cavalry, rallies
his soldiers to attack.

A Carthaginian
elephant crushes
a Roman soldier.

Despite his ele-
phants, Hannibal
was defeated at
Zama because the
Roman cavalry was
much stronger.

The Roman soldiers march forward
holding torches. The elephant is
frightened and carries away some
Carthaginian soldiers.

◢ Made in Brussels, *The Battle of Zama*,
ʌpestry, circa 1650–65. Rome, Palazzo
el Quirinale.

Horatii

Relatives and Origins
The legend of the Horatii and the Curiatii families dates to the war between Rome and the nearby city of Alba Longa during the seventh century B.C.

Characteristics and Activity
The Horatii of Rome were triplets, as were the three Curiatii of Alba Longa

During a war between the inhabitants of Alba Longa and the Romans, the opposite sides agree that the outcome of a battle should be decided by combat between six brothers, two sets of triplets who are close in age and bravery. The three Horatii are Roman, and the three Curiatii are from Alba Longa. Before the fight the Horatii take a solemn oath to sacrifice themselves for their homeland and to face their enemies fearlessly. Only one of the Horatii survives the struggle, giving Rome victory. As the young man returns triumphantly home, his sister realizes that he is bringing with him, as a trophy on his shoulder, the cape of her lover, who was one of the Curiatii. She despairs and bursts into tears. Her brother, infuriated at her weeping for one of Rome's enemies, which he considers arrogance on her part, slays her. He is condemned to death for doing so but is pardoned after his father passionately intercedes.

▲ Giuseppe Cesari (Cavalier d'Arpino), *The Battle Between the Horatii and Curiatii* (detail), 1612–13. Rome, Palazzo dei Conservatori.

▶ Jacques-Louis David, *The Oath of the Horatii*, 1784. Paris, Musée du Louvre.

Lucretia is primarily depicted at her death as she stabs herself with a dagger or falls upon a sword.

Lucretia

A virtuous Roman noblewoman, Lucretia is married to Collatinus. Unfortunately, Sextus Tarquinius, son of King Tarquinius Superbus, desires her and enters into her room by night, taking advantage of the fact that her husband is away with the army. He is armed and tries to seduce the woman in every way possible. At her unwavering refusal, he threatens to kill a slave and place the body next to her own, causing people to think that Lucretia was found committing adultery with a servant. Not having any choice, the woman accedes to Sextus's desires. The next day Lucretia sends for her father and husband. After telling them what happened, she makes them swear vengeance and then kills herself with a dagger. Junius Brutus, the grandson of Tarquinus Superbus, witnesses the scene and incites the people to revolt, expelling the king and his sons from Rome. This event marks the beginning of the Roman Republic, and Brutus and Collatinus are the first consuls.

Lucretia's preference for death rather than dishonor was a recurring theme in Renaissance imagery, which interpreted the woman's extreme sacrifice as a symbol of matrimonial virtue.

Relatives and Origins
According to Livy, the daughter of Spurius Lucretius Tricipitinus

Characteristics and Activity
Roman noblewoman; wife of Collatinus, the first consul of the Roman Republic

Parmigianino, ▲
Lucretia (detail), 1540.
Naples, Capodimonte.

Lucas Cranach the Elder, ◄
Lucretia, 1532. Vienna,
Gemäldegalerie.

The young woman's hairstyle, with her hair tied up under a cap, was typical of married women, suggesting that this picture was painted after the subject's marriage.

With a clear gesture of the right hand, the subject points toward the drawing. With this she identifies herself with the Roman heroine and shows her intention of maintaining her married virtue.

▶ Lorenzo Lotto, *Portrait of a Lady Dressed as Lucretia,* circa 1533. London, National Gallery.

The drawing that the woman holds recalls Lucretia's dramatic suicide.

A Latin phrase on this piece of paper reads, "No immodest woman should survive Lucretia's example" (Nec ulla impudica Lucretiae exemplo vivet). This motto means that no woman who loses her honor and continues living can cite Lucretia as any sort of precedent.

Wallflowers symbolize purity.

Tarquinius threatens Lucretia by rushing at her with a dagger.

Lucretia tries in vain to free herself from the menacing figure.

▲ Titian, *Tarquin and Lucretia*, circa 1570. Vienna, Gemäldegalerie.

Marcus Curtius appears as a young, proud, fully armed Roman warrior who leaps into an abyss on horseback.

Marcus Curtius

The legend of Marcus Curtius harkens back to the origins of Rome's history, when the city was still in conflict with Italic peoples.

Livy narrates how one day, probably because of an earthquake, a huge chasm opens up in the Roman Forum. The Romans hurriedly attempt to close up the deep opening by filling it with dirt, but no matter how hard they work, they are unable to fill it. Upon interrogating the seers, the Romans learn that the pit can only be closed with "the most important thing in Rome" and that the Roman state would be eternal if this offering is made. The perplexed Romans are discussing what to do when the young Marcus Curtius harshly criticizes their general uncertainty, saying that the most important things for the Romans are weapons and valor in battle. Then, amidst the silence of the onlookers, he raises his hands to heaven and offers himself to the gods. Fully armed, he mounts his horse, which is richly decorated for the occasion, and leaps into the deep chasm.

In honor of the soldier, the place was called "the hole of Marcus Curtius" and was still known as such during the Imperial period.

Relatives and Origins
The events of the life of Marcus Curtius date to the origins of Rome

Characteristics and Activity
Young Roman soldier

Marcus Curtius (detail), ▲ 1540–70. Milan, Castello Sforzesco, Museo d'Arti Applicate.

Benjamin Robert Haydon, ◄ *Marcus Curtius Leaps into the Abyss*, 1836–42. Exeter, Royal Albert Memorial Museum.

Mucius Scaevola is often portrayed in the presence of King Porsenna with his hand over a lighted brazier. The lifeless body of a scribe can appear next to the Etruscan king.

Mucius Scaevola

Relatives and Origins
The legend of Mucius Scaevola dates to the sixth century B.C., to the war between Rome and the Etruscans

Characteristics and Activity
Young Roman nobleman

Gaius Mucius is a young descendant from a noble Roman family. When Rome is besieged by the Etruscan king Porsenna, the young Roman manages to steal into the enemy's camp, intent on killing the king. However, Mucius mistakenly slays the king's scribe. He is caught by the guards and brought before Porsenna. He proudly declares what he planned to do and then disdainfully places his right hand over a nearby brazier to demonstrate how little he cares whether he lives or dies. Deeply struck by the Roman's bold gesture, Porsenna frees him and gives his sword back to him. The king then sends ambassadors to Rome to request a truce. From that day on, Mucius is called "Scaevola," or "left-handed."

Mucius Scaevola is one of the most famous characters in all Roman legends. Beginning in the Renaissance, the young man was seen as a model of patience and constancy. For this reason, a burning brazier can symbolize the virtue of perseverance.

▲ Peter Paul Rubens, *Mucius Scaevola Before Porsena* (detail), 1616–18. Budapest, Szépmüvészeti Múzeum.

▶ Sebastiano Ricci, *Mucius Scaevola*, 1684–85. Parma, Galleria Nazionale.

Mucius Scaevola places
his hand in the fire to
demonstrate his courage.

The artist sets this episode of Mucius
Scaevola in his own time. During the
first half of the sixteenth century, in fact,
Germany was marked by deep religious
and political upheavals.

The dead man next to
the king represents the
scribe that Mucius
Scaevola killed by
mistake.

King Porsenna is depicted as a noble
sovereign of the sixteenth century.

▲ Hans Baldung (Grien), *Mucius
Scaevola*, circa 1531. Dresden,
Gemäldegalerie.

Romulus and Remus are frequently shown as newborns being suckled by a wolf. The events of their lives are often illustrated in cycles of frescoes.

Romulus and Remus

Amulius and Numitor, sons of King Procas of Alba Longa—a descendant of Aeneas—succeed their father to the throne. In his thirst for power, Amulius deposes his brother and forces Rhea Silvia, Numitor's only daughter, to remain a Vestal Virgin. Later the god Mars comes to lay with the girl, and she gives birth to twins. Amulius then imprisons her and orders a servant to throw the infants in the Tiber River. However, the chest holding the children remains entangled on the shore, and there the twins are nursed by a she-wolf. Then the shepherd Faustulus finds them, and he and his wife raise the two. Growing up, Romulus and Remus learn of their origins and, after killing Amulius, return Alba Longa to Numitor. The twins then found a new city, Rome, at the site where they had been abandoned. Later they quarrel, and Romulus, after slaying his brother, continues founding the city by himself.

Relatives and Origins
Sons of Rhea Silvia and the god Mars

Characteristics and Activity
Twin brothers who played lead roles in the oldest legend of Rome

Special Devotions
The Quirinalia festivals were celebrated in honor of Romulus, the founder of Rome

▲ Peter Paul Rubens, *Romulus and Remus and the Wolf* (detail), 1615–16. Rome, Musei Capitolini.

▶ Agostino, Annibale, and Ludovico Carracci, *Romulus and Remus Nursed by the Wolf,* 1590–92. Bologna, Palazzo Magnani.

The shepherd Faustulus brings home the twins Romulus and Remus.

Laurentia, Faustulus's wife, takes in the twins. Livy records an ancient version of the myth in which Laurentia was nicknamed Mother Wolf. This was the origin of the legend that a wolf, an animal sacred to Mars, nursed the children.

The white pigeon about to lunge at its own "twin"—shown here quenching its thirst—is a clear reference to the future clashes between the two brothers.

▲ Sebastiano Ricci, *The Childhood of Romulus and Remus*, 1706–7. Saint Petersburg, Hermitage.

Sabines

The scene of the rape of the Sabine women by the Romans is often set inside or outside the newly founded city of Rome. The armed men are shown abducting the women, who try desperately to free themselves.

Relatives and Origins
The Sabines were an ancient people in Italy

Characteristics and Activity
The Sabine women were abducted by Romulus and raped to populate the newly founded city of Rome

After having founded Rome, Romulus realizes that in order for the kingdom to steadily grow, there must be a sure and steady lineage. To this end, he sends messengers to nearby peoples to establish new alliances and guarantee future marriages. None of these ambassadors are welcomed, however, since the nearby cities fear the future power of Rome. Romulus decides to organize a solemn festival in honor of Neptune, inviting the Sabines and other bordering peoples. During the celebrations, at a given signal the young Romans abduct the Sabine women and drive out their relatives. This provokes an inevitable reaction from the Sabines, who declare war on Rome. During a bloody battle, however, the Sabine women come between the two sides and implore them to lay down their weapons and establish a peace agreement. Their pleas are heard and the two populations come together with Rome as their capital.

▶ Nicolas Poussin, *The Rape of the Sabine Women*, circa 1633–34. New York, The Metropolitan Museum of Art.

Scipio Africanus is typically portrayed during the episode of his famous act of mercy. Aemilianus Scipio, instead, is shown sleepily resting between two female figures: one stern, the other seducing.

Scipio

Publius Cornelius Scipio Africanus (236–circa 183 B.C.) is the famous Roman general who defeated Hannibal at Zama (202 B.C.), after which he was called "the African." This Roman general was a proud man of sound principles, and artists often depict him in one particular episode that shows his generosity.

After conquering Carthago Nova, in Spain (209 B.C.), Scipio receives a beautiful girl as part of the spoils of war. However, he learns that the girl is betrothed and restores her to her fiancé, Allucius. He refutes any gifts that her relatives try to give him to ransom her, opting instead to offer these to the couple.

His adopted grandson, Publius Cornelius Aemilianus Scipio (circa 186–129 B.C.), destroys Carthage in 146 B.C., ending the Third Punic War. In his dialogue entitled *De Republica*, Cicero narrates that Scipio Africanus appears in a dream to his grandson. He shows him the heavenly kingdom that awaits those who dedicate themselves to an active and contemplative life, avoiding the temptations of the senses. The humanists later interpreted this vision as that of "universal man," a balanced synthesis of moral directions.

Relatives and Origins
Scipio is the last name of a noble Roman family

Characteristics and Activity
The two most famous members of the Scipio family, Publius Cornelius Scipio Africanus and Publius Cornelius Aemilianus Scipio, were famous generals

Francesco Guardi, ▲
The Continence of Scipio.
Oslo, Bogstad Stigrelse.

Francesco di Giorgio Martini, ◀
Scipio Africanus, circa 1490–1500. Florence, Museo Nazionale del Bargello.

In an elegant gesture, Scipio restores young Allucius's fiancée.

The girl comes to Scipio as part of the spoils of war from the fall of Carthago Nova.

The man at Scipio's feet is Allucius, who thanks the general for his generosity of spirit.

Gifts brought by the girl's parents in exchange for her freedom rest on the ground. Scipio gives them to the two lovers.

▲ Jean Restout, *The Continence of Scipio*, 1728. Berlin, Gemäldegalerie.

The sword that the sternly dressed woman offers symbolizes the knight's vigorous and courageous life.

Laurel, a symbol of fame and glory, alludes to the knight's death.

The book signifies contemplative life.

A young girl offers myrtle to the knight. An attribute of Venus, the plant refers to the tendency toward love.

Raphael, *Scipio's Dream*, 1504.
London, National Gallery.

Seneca

The philosopher Seneca is often pictured at his death. He is partly nude and immersed in a tub filled with water, and a woman frequently kneels at his side.

Relatives and Origins
Son of Seneca, a writer on rhetoric

Characteristics and Activity
Latin philosopher and writer; Emperor Nero's tutor

Lucius Annaeus Seneca (circa 4 B.C.–A.D. 65), a Stoic philosopher and Latin writer, was the emperor Nero's tutor. He is unjustly implicated in a conspiracy against the emperor, who upon hearing of it accuses the philosopher of plotting against him. He forces Seneca to commit suicide. The Latin historian Tacitus, who praises Seneca's stoic steadfastness and extraordinary strength of spirit, tells the episode of Seneca's death in *Annales*.

After having dictated his thoughts up to the very last moment, Seneca cuts open a vein and poisons himself. Then, since his death is slower than expected, he immerses himself in a tub of scalding water and soon dies. His wife tries to kill herself with him, but Roman guards prevent her from doing so.

This story is often featured in Italian and northern European painting, especially from the seventeenth century. This was a time of renewed interest in Stoic ideas, which presumed that reason could dominate the passions.

▲ Peter Paul Rubens, *The Four Philosophers* (detail), circa 1611–12. Florence, Palazzo Pitti.

▶ Gerrit van Honthorst, *Death of Seneca*. Utrecht, Centraal Museum.

The Sibyls are generally portrayed as young women with turbans and books in their hands; sometimes they alternate with the twelve prophets of the Bible.

Sibyls

The Sibyls are the most famous seers of antiquity. They are generally considered priestesses of Apollo. They predict the future and are able to interpret the god's oracles. Their origins date back to the lost reaches of time, and many places and countries boast of the honor of Sibyls being born there. The name of each Sibyl includes her place of origin. According to some sources, these famous soothsayers numbered four; others counted ten: the Persian, Libyan, Delphic, Cimmerian, Erythraean, Samian, Cumaean, Hellespontic, Phrygian, and Tiburtine Sibyls.

Western Christianity interpreted the oracles as an anticipation of Christian history and considered the Sibyls the pagan equivalent of the twelve prophets of the Bible. In this context, it is told how one day the emperor Augustus asks the Tiburtine Sibyl whether he should accept his deification, which the Roman Senate is proposing. The seer announces the future coming of a child who will be greater than all gods. At that moment the heavens open and the Virgin and Child appear to the emperor.

Relatives and Origins
The first Sibyl can be traced to Asia Minor

Characteristics and Activity
Ancient seers

Guido Reni, ▲
Sibyl (detail), 1635–36.
London, Sir Denis Mahon Collection.

Domenichino, ◀
A Sibyl, 1616–17.
Rome, Galleria Borghese.

▲ Antoine Caron, *The Tiburtine Sibyl,*
circa 1571. Paris, Musée du Louvre.

An image of Jesus and Mary
appears to Augustus.

The Sibyl shows
Augustus this
remarkable
vision.

A book is a symbol of the
Sibyls. The dark sentences that
these seers prophesied regarding
the future were collected by
priests and transcribed in the
so-called Sibylline Books.

Augustus asks the Tiburtine Sibyl if he
should accept his deification, which the
Roman Senate is proposing at the time.

The Sibyl of Cumae is shown as an
elderly woman. It is told that Apollo,
who falls in love with this priestess,
offers to grant her a wish, so she asks
the god to live as many years as the
number of grains of sand that can be
held in one hand. She forgets, however,
to ask for eternal youth.

The book,
which refers to
the famous
Sibylline Books,
is an emblem
of Sibyls.

▲ Michelangelo Buonarroti, *The Sibyl of
Cumae*, 1508–12. Vatican City, Palazzi
Vaticani, The Sistine Chapel.

Sophonisba is usually depicted as a richly dressed woman with a chalice in her hand or ready to take a cup brought by a servant.

Sophonisba

Sophonisba, the daughter of Hasdrubal, marries Syphax, a prince of Numidia allied with the Romans. She convinces her husband to rebel against the empire and remain loyal to the Carthaginians. However, another Numidian prince, Masinissa, also allied with Rome, captures Syphax, who is then imprisoned in Italy. Masinissa falls in love with Sophonisba and marries her. Scipio, afraid of losing another ally to Sophonisba's persuasions, orders Masinissa to hand her over so she can be brought to Rome as a prisoner. Not daring to oppose the order, the prince decides to send his wife a chalice containing poison with a message explaining everything. After reading the note, the queen drinks it without hesitation.

Sophonisba's death was a favorite subject for Baroque painters in Italy and northern Europe.

Relatives and Origins
Daughter of Hasdrubal, a Carthagian general

Characteristics and Activity
Marries Masinissa, the king of Numidia

Francesco Solimena, ▲ *Sophonisba Receives the Poison from a Messenger of Masinissa* (detail), circa 1705–9. From a private collection.

Rembrandt, ◄ *Sophonisba Receiving the Poisoned Cup*, 1634. Madrid, Prado.

Verginia is typically shown being killed by her father. Appius Claudius can also appear in the scene, seated on his chair.

Verginia

Relatives and Origins
Daughter of Lucius Verginius, a centurion from the fifth century B.C.

Characteristics and Activity
Her father, who did not intend to lose her to the decemvir Appius Claudius's lust, killed her

The decemvir Appius Claudius falls in love with the beautiful Verginia and attempts to seduce her in any way possible. The girl, however, who is already betrothed, refuses him. Being a judge, Appius Claudius orders one of his clients, Marcus Claudius, to take Verginia for himself, maintaining that she is the daughter of one of Marcus's family's slaves who had been stolen from his house and given to Lucius Verginius. As planned, the dispute reaches the tribunal presided over by Appius Claudius himself, who orders that the girl be handed over to his friend. Only after much insistence does Lucius Icilius, the girl's fiancé, manage to establish, in light of what has happened, that she will not be given to Marcus until her father has his say. The next day Verginius, Verginia's father, is present in the forum. Called to the front, he listens to Appius Claudius's ruling on the matter. He obtains permission to speak with the girl's nurse in order to learn the truth. When he is with Verginia, he turns from the bench and unexpectedly unsheathes a knife with which to slay his daughter, shouting that this is the only way to safeguard her freedom. The people are shaken by this terrible episode and rise up, rebelling against the government of decemvirs, who are expelled from the city (449 B.C.). Appius commits suicide in prison.

◄ Domenico Beccafumi, *Verginia before Appius Claudius* (detail), 1520–25. London, National Gallery.

► Filippo Abbiati, *The Death of Verginia,* circa 1678–83. Milan, Pinacoteca delle Civiche raccolte d'arte.

Appius Claudius orders the young woman to be handed over to Marcus Claudius.

Verginia's father implores the decemvir for mercy.

Verginia tries to flee from Marcus Claudius.

Marcus Claudius attempts to make Verginia accept Appius Claudius's lust.

The central scene of this painting shows the outbreak of the riot against the decemvirs.

Lucius Verginius lunges toward his daughter with a knife.

▲ Sandro Botticelli, *Stories of Verginia*, 1499–1500. Bergamo, Accademia Carrara.

Portrayed as a proud, unyielding woman, Zenobia is typically shown in military garb inciting her soldiers, or during her marriage with Odaenathus.

Zenobia

Relatives and Origins
Wife of Odaenathus
VII, king of Palmyra

**Characteristics
and Activity**
Queen of the city
of Palmyra

Zenobia Septimia (third century A.D.) was the second wife of Odaenathus VII, king of Palmyra. She is remembered as a woman of rare beauty and energetic disposition. The queen, in fact, actually participates in the king's military campaigns and takes an interest in court affairs. At Odaenathus's death, she succeeds her husband and guides the kingdom in the name of her young son. Palmyra has been a Roman colony for some time, and she dedicates herself to a new series of military campaigns, extending her kingdom over a large part of the East, and acquires such power as to be able to challenge Rome directly. Zenobia declares independence from the Roman Empire and begins to coin money with her image on it. Emperor Aurelianus wages war on Palmyra and lays siege to it. Not considering surrender an option, the queen flees but is captured. She is brought to Rome and forced to walk the streets of the city as a war trophy.

There are contradictory traditions regarding Zenobia's death. Some hold that the ruler passed the remainder of her days in a wonderful villa that the emperor gave her; others say she starved herself rather than suffer the disgrace of prison.

▶ Gerard Peemans, *The Wedding Feast of Zenobia and Odaenathus* (detail), from the end of the seventeenth century. Lucca, Palazzo Mansi.

Zenobia is portrayed as a proud and ambitious woman. The Roman emperor Aurelianus once said of her: "Those who think that I only defeated a woman do not know who this woman really was, how unexpected her decisions were, how stubborn she was in keeping them, or how determined she was with her soldiers."

With an expressive gesture, Zenobia rallies her soldiers.

▲ Giovanni Battista Tiepolo, *Queen Zenobia Addressing Her Soldiers*, 1725–30. Washington, D.C., National Gallery.

On the following page:
Sandro Botticelli, *The Birth of Venus* (detail), 1484–86. Florence, Uffizi.

Appendixes

Index of Names

Achilles, 259
Actaeon, 10
Adonis, 14
Aeneas, 324
Alexander the Great, 300
Antiope, 20
Apelles, 307
Apollo, 22
Arachne, 26
Archimedes, 308
Argus, 28
Ariadne, 30
Arion, 36
Aristotle, 309
Atalanta, 37
Atlas, 38
Aurora, 40
Bacchus, 44
Baucis, 208
Bellerophon, 50
Berenice, 51
Boreas, 52
Cadmus, 53
Caesar, 328
Callisto, 54
Calypso, 282
Cato, 333
Centaurs, 55
Cephalus, 57
Ceres, 60
Cheiron, 63
Cimon, 334
Circe, 283
Civilis, 335
Cleopatra, 336
Clytie, 64
Cornelia, 340
Coronis, 65
Cupid, 66
Danae, 76
Daphne, 78
Decius Mus, 341
Deianeira, 80
Democritus, 313
Deucalion, 227
Diana, 83
Dido, 342

Diogenes, 310
Endymion, 87
Europa, 89
Eurydice, 91
Fates, 93
Flora, 95
Galatea, 97
Ganymede, 100
Glaucus, 101
Graces, 103
Hannibal, 348
Hebe, 105
Hector, 267
Helen, 269
Heraclitus, 313
Hercules, 106
Hero, 123
Horatii, 352
Hyacinthus, 126
Hylas, 128
Icarus, 129
Io, 132
Iphigeneia, 134
Jason, 135
Juno, 137
Jupiter, 139
Laocoon, 271
Latona, 145
Leander, 123
Leda, 147
Lucretia, 353
Marcus Curtius, 357
Mars, 148
Marsyas, 154
Medea, 156
Medusa, 159
Meleager, 161
Mercury, 162
Midas, 166
Milon, 314
Minerva, 169
Minotaur, 176
Mucius Scaevola, 358
Muses, 177
Narcissus, 180
Neptune, 182
Nereids, 238

Niobe, 184
Oedipus, 186
Olympus, 187
Orpheus, 189
Pan, 193
Pandora, 196
Paris, 273
Pegasus, 197
Penelope, 287
Pero, 334
Perseus, 200
Phaethon, 206
Philemon, 208
Philoctetes, 275
Pluto, 212
Polyphemus, 290
Polyxena, 276
Prometheus, 214
Proserpina, 216
Psyche, 219
Pyramus, 226
Pyrrha, 227
Remus, 360
Romulus, 360
Sabines, 362
Saturn, 228
Satyrs, 230
Scipio, 363
Scylla, 101
Semele, 232
Seneca, 366
Sibyls, 367
Silenus, 233
Sirens, 292
Socrates, 316
Sophonisba, 371
Theseus, 234
Thetis, 277
Thisbe, 226
Tritons, 238
Trojan Horse, 279
Ulysses, 294
Venus, 240
Verginia, 372
Vertumnus, 248
Vulcan, 250
Zenobia, 374

Sources

What follows is a list of major authors who have inspired artists throughout the ages, and their works related to mythology. It is important to remember that artists did not always draw from the original sources directly but often utilized outlines or poetic retellings of the myths. In addition, especially during the Baroque period, themes from mythology and Greco-Roman history were varied yet again and reworked in poetry, music, and imagery.

Aeschylus
(Eleusis, 525/4 B.C.–Gela, 456 B.C.), a Greek tragedian. Out of close to eighty plays that have been attributed to Aeschylus, only seven have survived: *Supplices, Prometheus Bound*, the *Oresteia* trilogy (*Agamemnon, Choephoroe*, and *Eumenides*), *Seven Against Thebes*, and *The Persians*.

Aesop
(seventh or sixth century B.C.), a Greek teller of fables. He composed a body of fables whose popularity can be seen in Aristotle and Plato. These brief fables, whose characters are mostly animals, are aimed at moral teaching.

Apollodorus of Athens
(circa 180–115 B.C.), a Greek scholar. He is especially remembered for his writings *On Ships*, a commentary on the second book of the *Iliad*; *On Gods*, a compilation of mythological facts; and *Chronicles*, which narrates events between the fall of Troy and 199 B.C.

Apollonius Rhodius
(circa 295–215 B.C.), a Greek epic poet. He was a student of Callimachus and directed the famous library of Alexandria in Egypt from 260 to 247 B.C. Among his works is the *Argonautica*, a poem of four books that tells of the voyage of the *Argo*, the quest for the Golden Fleece, how Jason was able to take possession of the famous relic, and the heroes' return. The poem was widely read in antiquity and was later reworked in Latin by Valerius Flaccus.

Apuleius
(Madaurus, Algeria, circa A.D. 125–after A.D. 170), the celebrated author of *Metamorphoses*, also known as *The Golden Ass*, an eleven-book novel that describes the adventures of young Lucius, who is transformed into an ass and then restored to human form through the goddess Isis's intervention. In the fourth book Apuleius narrates the famous story of Cupid and Psyche.

Giovanni Boccaccio
(Florence? 1313–Certaldo, Florence, 1375), an Italian writer. Besides the famous *Decameron*, toward the middle of the fourteenth century Boccaccio wrote *Genealogia deorum gentilium*, an authoritative treatise on classical mythology spanning fifteen books. It became an important reference for knowledge of mythology through the first half of the sixteenth century.

Gaius Julius Caesar
(100–44 B.C.), a Roman politician, military general, and writer, too. He described his life in *De Bello Gallico*, which narrates his military campaigns against Gaul, and *De Bello Civili*, an account of the war against Pompey that shook the Roman state in 49 and 48 B.C.

Vincenzo Cartari
(Reggio Emilia, circa 1531–1587), an Italian writer who worked under the protection of the Este court. He authored *Le immagini colla sposizione degli dei degli antichi* (Images displaying the gods of antiquity), published in Venice for the first time in 1556. It was one of the most widespread treatises on mythology and provided a discussion of an entire iconographic repertory, inspiring many Renaissance artists.

Gabriello Chiabrera
(Savona, 1552–1638), an Italian poet. His vast literary work includes all genres that were fashionable at the time: tragedy, heroic poems, didactic poems, satiric compositions, and melodramas. *The Abduction of Cephalus*, a work that was widely known during the Baroque period, falls in this last category.

Marcus Tullius Cicero
(Arpinum, 106 B.C.–Formiae, 43 B.C.), a Roman orator, writer,

and politician. Cicero authored orations, rhetoric works, and philosophical treatises. In his *De Republica* he lays out his thoughts on the best form of government, and in the sixth book he relates the famous "dream of Scipio." This later became quite popular with humanists.

Niccolò da Correggio
(Ferrara, 1450–1508), an Italian poet. He was in the service of the Este court and wrote the play *Cephalus*. This was directly inspired by the ancient myth, although it was reworked with added characters and a happy ending.

Diodorus Siculus
(Agyrium, circa 90–20 B.C.), a Greek historian. He left behind the extensive *World History*, a forty-book series that has only partly survived. It can be considered the first example of universal history, spanning from the earliest times to Caesar's consulate.

Diogenes Laertius
Laertes, Sicily, third century A.D.), a Greek writer. He is famous for having written the volume *Lives of the Philosophers*, from Thales to Epicurus, which is rich in anecdotes and important citations.

Euripides
Salamis, circa 485 B.C.–Pella, 06 B.C.), a Greek tragedian. Out of close to ninety-two tragedies that have been attributed to him, the following have

survived: *Alcestis, Medea, Hippolytus, Andromache, Heracleidae, Supplices, Heracles, Troades, Electra, Helen, Iphigeneia in Tauris, Ion, Phoenissae, Orestes, Iphigeneia in Aulis, Bacchae*, and a satirical play, *Cyclops*.

Gesta Romanorum
(author unknown, probably compiled in fourteenth century), a collection of myths, fables, and anecdotes taken directly from Roman history and medieval legends. It was widely read and popular during the Middle Ages and the Renaissance.

Herodotus
(Halicarnassus, Cariae, circa 484 B.C.–after 430 B.C.), a Greek historian. In his *History*, he mostly describes the contrasts and conflicts between the Greeks and the so-called barbarians—peoples of the Middle East—before and during the Persian War. In trying to uncover the causes of such hostility, the historian studies the religious customs and beliefs of the various peoples, including a number of historical episodes and anecdotes.

Hesiod
(Ascra? Boeotia, seventh or sixth century B.C.), a Greek poet. His poem, *Theogony*, represents a first attempt to rationally order Greek mythological and religious heritage, and he describes the origins of the world of the gods. In his *Works and Days*, which defines agricultural and navigational practices, a number of

mythological anecdotes are included.

Homer
(eighth or seventh century B.C.?), a Greek epic poet. He is the author of the *Iliad*, a poem that tells the events of the last year of the Trojan War, and the *Odyssey*, which narrates the perilous return home of Ulysses, king of Ithaca.

Hyginus, Gaius Julius
(first century A.D.), a Latin scholar. A freedman of Augustus and director of the Palatine Library, he wrote two publications related to mythology: *Fabulae* and *Poetica Astronomica*.

Livy (Titus Livius)
(Padova, 59 B.C.– A.D. 17, or 64 B.C.– A.D. 12), a Roman historian. Livy wrote *Ab urbe condita libri* (From the founding of the city), a huge work of 142 books that tells the events of Rome's history from Aeneas's landing in Italy to the funeral of Augustus's stepson, which was probably meant to conclude with the emperor's death. Only thirty-five books have survived, and for the rest only summaries, mostly compiled during the Middle Ages, remain.

Musaeus Grammaticus
(fifth century B.C.), a Greek epic poet. He wrote the tiny poem *Hero and Leander*, which has survived in its entirety. It narrates the famous love story between those two mythological characters.

Ovid (Publius Ovidius Naso)
(Sulmo, 43 B.C.–Tomis, Black

Sea, A.D. 17), a Latin poet. Ovid is the famous author of the *Metamorphoses*, the fifteen-book poem that narrates the transformations of humans and gods. It was quite influential in the Middle Ages. In addition, Ovid describes the festivals of the Roman calendar and recounts related legends, rites, and events in *Fasti*. *Heroides*, finally, is a collection of letters that the various heroines of antiquity and mythology write to their lovers.

Ovide Moralise (author unknown), a poem written at the beginning of the fourteenth century. Its anonymous author is sometimes thought to be Philip of Vitry, bishop of Meaux, or Chrestien Legouais de Sainte-More. This extensive poem provides a moral interpretation of Ovid's *Metamorphoses* according to Christian thought.

Petrarch (Francesco Petrarca) (Arezzo, 1304–Arquà, 1374), an Italian writer. This famous author of *Canzoniere* (Songbook) also wrote *Africa*, a poem telling of the Second Punic War. In it he followed Livy and exalted Rome. *De viris illustribus* (On illustrious men) tells instead of the heroes of the past and their exemplary actions.

Phaedrus (circa 15 B.C.–circa 50 A.D.), a Latin poet. A freedman of Augustus, he left behind fifteen books of fables that were directly inspired by Aesop and Hellenistic fables. This body of work did not survive entirely, although certain fables were handed down in me-

dieval codices and eventually discovered by humanists. *Romulus*, a text that was extremely popular during the Middle Ages, deserves particular mention. In it, a number of fables by Phaedrus were paraphrased into prose.

Pindar (Cynosephalae, Boeotia, 518 B.C. –Argos, 438 B.C.), a Greek poet. *Epinicians* celebrates the abilities of the winning athletes in various competitions, and Pindar inserts a number of mythological anecdotes linked to either an athlete's family or the place where the competitions were being held.

Pliny the Elder (Gaius Plinus Secundus) (Como, 24/23 B.C.–Stabiae, A.D. 79), a Latin scholar. Pliny owes his fame to his encyclopedic *Naturalis Historia*, which comprises thirty-two books. It is one of the most important works for the culture of antiquity and the Middle Ages. In telling a number of mythological anecdotes, Pliny also writes astronomy, botanic medicine, metals, art, and architecture.

Plutarch (Chaeronea, A.D. 46/50–after A.D. 120), a Greek scholar and philosopher. He is primarily famous for writing *Parallel Lives*, where he compares the lives of famous Greek and Roman generals and statesmen.

Quintus Curtius Rufus (first century A.D.), a Latin writer who authored a history of Alexander the Great. The ten books, which were quite popular

in the Middle Ages, have not survived in their entirety.

Sophocles (Colonus, Athens, 496 B.C.– Athens, 406 B.C.), a Greek tragedian. Of his vast output, only seven of his tragedies (*Antigone, Philoctetes, Ajax, Oedipus Tyrannus, Trachiniae, Electra,* and *Oedipus Coloneus*) and one satyr play (*Ichneutae*) remain.

Cornelius Tacitus (circa A.D. 55–120), a Roman politician and historian. His two great historical works are *Histories*, which covers the history of Rome from Galba's rise to power until Domitian's death, and *Annals*, which describes events from Tiberius's reign until the death of Nero.

Valerius Maximus (first century A.D.), a Roman historian. He wrote *Factorum et dictorum memorabilium libri* (Memorable facts and sayings), where he uses brief sentences to record famous anecdotes, especially from Greek and Roman history. The text was quite popular during the Middle Ages.

Virgil (Publius Vergilius Maro) (Andes, Mantua, 70 B.C.– Brindisi, 19 B.C.), a Latin poet. Between 42 and 39 B.C., Virgil composed *Bucolics*, a collection of pastoral poems, and some years later *Georgics*, a poem on agriculture in four books. Above all, he is famous for being the author of the *Aeneid*, the twelve-book poem that tells Rome's legendary origins.

Symbols and Attributes

anvil: Vulcan
armor: Mars
arrows: Apollo, Cupid, Diana,
 Hercules
barrel: Diogenes
bear: Callisto
bow: Apollo, Cupid, Diana,
 Hercules
caduceus: Mercury
club: Hercules
cornucopia: Ceres
crescent moon: Diana
crow: Apollo, Coronis
crown made of ears of corn:
 Ceres
crown of flowers: Flora
crown of vine branches: Bacchus,
 satyrs, Silenus
cuirass: Mars, Minerva
dog: Diana
donkey: Silenus
dove: Venus
eagle: Jupiter
goat: Bacchus
gold crown: Juno
grain: Ceres
grapes: Bacchus, satyrs, Silenus
halberd: Mars, Minerva
hammer: Vulcan
hawk: Saturn
heavens: Atlas
helmet: Mars, Minerva
hourglass: Saturn
ivy crown: Bacchus, satyrs,
 Silenus
lance: Mars, Minerva
lantern: Diogenes
laurel: Apollo, Orpheus
leopard: Bacchus
lightning bolt: Jupiter
lion skin: Hercules
lyre: Apollo, Orpheus
owl: Minerva
peacock: Juno
quiver of arrows: Apollo, Cupid,
 Diana, Hercules

scepter: Juno, Jupiter
scythe: Ceres
shield: Mars, Minerva
snake biting its own tail:
 (eternity) Saturn
sphere: Apollo
stag: Diana
sunflower: Clytie
swan: Apollo, Venus
sword: Mars, Minerva
thread: Ariadne
thyrsus (a decorated staff):
 Bacchus
tiger: Bacchus
torch: Ceres
trident: Neptune
trumpet: tritons
wine glass: Bacchus, satyrs,
 Silenus
winged hat (petasus): Mercury
winged shoes: Mercury, Perseus
wolf: Apollo, Mars

Index of Artists

Aachen, Hans von, 217
Abbiati, Filippo, 372
Allori, Alessandro, 296
Altdorfer, Albrecht, 303
Amigoni, Jacopo, 265, 273
Appiani, Andrea, 139, 220–21
Arcimboldi, Giuseppe, 248
Bacigalupo, Giuseppe, 123, 208
Baldung, Hans (Grien) 104, 226, 359
Barabino, Nicolò, 308
Barocci, Federico, 325
Bartolommeo Veneto, 95
Batoni, Pompeo, 63, 108, 250
Bazzani, Giuseppe, 267
Beccafumi, Domenico, 227, 340, 372
Bellini, Giovanni, 8–9, 46, back cover
Benvenuti, Pietro, 22
Berger, Giacomo (Jacques), 201
Bernini, Gian Lorenzo, 78, 182, 212, 238
Berthélemy, Jean-Simon, 302
Bertoldo di Giovanni, 50
Bloemaert, Abraham, 185, 278
Böcklin, Arnold, 193, 239, 282, 292, 294
Bordone, Paris, 202
Bortoloni, Mattia, 331
Bos, Michel de, 39
Bossi, Giuseppe, 54
Bottani, Giuseppe, 283, 286
Botticelli, Sandro, front cover, 55, 66, 68–69, 96, 150–51, 162, 169, 174, 241, 373, 375
Boucher, François, 242
Boulanger, Gustave Clarence Rodolphe, 294, 297
Bramante, Donato, 313
Bronzino (Agnolo di Cosimo), 72
Brueghel, Jan, 190, 195, 282
Brueghel the Elder, Pieter, 129, 131
del Cairo, Francesco, 196
Camuccini, Vincenzo, 332
Canal, Giambattista, 328

Canova, Antonio, 91, 105, 109, 121, 176, 189, 200, 219, 235
Caravaggio (Michelangelo Merisi da Caravaggio), 44, 66, 71, 159, 180, 334
Carneo, Antonio, 248, 333
Caron, Antoine, 368–69
Carracci, Agostino, 212, 277, 360
Carracci, Annibale, 48–49, 87, 193, 233, 273, 360
Carracci, Ludovico, 156, 158, 360
Castiglione, Giovanni Benedetto (Il Grechetto), 284–85
Cecco Bravo (Francesco Montelatici), 145
Cedini, Costantino, 153
Cesare da Sesto, 147
Cesari, Bernardino, 10
Cesari, Giuseppe (Cavalier d'Arpino), 352
Champaigne, Jean-Baptiste de, 40
Cima da Conegliano, 30, 87, 166
Claude Lorrain, 97, 163
Clouet, François, 85
Congnet, Gillis, 54
Correggio (Antonio Allegri), 67, 100, 131
del Cossa, Francesco, 149
Costa, Lorenzo, 136
Cranach the Elder, Lucas, 73, 119, 240, 274, 353
Crespi, Giuseppe Maria (Il Cerano), 63, 93
Crosato, Giovanni Battista, 306–7
David, Jacques-Louis, 268–69, 320–21, 352
Delacroix, Eugène, 156, 261
Della Porta, Guglielmo, 107
Demin, Giovanni, 329
Desoubleay, Michel, 51
Diotti, Giuseppe, 316
Domenichino (Domenico Zampieri), 19, 83, 86, 126, 166, 168, 367
Dossi, Dosso, 164, 194

Draper, Herbert James, 293
Drouais, Jean-Germain, 275
Dürer, Albrecht, 36, 112
El Greco (Domenikos Theotokopulos), 272, 279
Elsheimer, Adam, 62, 65, 210–11
Falciatore, Filippo, 198
Ferrari, Luca (Luca da Reggio), 267
Ferraro, Orazio, 319
Fetti, Domenico, 124–25
Fiammingo, Paolo (Pawels Franck), 170
Figino, Ambrogio Giovanni, 137
Flemish school, 60
Fontainebleau school, 84
Fontana, Lavinia, 175, 336
Franceschini, Giacomo, 260
Franceschini, Marc Antonio, 15–16
Füssli (Fuseli), Johann Heinrich, 264, 291
Gentileschi, Orazio, 76
Baron Gérard, François, 128, 219
Ghirlandaio, Ridolfo, 147
Giambologna (Jean de Boulogne), 162
Giani, Felice, 183, 259, 266
Gimignani, Giacinto, 97
Giordano, Luca, 57, 94, 99, 122, 154, 200, 203, 214, 216, 218, 238, 339
Giulio Romano, 45, 222, 279, 290
Glaize, Auguste-Barthélemy, 246
Goltzius, Hendrick, 53
Goya y Lucientes, Francisco de, 228, 348, 350
Gran, Daniel, 206
Guardi, Francesco, 363
Il Guercino (Giovan Francesco Barbieri), 38, 40, 152, 342, 347
Baron Guérin, Pierre-Narcisse, 4
Haydon, Benjamin Robert, 357
Heintz the Elder, Joseph, 206

Heintz the Younger, Joseph, 213
Hetsch, Phillip Friederich von, 340
Ingres, Jean-Auguste-Dominique, 20, 144, 186, 256–57
Janssens, Abraham, 61, 120
Jones, Thomas, 345
Jordaens, Jacob, 231
Kauffmann, Angelica, 32
La Fosse, Charles de, 64
La Hyre, Laurent de, 102, 235
Lazzari, Gregorio, 192
Limborch, Hendrik van, 262
Lippi, Filippino, 55
Loth, Johann Carl, 208, 333
Lotto, Lorenzo, 230, 354–55
Mabuse (Jan Gossaert), 77
Maffei, Francesco, 327
Manfredi, Bartolommeo, 75
Mantegna, Andrea, 36, 172–73, 177, 197, 328, 330
Martini, Francesco di Giorgio, 363
Master of the Campana Cassoni, 234, 236–37
Matteis, Paolo de', 106
Maulpertsch, Franz Anton, 310
Mazzola, Giuseppe, 14
Meyvogel, Mattheus, 334
Michallon, Achille Etna, 275
Michelangelo Buonarroti, 56, 370
Mola, Pier Francesco, 88, 318
Moreau, Gustave, 111, 186, 214, 269
Mura, Francesco de', 346
Oudenaarde, 113
Padovanino (Alessandro Varotari), 224
Palagi, Filippo Pelagio, 31
Parmigianino (Francesco Mazzola), 70, 83, 353
Pécheux, Laurent, 80
Peemans, Gerard, 374
Pellegrini, Giovanni Antonio, 53
Perino del Vaga, 141
Perugino, 154

Peruzzi, Baldassare, 105
Piero di Cosimo, 57–59, 204–5, 215, 251
Pierre, Jean-Baptiste-Marie, 165
Pietro da Cortona, 326
Pinturicchio, 289
Pittoni, Giovanni Battista, 30, 276, 338, 343, 349
Pollaiuolo, Antonio, 79, 106, 118
Pordenone (Giovanni Antonio de' Sacchis), 314
Pouget, Pierre, 315
Poussin, Nicolas, 140, 167, 181, 226, 362
Poynter, Edward John, 37
Primaticcio, Francesco, 287
Raon, Jean, 139
Raoux, Jean, 191
Raphael (Raffaello Sanzio), 98, 103, 142–43, 177–79, 298–99, 309, 365
Redon, Odilon, 290
Rembrandt Harmenszoon van Rijn, 12–13, 90, 95, 100, 169, 300, 335, 371
Reni, Guido, 33, 37, 42, 82, 367
Restout, Jean, 364
Ribera, Jusepe de (lo Spagnoletto), 233, 308
Ricci, Sebastiano, 14, 47, 74, 207, 232, 270, 310, 358, 361
Richmond, William Blake, 189
Ripanda, Jacopo, 348
Rosa, Salvator, school of, 135
Rossetti, Dante Gabriel, 216
Rubens, Peter Paul, 29, 110, 114, 123, 130, 159, 195, 197, 209, 223, 229, 247, 322–23, 341, 358, 360, 366
Sabatelli, Luigi, 187
Sacchi, Andrea, 129
Salviati, Francesco, 93
Sandys, Anthony, 157
Scarsellino (Ippolito Scarsella), 160
Schiavone (Andrea Mendolla), 225

Schoonjans, Anton, 336
Schoor, Ludwig van, 91–92
Solimena, Francesco, 43, 52, 344, 371
Spranger, Bartholomeus, 17, 81, 101, 171, 250
Strozzi, Bernardo, 51
Sustris, Lambert, 148, 243
Thulden, Theodore van, 199
Tiarini, Alessandro, 252
Tibaldi, Pellegrino, 280, 295
Tiepolo, Giovanni Battista, 23, 50, 127, 134, 228, 259, 263, 277, 301, 307, 324, 337, 375
Tiepolo, Giovanni Domenico, 258, 280
Tintoretto (Jacopo Robusti), 27, 138, 232, 254
Titian (Tiziano Vecelli), 10–11, 34–35, 76, 89, 155, 356
Trotti, Giovanni Battista (Malosso), 283
Turchi, Alessandro (L'Orbetto), 89
Vaccaro, Domenico Antonio, 65, 161, 184
Van Dyck, Anthony, 27, 249, 253
Van Everdingen, Cesar, 311, 317
Van Heemskerck, Maerten, 244–45
Van Honthorst, Gerrit, 366
Vassallo, Anton Maria, 146
Velázquez, Diego, 22, 24–25, 26, 28, 44, 148
Veronese (Paolo Caliari), 18, 26, 188, 300, 304–5
Viani, Antonio Maria (Vianino), 187
Waterhouse, John William, 52, 116–17, 126, 196, 292
Watteau, Jean-Antoine, 60
Watts, George Frederick, 176
Wright, Joseph (Wright of Derby), 287–88
Zelotti, Giovanni Battista, 132–33
de Zurbarán, Francisco, 115